Art, Mind, and Education

Art, Mind, and Education:
Research from Project Zero

Edited by

Howard Gardner and D. N. Perkins

University of Illinois Press *Urbana and Chicago*

The articles in this book orginally appeared in the *Journal of Aesthetic Education*, Volume 22, Number 1 (1988).

Library of Congress Cataloging-in-Publication Data

Art, mind, and education.

 Originally published as v. 22, no. 1 (1988) of
Journal of aesthetic education.
 Includes index.
 1. Arts and children. 2. Arts—Study and teaching.
3. Cognition in children. 4. Harvard Project Zero.
I. Gardner, Howard. II. Perkins, David N.
NX180.C45A74 1989 700'.7 88-29583
ISBN 0-252-01637-8 (cloth: alk. paper)
ISBN 0-252-06080-6 (paper: alk. paper)

CONTENTS

Why "Zero?" A Brief Introduction to Project Zero

D. N. PERKINS and HOWARD GARDNER

Mention that you are associated with Project Zero of the Harvard Graduate School of Education, and the first question you are likely to hear is a skeptical "What's that?" Or sometimes you are simply misidentified: "Oh, that has something to do with zero population growth, doesn't it?" Whatever the response, you certainly have to explain. The short version goes something like this:

Project Zero is an interdisciplinary basic research project in human symbolic development. We are concerned to understand the nature of cognitive abilities, their development in school, family, and other settings, and their mediation by a variety of symbol systems—language, writing, picturing, gesture, symbolic play, and so on. We draw upon the disciplines of philosophy, developmental and cognitive psychology, neurology, education, and the arts and sciences in general. The project was founded in 1967 at the Harvard Graduate School of Education by the well-known philosopher Nelson Goodman. The project's initial mission was to examine the philosophy and psychology of the arts, with an eye to informing arts education. In the early 70s, Howard Gardner and David Perkins, original members of Project Zero as graduate students at Harvard and M.I.T., respectively, assumed codirectorship of Project Zero and still fill the role today.

Over the years, the interests represented by the several doctoral-level individuals associated with the project expanded to include a number of other themes besides the arts: children's response to television, the early development of symbolic capacities, the nature of intelligence, the development of informal reasoning abilities, and the nature of higher-order thinking skills in general, to name just a few. However, the arts and arts education have always remained prominent foci of work at Project Zero.

As our interests broadened, our confidence in our perspective matured in other ways as well. During the late 60s and early 70s, we functioned principally as a think-tank—reading, reflecting, and writing. As the 70s progressed, we became deeply involved in a diversity of empirical work in

laboratory and school settings, probing the nature of cognitive development and cognitive skills and seeking to evolve better understandings of complex phenomena such as artistic giftedness and creativity. While that work has continued into the 80s, we have felt emboldened to embark upon several teaching experiments. We have sought to give concrete practical expression to some of our ideas in such areas as the teaching of artistic skills, detection and nurturing of special talent, and the development of critical and creative thinking in general. The aim has not been so much to provide curricula as to learn more about the nature of the phenomena by observing how our ideas play out in practice.

While the foregoing sketch of Project Zero will satisfy some, others more curious will have further questions. A favorite is "When will you be done?" It's easy to understand the source of this question. We are, after all, called *Project* Zero, and talk of projects inevitably conjures images of putting a man on the moon, a dam across a valley, or the end to a quest. However, Project Zero is not that sort of endeavor. We find ourselves now as always engaged in ongoing exploration, with new questions emerging as older ones become at least partly settled. The arrival of our twentieth year, and the invitation of Ralph Smith of the *Journal of Aesthetic Education*, provided an opportunity for us to review for *JAE* readers some of the lines of work in the arts and arts education that have occupied us in recent years. We hope that this collection of essays, now in book form, will provide a useful introduction to those unfamiliar with Project Zero, a state-of-the-art report for friends and associates, and, for both old and new colleagues, a fresh perspective on thinking in arts education at a number of different levels of analysis.

One way in which we have sliced the complicated pie of the arts honors the boundaries of various artistic media. For example, in "The Art of Children's Drawing," Elizabeth Rosenblatt and Ellen Winner examine the development of perceptual, productive, and reflective abilities in normal and gifted youngsters. In "From Endpoints to Repertoires," Dennie Wolf and Martha Davis Perry highlight how the development of drawing abilities involves not just mastery of more sophisticated representational systems but the accumulation of a flexible repertoire including systems acquired earlier.

Addressing the language arts in tandem with television, Laurene Krasny Brown in "Fiction for Children: Does the Medium Matter?" examines how narrative rendered in writing or television media shapes distinctive responses in youngsters. Israel Scheffler, in "Ten Myths of Metaphor," informs our understanding by systematically challenging a number of facile beliefs about the nature of metaphor. The complementary "Children's Understanding of Nonliteral Language," by Ellen Winner, Jonathan Levy, Joan Kaplan, and Elizabeth Rosenblatt, traces the developmental

trajectory of children's increasing mastery of metaphor and irony.

The musical arts are also represented. In " 'Happy Birthday': Evidence for Conflicts of Perceptual Knowledge and Conceptual Understanding," Lyle Davidson, Lawrence Scripp, and Patricia Welsh focus on the perception and production of simple melodies, highlighting how conventional musical instruction can lead to conflicts between the two. Lawrence Scripp, Joan Meyaard, and Lyle Davidson track aspects of musical development employing the power of contemporary technology in "Discerning Musical Development: Using Computers to Discover What We Know."

While considerable work at Project Zero has focused on particular artistic media and symbol systems, we have never been able to resist the lure of cutting across the arts and importing unusual perspectives to illuminate the arts. Thus, for example, Kathryn Lowry and Constance Wolf, in "Arts Education in the People's Republic of China," elaborate a picture of Chinese art and music education that discloses a number of intriguing contrasts with U.S. practices. Joseph Walters, Matthew Hodges, and Seymour Simmons examine the manifold opportunities afforded by computers as tools of musical and visual expression and review the potential impacts on education in "Sampling the Image: Computers in Arts Education."

From time to time, we try to rise above the trees entirely and get a perspective on the whole forest of the arts and art education by way of some central issue. Thus, David Perkins, in "Art as Understanding," lays out how certain misunderstandings not unlike those found in science education can interfere with learning in the arts. Vernon Howard in "Expression as Hands-on Construction" examines a number of misconceptions about the role of the emotions and of intention in artistic expression. In "Artistic Learning: What and Where is It?" Dennie Wolf describes through a compelling case study of one student a portfolio-based approach to fostering and assessing artistic growth evolved at Project Zero. In "Toward More Effective Arts Education," Howard Gardner addresses point-blank the educational challenge in the arts, urging the necessity of parallel attention to contributions from philosophy, psychology, artistic practice, and the ecology of educational systems.

The many perspectives of these essays may lead one to wonder about the tight focus intimated by the word "project" in our name. Indeed, our efforts are diverse, reflecting varied interests of the several individuals who have been associated with the project for some time. However, this survey of titles and topics suggests what a close look at the articles confirms: A number of core convictions mark and unify our enterprise. We share a belief that the arts, usually celebrated as the dominion of the emotions, are profoundly cognitive activities; a belief that human intelligence is symbolically mediated and must be understood from the perspective of sym-

bolic development; a belief that creative and critical thinking in the arts and the sciences have far more in common than is often thought; a concern to study and understand the psychological processes and resources underlying some of the peak achievements of humankind.

A celebration provides an opportunity to look ahead to the work that remains to be done, but also an opportunity to look back in gratitude to those who have helped and supported us in the past. We wish to acknowledge here valued colleagues who joined forces with us in the early days of Project Zero: Founding Director Nelson Goodman, Jeanne Bamberger, Frank Dent, John Kennedy, Diana Korzenik, Barbara Leondar, and our late esteemed friend Paul Kolers. And with deep appreciation, we acknowledge the many private and governmental agencies that have supported our work: The Carnegie Corporation, The Livingston Fund, The John D. and Catherine T. MacArthur Foundation, The John and Mary R. Markle Foundation, The James S. McDonnell Foundation, The Milton Fund, The National Institute of Education, The National Science Foundation, The Rockefeller Brothers Fund, The Rockefeller Foundation, The Alfred Sloan Foundation, and The Spencer Foundation. For support of this publication we thank the Ahmanson Foundation and also our cherished colleagues Lonna Jones of the Rockefeller Brothers Fund and Ralph Smith of the University of Illinois.

This rounded sense of mission, involving invaluable support from many quarters, resurrects the classic question of them all: "With so much on your agenda, why 'Zero'?" We can trace our odd name back to our founder, Nelson Goodman. He had more or less this to say when he announced it: "The state of general, communicable knowledge about arts education is zero. So we are Project Zero." Here as always, he meant his words to be taken with precision. To be sure, many gifted teachers existed in the arts, who knew something about how to impart spirit and ability to their students. But what about *general* and *communicable* knowledge? There seemed to be little enough of that, so Project Zero we became.

"And are you still at zero?" Like so many answers, the reply depends on how one measures. We think that we have teased out some important questions and gone at least halfway toward answering some of them. So in absolute terms, we are well beyond zero. On the other hand, we don't seem to be running out of questions. While our accomplishments are certainly very finite, the domain to be addressed shows no signs of being anything but infinite, and by that gauge we are still virtually at zero. That gives us one excuse for hanging onto the name. But another probably has more force: Nelson Goodman has always been fond of saying that one way to teach is to create fruitful obstacles. Maybe our 'zero' is like that—it teaches us by giving us something to live up to or live down. We have lived it up and down for twenty years now, and, as often happens with fruitful obstacles, we've grown fond of it.

Introduction
Aims and Claims

NELSON GOODMAN

When Project Zero started twenty years ago with a staff consisting of one philosopher, two psychologists part-time, and some volunteer associates, it had no fixed program and no firm doctrines but only a profound conviction of the importance of the arts, and a loose collection of attitudes, hunches, problems, objectives, and ideas for exploration. We viewed the arts not as mere entertainment but, like the sciences, as ways of understanding and even of constructing our environments, and thus looked upon arts education as a requisite and integrated component of the entire educational process.

We found at once that we had to begin almost at zero, with basic theoretical studies into the nature of art and of education and a critical scrutiny of elementary concepts and prevalent assumptions and questions. What abilities are employed in the production, comprehension, and implementation of works of art? How are such abilities different from and related to those required by other pursuits? How does improvement in certain abilities enhance or inhibit others?

Since most abilities of the sort in question involve operations with symbols—linguistic, pictorial, or other—a general theory of symbols, symbol systems, and ways of symbolizing offered a basis for comparing, distinguishing, interrelating tasks of many kinds and abilities involved in dealing with these tasks.

While many of our studies were thus conceptual, theoretical, even philosophical, we did not confine ourselves to the armchair, the desk, and the conference table. From its early years, the Project has participated actively in clinical work on the differential impairment of abilities that results from kinds of brain damage. And in its early years, though not recently, it planned and produced a series of arts orientation programs as experiments toward increasing audience understanding of the arts, severally and in general. Planning these programs with the artists presenting them, and observing the effects upon audiences, gave us personal experience to complement and sometimes counteract our flights of theory. Furthermore,

we wanted to look to the athletic field, the shop, and the factory for un-orthodox training methods suggestive for the arts.

What I have been saying pertains primarily to the Project during its first four years. The present collection of essays offers some samples of what has been going on lately. But a project that has survived so long and ex-panded and expended so much faces increasingly insistent demands to say what has been accomplished.

We must first repeat that we are engaged in basic theoretical research. The physiologist is not the physician. Our primary function is not to select educational procedures, plan curricula, or design educational programs. That is for the educator to do in the particular situation at hand and with his own experience and insight. Our task is to provide analyses and infor-mation that may help in clarifying objectives and concepts and questions, in avoiding some pitfalls, in recognizing obstacles and perceiving oppor-tunities. The considerable corpus of reports and publications by the Proj-ect and its members and associates contains, I think, a nonnegligible amount of such material. Much remains to be done, but when Project Zero turns to writing prescriptions and instruction books, when it becomes Project-How-To, it will have passed on to an unjust reward.

In the early years of the Project, the very idea of the arts as cognitive and of systematic research into arts education met with widespread and virulent hostility. Nowadays the approach and the whole conception of the Project attract wide though scattered interest and respect. This is perhaps symptomatic of a growing respect for and understanding of the arts in the ambient culture. But I like to think that the Project itself, by its persistent work with some unwelcome ideas, may in some slight way have contributed to this change. If so, that too can be accounted an accomplishment.

The Art of Children's Drawing

ELIZABETH ROSENBLATT and ELLEN WINNER

Prior to the latter half of the nineteenth century, children's drawings were seen primarily as unskilled and primitive attempts at representation and hence received no serious attention. But with the growth of interest in child development at the end of the nineteenth century came a surge of interest in children's drawings. Perhaps because children's drawings look so strikingly different at different ages, drawings were seen as providing a sharply focussed lens through which to view development.

Psychologists have typically viewed children's drawings as windows on personality and affect, on the one hand, or as perspectives on cognition and intelligence, on the other. Altschuler and Hattwick (1947) used drawings as indications of personality structure; Goodenough (1926) used drawings as measures of intelligence; Piaget (1963) used drawings as reflections of the child's concepts; and recently Freeman (1980) and Goodnow (1977) have made use of drawings to reveal the child's cognitive strategies such as planning and sequencing.

These approaches have often used early drawings as indications of *deficiencies* of some sort: for instance, "tadpole" drawings of humans have been seen as a reflection of a global rather than differentiated concept of the human body (Piaget, 1963) or as evidence for poor memory for body parts (Freeman, 1980); lack of detail in drawings has been taken as evidence for low intelligence (Goodenough, 1926); transparencies (when the child reveals the insides of objects drawn) have been taken as evidence that the child can only draw what he knows but not what he sees (Piaget & Inhelder, 1967); and the overuse of dark colors has been taken as evidence of psychopathology (Altschuler & Hattwick, 1947).

Only rarely have children's drawings been studied on their own terms, for what they can tell us about the child's knowledge of the symbol system of drawing and for what they can tell us about the child's aesthetic goals. Researchers in this tradition have reminded us that children's drawings may look odd not because the child lacks some set of skills possessed

by the adult, but rather because the child's goals differ from those of the adult. The child is seen as guided less by the goal of realism than by the goal of simplicity, lack of ambiguity, and visual logic (Arnheim, 1974; Golomb, 1981; Schaeffer-Simmern, 1948). Moreover, rather than using drawings as windows onto something other than drawing, researchers in this tradition have shown us what we can learn about children's mastery of the rules specific to the medium of drawing (e.g., Arnheim, 1974; Golomb, 1981).

Research on children's drawings carried out at Project Zero has been stimulated by research in the "aesthetic" rather than the "deficiency" tradition. Our focus has been on an examination of children's drawings as a means of understanding the child's artistic knowledge, rather than as a window on some other form of knowledge. In addition, we have treated the drawings that children produce as only part of the picture. Also essential, in our view, are two other features: (1) an examination of the perceptual skills that children bring to the task of drawing; (2) a consideration of children's abilities to reflect about the kinds of processes and decisions involved in either the making or the understanding of an art object.

Our subjects have for the most part been children with no special abilities or training in drawing. Only recently have we begun to study children gifted in drawing. Our goal in working with these talented children is to determine what skills distinguish such children and whether these distinguishing abilities are apparent not only in the kinds of drawings produced, but also in the qualities perceived and the processes reflected upon.

In what follows, we focus first on studies of the making of drawings. We then turn to studies of perceptual abilities and then to a recently undertaken investigation of reflective capacities. We conclude with a description of studies of children with special abilities in the arts.

Drawings Produced

The major question that has guided our studies of drawings produced by children is the relationship between preschool drawings and those produced by twentieth-century artists on the one hand and by elementary-school-age children on the other. We have been struck by the clear resemblances between the works of very young children and those produced by contemporary artists (e.g., Klee, Miró, Picasso). Drawings by preschool children are spontaneous, fanciful, nonstereotyped, and aesthetically appealing. As children move into the middle elementary school years, they begin to draw with less frequency, and their drawings appear much more literal-minded: they are rigid and stereotyped. The child at this age seems dominated by one goal—that of drawing things the way they look or the way they look in pictures. Although their drawings are more "accurate,"

they are considerably less pleasing aesthetically. While one might slip a painting by a five-year-old into the Museum of Modern Art, one could never get away with introducing a painting by a ten-year-old.

Hence, it appears as if something is lost with age: with increasing skill and technical competence comes a decline in aesthetic appeal. We have come to call the early years the preconventional years and the years of middle childhood the conventional years. It is only those individuals with special skill and interest in visual art who emerge from the conventional phase and begin to violate the rules mastered in the elementary school years. We call this last phase the postconventional stage. Hence the preschooler *lacks* conventions, while the adult artist may *reject* them. Because neither preschool nor adult art is thus dominated by conventions, the two types of work appear similar. In our view, the similarity between the two is more than superficial. In the intensity of involvement in drawing, in the willingness to play and experiment, in the lack of concern for "how it should be done," the preschooler resembles the adult master in nontrivial respects.

To test our view that drawings decline in aesthetic appeal and interest from the preschool to middle elementary school years, we pitted drawings by five-year-olds against ones by ten-year-olds and asked artists and nonartists which they preferred (Wan & Winner, 1980). Artists strongly preferred the preschool drawings. Adults who were not artists, however, liked each type equally. Hence, for individuals sensitized to the visual arts, children's drawings decline with age in aesthetic appeal.

It is possible that this apparent decline is due not to an actual *loss* of ability, but rather to a shift in the child's focus of concern. Perhaps ten-year-olds retain the ability to draw as imaginatively as five-year-olds, but do not choose to do so because they are striving instead for realism. To address this question, we attempted to inspire elementary-school-age children to draw once again like preschoolers (Winner et al., 1980). Ten-year-old children were first asked to make drawings of their own. They were then shown pictures that had been done by "another person" (a preschooler) and were asked to re-draw their own drawing in the way that this "other person" would have drawn it.

Ten-year-olds were able to alter their drawings in response to the instructions. However, they were only able to capture the superficial aspects of preschool drawings. Their second drawings were messier and less realistic than their first ones, but not more imaginative and flavorful. Thus, children at the conventional stage in fact may *not* be able to recapture the fanciful, playful quality of their younger drawings. It is possible, however, that these children simply did not understand what we were asking them to do—i.e., to capture the playful, imaginative quality of preschool art. Perhaps if more strongly cued they could have produced imaginative draw-

ings. However, making playful, inventive drawings seems to be such a low priority for conventional-stage children that, given any ambiguity in the task, they fall into other patterns.

We sought further evidence for an age-related decline in a study in which children were asked to complete line drawings that were either quite realistic or sketchy and schematic (Winner et al., 1983). We wanted to determine whether conventional-stage children are willing to complete a nonrealistic picture nonrealistically or if they are unable to free themselves of the goal of realism.

Confirming our expectations, middle elementary-school-age children completed all of the drawings realistically, regardless of the level of realism in the rest of the picture. For example, a ten-year-old added identical realistic hands, drawn with all five fingers, to both a schematic Picasso drawing and a much more realistic one. In contrast, six-year-olds, while able to complete realistic drawings fairly realistically, were willing to complete schematic drawings much less realistically. For example, a six-year-old completed the unrealistic Picasso with a schematic hand—a sunlike form with a few radiating lines for fingers—but completed the realistic Picasso with a much more articulated hand. Twelve-year-olds performed like six-year-olds, completing each drawing according to the drawing's level of realism. Thus, six-year-olds performed as well as twelve-year-olds. They were able and willing to vary the level of realism according to the style of the original drawing. In contrast, eight- and ten-year-olds—children in the midst of the conventional stage—were dominated by one goal: to draw as realistically as they could regardless of the invitation provided by the picture's style.

Our studies point to the conclusion that there is indeed a real loss of aesthetic sensibility during the conventional stage. Whether the loss is inevitable or an artifact of a cultural preference for realism in art is not known. It is certainly possible that the loss is an inevitable concomitant of skill mastery. That is, children may have to re-focus their attention on rules in the initial stages of skill mastery and may simply not have the scope to be able to retain an interest in play and exploration. Perhaps only when the basic skills of drawing have become a relatively automatic part of their repertoire do they have the freedom to turn their attention back to play.

Drawings Perceived

When preschool children are asked which they prefer, a drawing by a five-year-old or one by a ten-year-old, they invariably vote for the older children's drawing. In fact, preschool children are as dismissive of their own drawings as older children are of preschool drawings (Wan & Winner,

1980). The finding that preschoolers actually prefer pictures that are more stereotyped, realistic, and conventional is antithetical to a romantic view of the very young child as "natural, avant-garde artist." It suggests that the aesthetic effects found in their drawings may be accidental rather than intentional. Perhaps in their spontaneous drawings children strive for realism but fail to attain it.

We have tried to develop measures that can reveal the degree to which the young child is aware of, and in control of, the aesthetic effects of his drawings. We have isolated several key aesthetic properties of drawings and have examined the child's emerging sensitivity to such properties. To the extent that children show sensitivity to these properties, we can feel strengthened in our coupling of the five-year-old with the adult master. But to the extent that children are blind to these properties, we are forced to accept an antiromantic view of early art and conclude that its aesthetic appeal is more accidental than intentional.

Based on the work of Nelson Goodman and Rudolf Arnheim, research at Project Zero has focussed on children's sensitivity to the three properties of drawings that we consider to be central to the arts: *repleteness, expression,* and *composition.*

Repleteness refers to the "fullness" of a symbol when it is functioning as art (Goodman, 1976). For example, in a line drawing (but not in a picture functioning nonaesthetically, such as a scientific graph) one is meant to attend not only to the forms the lines create, but also to the properties of the lines themselves (e.g., the texture, thickness, rhythm). These aspects are part of the meaning of the drawing, but not the graph.

Expression refers to the metaphoric conveyance of properties (such as sadness, anxiety, loudness, sharpness) in a work of art (Goodman, 1976). These properties are conveyed through the aspects of color, line, composition, and so forth. For example, "sadness" (which may be represented through denotational symbols, such as a frowning face) may also be expressed through the use of dark colors and droopy lines.

Composition refers to the structural organization and overall balance in a work of art (Arnheim, 1974). Balanced compositions may be achieved in a number of ways. They may be achieved through symmetry, but are more commonly achieved through a dynamic, asymmetrical organization of forms. For instance, a large form may be offset by a much smaller, brighter form due to the apparent weight of brighter hues.

To the extent that children fail to attend to repleteness, expression, and composition, we must conclude that works of art are functioning for them as nonaesthetic symbols such as maps and graphs. In an initial study, we focussed on sensitivity to repleteness and expression in six-, nine-, and eleven-year-olds (Carothers & Gardner, 1979). Children were shown pairs of incomplete drawings which were identical in all respects except line

quality or mood, respectively. The drawings were simple sketches in the style of drawings by ten-year-olds created for the purposes of this study. In the repleteness tasks, the children were asked to add a person to the picture and to draw it the way the person who drew the picture would make it. In the expression tasks, they were asked to add a tree and flower to a picture of a sad person and to a picture of a happy person. For each production task, there was an analogous multiple-choice task.

We reasoned that if children are sensitive to repleteness and expression and realize that these properties are relevant to the drawings, they should complete the picture by employing the same line quality or mood. Similarly, they should be able to select the completions which maintain the properties varied.

The findings revealed that the six-year-olds selected at random on both types of perception tasks and were also unable to complete the drawings along the dimensions required. Nine-year-olds succeeded on the perception tasks, but performed less well on the production tasks. Not until the age of eleven were children able to succeed on both types of tasks for both of the aesthetic properties.

These findings suggest that while very young children seem to have the capacity to produce quite aesthetically appealing works, they are not sensitive to certain basic aesthetic properties. Preconventional children fail to discriminate repleteness, expression, and composition; they prefer realistic pictures, yet they produce aesthetically appealing, nonrealistic pictures. In addition, at the age at which they begin to be aesthetically aware, their own drawings become highly conventionalized and therefore less pleasing. Hence, we are left with something of a mystery, about which we offer the following speculations.

Perhaps a beginning of a solution to the mystery of preconventional art comes from the results of the study in which children had to complete realistic and unrealistic pictures (Winner et al., 1983). Recall that six-year-olds were better than older children at attending to a fourth dimension—how articulated and realistic a drawing is vs. how sketchy and unrealistic. While preschool children cannot be said to manipulate repleteness, expression, and composition intentionally in the service of aesthetic creation, perhaps they are aware of the overall style of a drawing and strive to keep it consistent.

Conventional-phase children, while able to perceive such properties, seem unconcerned with them in their own drawings. It is not until early adolescence that these divergent lines of development converge, allowing both perception and production to interact. Fluidity, expressivity, and imaginativeness are now created because the adolescent *intends* to do so and is clearly aware of the effects produced.

In another line of investigation, we sought to determine whether and

to what degree perceptual abilities in the visual arts are general skills that could be applied to any artistic domain or whether these skills are domain specific. A large-scale study of aesthetic sensitivity was designed to look at development in other artistic domains—music and literature as well as visual art (Winner et al., 1986). This allowed the examination of two questions: (1) Does perception in one domain generalize to other domains? (2) Does sensitivity to one property in a domain generalize to other properties within that same domain?

Children aged seven, nine, and twelve years were given tasks that either examined one property across all three domains (e.g., repleteness in visual art, music, and literature) or all three properties in one domain (e.g., expression, composition, and repleteness in visual art). All of the tasks involved the presentation of a target and the selection of the best completion (given two choices) and were analogous across domains. For example, for composition in visual art, children were shown an incomplete picture and two completions, one that was clearly balanced and one that was not. Then they were asked to choose the completion that finished the target "in the best way." Similarly, in music (or literature), children heard an incomplete piece of music (or story) and then two completions, and were asked to select the one that made the best ending.

Several problems with the tasks used previously (Carothers & Gardner, 1979) were addressed here. One could argue that the stimuli used in the previous study had not been produced by artists and therefore were not "art." Thus, it is possible that the children did not respond to them aesthetically, but might have if "real" works of art had been used. In addition, there was an ambiguity in the way we initially tested sensitivity to expression. In the initial task, children were asked to add a tree to both a sad and a happy picture and also to decide which of two trees (wilted vs. blooming) would best complete a picture that showed a happy person. It is possible that children saw the moods expressed by the two trees but did not realize that they should complete the pictures in the same mood. For instance, they might have deliberately added a happy tree to a sad picture. In response to these problems, all of the stimuli used in the succeeding study were taken from works by well-known artists, and the expression task was changed to a "matching" task in which children were asked to match pictures according to similarity in mood.

Correlational analyses revealed no consistent relations within *or* across the domains. That is, high performance on tests of repleteness in visual art did not predict high performance on tests of repleteness in music or literature. In addition, high performance on repleteness in visual art did not predict performance on either expression or composition in visual art. We are forced to conclude that aesthetic sensitivity is both art form specific *and* property specific. Rather than one central skill, aesthetic sensitivity

seems to be composed of several abilities that develop along separate trajectories.

Children's Reflections about the Arts

In past studies conducted at Project Zero, reflection, a skill we believe essential to artistic learning and creation, has been ignored. Reflection entails thinking about the process of making, and the final product. The ability to reflect about one's goals, decisions, and solutions, as well as about the influences of the works of others on one's own work, seems to be crucial to cultivate in the service of any artistic endeavor.

Children's reflections about the arts were initially investigated in a study in which we interviewed children and adolescents about a broad range of topics and several aesthetic media (Gardner et al., 1975). We asked subjects to reflect about how art is made and how aesthetic judgments are made and justified. The results revealed parallels between the development of reflections about art and more general conceptions of the world (cf. Piaget, 1963). Preschool children articulated a very concrete view of art, as they do of the world in general, and were concerned primarily with the mechanics of how a work is produced. For instance, they told us that a painting is finished when the paper is filled up or when the artist gets tired. They had no notion that training of any kind is required to be an artist and even believed that animals could create art—as long as they could hold a pencil or paintbrush. By the age of seven to nine years, the child's obsession with rules spills over into the aesthetic domains: children judged the value of a drawing in terms of "neatness" and realistic rendering. Between the ages of nine to thirteen years, children began to be able to recognize the aesthetic effects that an artist has intended to create. Realistic accuracy was no longer held to be the only criterion by which works are judged. Instead, a full range of artistic properties were recognized and valued. The highly relativistic view that is characteristic of adolescence was also apparent in their judgments of the relativity of various aesthetic effects: what is good, they said, is simply a matter of opinion. In sum, reflection about the arts was shown to follow a specific course of development and to mirror trends in other areas of cognitive growth. Reflective skills were found to develop late: not until adolescence did children begin to reflect about intentional aesthetic effects of artworks, and even at this age children were unable to consider how one might justify an aesthetic judgment beyond the claim of personal preference.

Similar findings concerning the late emergence of reflective skills came from a study of children's abilities to make critical judgments in the arts (Rosenstiel et al., 1978). Children aged six, eight, eleven, and fifteen years were shown pairs of painting reproductions and were asked to decide which they preferred, which others would prefer, and which was the bet-

ter work. The youngest children (six-year-olds) failed to distinguish among the various standards, and all of the younger age groups (six-, eight-, and eleven-year-olds) demonstrated a severely limited vocabulary with which to discuss their aesthetic judgments. Only the oldest children were able to articulate distinctions among the three standards and were able to consider a wide variety of criteria in their reflections. Their responses ranged from discussions of formal properties to the influence of specific periods in art history.

It is possible that subjects in this study made finer distinctions than they were able to verbalize. Clearly, one needs to nourish not only reflective skills, but also the ability to talk about them. A research project is now underway at Project Zero in cooperation with Princeton's Educational Testing Service and the Pittsburgh Public School System. In this study, we are attempting to address the role of reflection (and the ability to make reflection explicit) in artistic learning, along with the role of production and perception. We believe that reflection about one's artistic abilities is a virtue, that it frees rather than hampers the artist, and that it can be shown to improve the artist's productive and perceptual abilities. We also believe that reflection should be considered along with perception and production in any assessment of the student's learning and progress in art.

Our goal is to build upon the naturally occurring reflective activities that have been observed in a variety of classrooms—the informal discussions that take place between teacher and student about the revision of a work, peer discussions of works, and students' thoughts about preliminary sketches and revisions, which, though usually discarded, can provide crucial information about the growth of a project from conception to completion.

Although this study is in its infancy, we have already begun to find that the process of making reflection explicit has helped students make decisions about their work. In one instance, a student who was dissatisfied with his work was helped to talk through the differences he saw between his first sketch and a second draft. During the course of this reflective activity, he came to see a new possibility to explore that he felt would resolve his feeling of dissatisfaction. We feel that a focus on reflection as well as on production and perception may provide a view into the learning process in the arts and may also provide a means of assessing progress and stimulating further learning.

The Development of Production, Perception, and Reflection in Children Gifted in the Arts

We have recently begun to look at children with exceptional abilities in the arts. It is clear that the difference between gifted and nongifted children is most readily apparent in the realm of production. In fact, it seems as

though this difference is demonstrated very early on (Clark & Winner, 1985; Gardner, 1980). Longitudinal analyses of drawings produced by children who retained a strong interest in drawing in late adolescence has shown that the early drawings of such children are marked by advanced technical skill, more articulated contours, and far less stereotyped forms than the drawings of their less gifted peers. In addition, gifted children demonstrate strong and preferred themes, such as a fascination with linearity, and the majority of their drawings are repeated explorations of this theme.

We have begun to examine the extent to which the exceptional production skills of gifted children are also apparent in perception and reflection. In a study of perceptual skills in visually gifted children, we compared memory for visual information in gifted and nongifted children (Rosenblatt & Winner, 1988). We sought to examine incidental rather than deliberate memory in order to determine whether visually gifted children retain visual images without intentionally committing them to memory. Two groups of children were selected by their art teachers to participate: those who demonstrated unusual talent in drawing, and those with only average ability. The children (aged eleven to fourteen years) were shown pairs of pictures and were asked which one they preferred. We used this preference task as a means of ensuring that the children looked at the pictures carefully without knowing that their memory would be tested later. After a fixed period of time, the children were shown the pairs again; but this time, one picture in each pair was an altered version of that seen originally. The alterations varied systematically along dimensions of line quality, composition, color, form, and content. The children were asked first to identify the altered picture and then to describe the details of the changes they observed.

The gifted children were not only better able to identify the altered pictures, but they also recalled more of the specific details. In fact, these children scored even higher than a sample of adult artists tested during the piloting of the materials.

Surprisingly, 24 percent of the gifted children were left-handed (the incidence of left-handedness is about 10 percent in the population at large). In contrast, none of the nongifted children was left-handed. Thus, there is some indication that brain laterality may play a role in giftedness in visual art.

A second study addressed the question of whether the superior memory skills of children gifted in drawing are domain specific (limited to visual stimuli) or more general (cutting across visual and verbal stimuli) (Rosenblatt & Winner, unpublished manuscript). Tests of visual and verbal memory were constructed and administered to children gifted in drawing and those gifted in creative writing. These tests were designed to compare

memory for stimuli functioning aesthetically (ones in which repleteness, expression, and composition are meant to be noticed) with memory for stimuli functioning nonaesthetically (ones in which aesthetic properties are irrelevant). The aesthetic pictures consisted of paintings, line drawings, and collages; the nonaesthetic pictures were maps, diagrams, and graphs. The verbal memory test was analogous to the visual test and also included items with an aesthetic function (poems, stories) and a nonaesthetic function (newspaper articles, instructions).

There were striking differences in memory skills between the two groups. Visually gifted children demonstrated superior recall for visual stimuli; verbally gifted children had superior recall for verbal stimuli. These results are consistent with our previous findings of domain-specificity in aesthetic perception with ordinary subjects (Winner et al., 1986). Perceptual skills within a domain of talent do *not* generalize to other domains, even in children with exceptional ability.

Differences were found in the way the visual and verbal children recalled pictures which functioned aesthetically vs. nonaesthetically. The visual children recalled nonaesthetic pictures as well as aesthetic ones. Verbal children recalled the aesthetic items better than the nonaesthetic. Thus, it appears as if for visually gifted children, all visual stimuli function aesthetically. All images are accorded the kind of "thick," sensuous attention ordinarily reserved for aesthetic objects. In contrast, nonvisual children respond to pictures identified as "art" with thick attention, but look right through the sensuous properties of those identified as nonart.

Both groups of children had heightened reflective skills. They were unusually aware of the effects they attempted to achieve and of the "phases" they passed through in the development of their work. For example, when discussing a painting she had done a year ago, an eleven-year-old girl stated that she had been fascinated with Oriental painting at that time and had tried to incorporate certain techniques into her own style. When she felt she had exhausted the use of these techniques, she decided to explore other possibilities. It is important to note that these children had received no training in reflection. Hence, reflection seems to be a skill that develops precociously in visually gifted children, based perhaps on their rich experience with the visual medium. The spontaneously greater development of reflective capacities reported here could be taken as evidence that reflection is appropriate to the visual arts, that it is natural and enriching, not destructive and constraining.

Conclusion

The work conducted over the years at Project Zero suggests that development in the arts involves not one unified course of growth, but rather

three separate and distinct lines. Perception proceeds linearly and is not marked by stagelike properties. In contrast, production follows a U-shaped curve and is more clearly divided into highly characteristic stages. Like perception, reflection seems to progress linearly with age, but also mirrors the development of more general knowledge and conceptions of the world.

Our studies of giftedness suggest that children with talent in production may possess heightened skills in perception and reflection as well. Not only do they seem to *see* artworks (and even nonaesthetic visual stimuli) differently than do nongifted children, but they also appear to think and talk about them in a qualitatively different way. Undoubtedly nongifted children can be helped to perceive and reflect at a higher level were perception and reflection included in ordinary art education. For the most part, children learn to produce in art classes, but not to look at, reflect on, or talk about artworks. Perhaps it is because of the exclusive focus on production that involvement declines with age. If art education fostered perception and reflection as well, children at the conventional stage might retain an interest in the arts. That is, they might be stimulated to look and reflect even if they do naturally resist exploration and play in their own drawings.

REFERENCES

Arnheim, R. (1974). *Art and visual perception*. Berkeley: University of California Press.
Altschuler, P., & Hattwick, L. (1947). *Painting and personality: A study of young children*. Chicago: University of Chicago Press.
Carothers, T., & Gardner, H. (1979). When children's drawings become art: The emergence of aesthetic production and perception. *Developmental Psychology*, *15*(5), 570-580.
Clark, P., & Winner, E. (1985). Unpublished data, Harvard Project Zero.
Freeman, N. (1980). *Strategies of representation*. London: Academic Press.
Gardner, H. (1980). *Artful scribbles*. New York: Basic Books.
Gardner, H., Winner, E., & Kircher, M. (1975). Children's conceptions of the arts. *Journal of Aesthetic Education*, *9*(3), 60-77.
Gardner, H. (1970). Children's sensitivity to painting styles. *Child Development*, *41*, 813-821.
Golomb, C. (1981). Representation and reality: The origins and determinants of young children's drawings. *Review of Research in Visual Arts Education*, *14*, 36-48.
Goodenough, F. L. (1926). *Measurement of intelligence by drawing*. New York: Work Book Co.
Goodman, N. (1976). *Languages of art*. Indianapolis: Hackett.
Goodnow, J. (1977). *Children's drawings*. Cambridge: Harvard University Press.
Piaget, J. (1963). *The origins of intelligence in children*. New York: Norton.
Piaget, J., & Inhelder, B. (1967). *The child's conception of space*. New York: Norton.
Rosenblatt, E., & Winner, E. (1988). Is superior visual memory a component of superior drawing ability? In L. Obler and D. Fein (Eds.), *The exceptional brain*. New York: Guilford Press.
Rosenstiel, A., Morison, P., Silverman, J., & Gardner, H. (1978). Critical judgment: A developmental study. *Journal of Aesthetic Education*, *12*(4), 95-107.

Schaefer-Simmern, H. (1948). *The unfolding of artistic activity*. Berkeley: University of California Press.

Wan, D., & Winner, E. (1980). Unpublished data, Harvard Project Zero.

Winner, E., & Gardner, H. (1981). The art in children's drawing. *Review of Visual Arts Research*, *14*, 91-105.

Winner, E., & Pariser, D. (1985). Giftedness in the visual arts. *Items*, *39*(4), 65-69.

Winner, E., & Rosenblatt, E. (unpublished). Cognitive skills and personality profiles of children gifted in the arts.

Winner, E., Blank, P., Massey, C., & Gardner, H. (1983). Children's sensitivity to aesthetic properties of line drawings. In *Proceedings of NATO conference on the acquisition of symbolic skills*. New York: Plenum Press.

Winner, E., Mendelsohn, E., Barron, J., and Gardner, H. (1980). Unpublished data, Harvard Project Zero.

Winner, E., Rosenblatt, E., Windmueller, G., Davidson, L., and Gardner, H. (1986). Children's perception of properties of the arts: Domain-specific or pan-artistic? *British Journal of Developmental Psychology*, *4*, 149-160.

From Endpoints to Repertoires: Some New Conclusions about Drawing Development

DENNIE WOLF and MARTHA DAVIS PERRY

In trying to broaden our conception of language development, the socio-linguist Dell Hymes suggested that we imagine a child who had impeccable control of the grammar of his native language, but who lacked the ability to tune his speech to the demands of different audiences and situations. When he called his little grammarian a misfit and a monster, Hymes was arguing that children acquire not language, but languages—ways of using words in face-to-face conversations and long-distance communications, in arguments and songs, in writing and in speech, in poems and recipes. The caricature was meant originally to startle linguists out of their concern for grammar apart from situation, but it has deep implications for any form of symbolic development—number, gesture, and even drawing.

Imagine someone looking through an apartment window at a large city spread out below, about to take up a pencil to render what he sees. Even as he lays down the first marks, he has to chose which of many visual languages he will claim. Suppose he decides to make a picture. He faces the question of choosing which geometry or *drawing system(s)* he will use to translate the way in which walls, stairs, and cornices project, recede, and occlude: will he create a flat pattern of facades, a deep space based on perspective, or a deliberately fractured multiview panorama such as occurs in cities painted by Futurists? But, after all, he may not make a picture—he could make a map of streets and landmarks or a diagram showing the flow of traffic. These *genres* can also record what he sees or intuits about the landscape. Or if, in the end, he elects to make an aesthetic image, he still must choose what kind of *rendition* he will give the image. Is it to be a clean stylization in the tradition of Charles Sheeler or a kind of expressive urban portrait like those Joseph Stella made of Brooklyn?

Hypothetical as they are, this set of choices raises questions concerning a fundamental conception of the development and exercise of drawing skills. At the heart of this conception is the assumption that the development of drawing skills can—at least within a culture—be adequately under-

stood in terms of a single endpoint, usually the rules for *the* predominant system of visual representation in that setting (Hagen, 1986). Thus, in Western cultures, where pictorial realism dominates, many developmental studies of drawing focus chiefly on the acquisition of those drawing skills which make illusionistic picturing possible (Chen, 1985; Cox, 1985; Gardner, 1980; Goodenough, 1926; Harris, 1963; Lowenfeld, 1957; Willats, 1977). Thus, development comes to be defined largely, if not wholly, in terms of being able to add shoulders to figures or oblique lines to cube drawings, to show occlusion or note relative size.

However, assuming the achievement of realistic picturing as the *single* endpoint for graphic representation has two far-reaching consequences. First, by focusing solely on the endpoint of illusionistic picturing, we fail to see that drawing, as a particular symbolic activity, takes on definition in the context of other forms of graphic representation, such as mapping or diagramming. Second, in describing the development of drawing skills, other drawing systems which young children invent are seen as simply preparatory rather than as alternative and continuously useful ways of picturing. In effect, the focus on a single endpoint provides too narrow a description of graphic symbolization. In essence, it ignores the many choices open to that city-dweller staring out his window at the urban landscape.

But the apartment-dweller's sheaf of city drawings contains a suggestion for a different conceptualization of drawing skills: after all, they argue that a skilled draftsman is not merely fluent in the rules of a particular graphic language. Instead, he knows several such languages *and* how to select among them. This fact suggests, in turn, that we might want to reconceive drawing development as yielding not one type of drawing, but a repertoire of visual languages, as well as the wit to know when to call on each. These languages might include varied drawing systems, numerous genres, the capacity to make a number of distinct renditions. With this multiple end to drawing development, the central question becomes not "How do individuals discover the rules of pictorial realism?" but "How do people acquire a set of visual languages along with an understanding of the obligations and powers of each?"

In what follows we take a close look at three moments in the development of graphic representation: the onset of representation made possible by the invention of *drawing systems*; the construction of the differences between graphic *genres* such as maps and drawings; and the evolution of specific *renditions* of a visual image. By closely examining both research findings and sample drawings, we will discuss how the development of drawing skills might be understood as a process of generating a repertoire of visual languages and requiring a keen sensitivity to when each is appropriate.

Early Representations: A Repertoire of Drawing Systems

Because we have so long concentrated on a concept of drawing development as evolving toward a single end—realistic picturing—we have assumed that graphic representation occurs only with the onset of children's ability to produce simple lookalike forms: tadpoles, suns, spiders. Given the amount of eye-hand coordination and planning required for these figures, it is typical to describe children under three as making what Burt called "purposeless pencillings" and what others have termed "scribbles" (Kellog, 1969).

This description of early drawing is suspect on a number of grounds. Between the ages of one and three, children exhibit an almost "rampant" exploration of symbolization. During these years they construct the basic rules for linguistic and gestural forms of reference. In addition, there is equally strong evidence that children this young are capable of a range of forms of visual-spatial representation. They make apt choices in turning yellow blocks into "cheese" or in reconstructing the pattern of a table setting using items like leaves and pine cones (Winner et al., 1979; Wolf & Grollman, 1982). Children under three also read visual patterns with a fair degree of sophistication—they can see a tree branch as a "Y" and recognize real or imaginary objects in either line drawings or photographs (DeLoache, Strauss, & Maynard, 1979; Hochberg & Brooks, 1962). It would require a highly specific and focused concept of symbolization to imagine that children who are this visually sophisticated see their own marks as only scratches or accidents.

As a part of a broader study of early symbolization, researchers at Project Zero have collected both longitudinal and cross-sectional observations of drawing sessions with children old enough to create such meaningful visual patterns but still too young to draw in the conventional sense (Shotwell, Wolf, & Gardner, 1980; Wolf, 1983). In analyzing these productions, we looked for evidence of a full range of representational behaviors: the use of drawing materials in symbolic play; verbal labeling of tools, paper, or marks; or representational pointing and gesturing with a marker or a crayon. As a result of this broadened definition of representation, we observed the appearance and use of a series of distinguishable *drawing systems* that appear as early as twelve to fifteen months. Simply put, a drawing system is a set of rules designating how the full-sized, three-dimensional, moving, colored world of ongoing visual experience can be translated into a set of marks on a plane surface. At least implicitly, any drawing system contains two types of rules: (1) rules specifying the kinds of information it is crucial to represent (e.g., characteristic motions, position, size, etc.); and (2) rules regarding which aspects of the individual drafter's behavior (e.g., his motions, speech, marks, etc.) are entitled to carry mean-

ing. Across the first twelve to twenty-four months of drawing activity, it is possible to observe the advent of a series of distinct systems, each characterized by different rules about the kinds of information to be recorded and the most powerful or satisfying ways to make those records.

Children's earliest drawing systems yield visual-spatial displays which are not yet graphic, since neither what they record nor how they make those recordings depends on the characteristic of lines on paper. In *object-based representations* (appearing first between twelve and fourteen months), children handle markers and paper precisely as they treat other objects in the course of simple symbolic play episodes: a child may roll up a marker inside the paper and call out "hot dog" or "bye bye." Thus, the child represents objects and characteristic positions by substituting drawing materials for the particular referents she has in mind. Basically, she reinvents the spatial configurations of the real world: the way frankfurters burrow in rolls or the way disappearing objects escape from sight. *Gestural representations* also appear early in the second year. In these instances, children focus on representing characteristic motions, using the modality of gesture, often in combination with naming. Thus, one child hopped an uncapped marker across the page, saying "bunny" and creating a trail of dotted footprints. Another child traced a long winding path across the paper, making humming noises as he went. At the far edge of the paper, he inscribed a tangle of intense lines, accompanied by crashing noises. Spontaneously, he summed up his drawing saying, "Car going, going, going CRASH."

Clearly, both the object-based and the gestural systems each commit particular slices of experience to paper—but do so in ways we can hardly call visual or graphic in the conventional sense. However, the experience of committing meaning (however unconventionally) to paper appears to lay an important foundation for later, increasingly graphic drawing systems. Children first make planful use of graphic properties in their *point-plot representations* which appear at approximately twenty months. In these primitive drawings, children manage to record the number and location of an object's features, using the paper surface to integrate these parts into a whole. In this way, a child can "draw" a human figure placing a slash for the head, another lower slash for the "tummy," two still lower slashes for the feet (Wolf, 1983). Here only existence, number, and position—not shape or color or volume—are being inscribed. Nevertheless, such plottings mark the first system in which it is the qualities of marks, more than the attendant behaviors of the child, that carry meaning.

Late in their second year, children begin to make use of a still another drawing system—one which includes relative shape and size. Between eighteen and thirty months, many of them begin to monitor the visual results of pushing the marker across the paper surface. The result is often a com-

plex-contoured line pattern into which graphic meaning can be "read" (Wolf, 1983, 1984). In this graphic system one loopy profile overlapping another can be called "a pelican kissing a seal," "two pajamas," or "noodles in soup." While the geometry of these drawings appears sophisticated, entailing parts and wholes, insides and outsides, along with varied contours, it is largely the result of perception and accident. It is a discovered geometry rather than one children can use to generate whole drawings. Shortly after their third birthdays, children refine this system for graphic information. This time the rules yield the lookalike pictures usually thought to mark the onset of representational drawings. It is only at this point that children invent reliable production rules which reproduce the geometry implied by their earlier accidental representations. It is then that they construct a system for recording visual-spatial information that includes rules about representing outside contours, surfaces, and relative sizes (Arnheim, 1974; Freeman, 1980; Freeman & Cox, 1986).

Between five and seven, children begin the construction of an additional drawing system—one that requires the representation of objects as they are situated in a larger space. They add rules about representing spaces between objects both on the left-to-right and the back-to-front axis, learning some basic rules about using the upper regions of the page to represent further distances, how to overlap objects, and the way size diminishes with distance (Arnheim, 1974; Freeman, 1980). Still older children work out the detailed rules of projective geometry (Phillips, Hobbs, & Pratt, 1978; Pratt, 1983; Willats, 1977). Much later still, the development of drawing systems continues: think about engineering students learning the rules which permit them to draw orthogonal projections of structures (Dubery & Willats, 1983) or artists who adopt the geometries they find in Chinese or Persian paintings.

Described as a sequence of acquisitions, this portrait of drawing development seems, if longer or more detailed, still largely similar to earlier descriptions: a sequence of increasingly "sufficient" systems for capturing information about the three-dimensional world in two-dimensional marks. However, the point is that each of these drawing systems is not so much a stage on the way to realism as a system with distinct motives and powers. While it is true that the several systems first appear at different times, drawing development does not consist merely of their staggered onset. Rather, drawing development might be more fully understood if we recognize two other patterns of change: (1) the continued evolution of *each* of these systems; and (2) the individual's growing vocabulary of drawing systems.

In most cases, once acquired, a drawing system continues to develop. Even a drawing system as apparently primitive as *object-based representations* persists and changes. When a six-year-old struggles to depict the vol-

ume of a red sphere, she adds several layers of color, claiming that this build-up in color makes the shape "fatter." Artists as different as Braque and Salle use the physical realities of obscuring, layering, and covering over where they play at deliberately blurring the conventional boundaries between two- and three-dimensional works. Eight- to ten-year-olds depend on gestural forms when they make the "zoom lines" that come out of the back of racing cars. Among adult artists, the gestural quality of lines continues to bear meaning in forms as diverse as cartoons and abstract expressionist paintings. The point-plot systems invented by two-year-olds also continue to evolve. Add the notion of a grid and the possibility of representing quantities or distances, and you have a subway map, a Cartesian graphing system, even plots or graphs for statistical analysis.

Beyond the development within a drawing system, change also occurs across systems as individuals learn to select among their available ways of making visual records. A careful look at the human figures completed within several days by one three-and-a-half-year-old illustrates this point. In the first drawing (fig. 1a), Max draws Mickey Mouse wearing his power belt. Because it is so important that the belt encircles Mickey, Max draws on a kind of object-based representational scheme: he literally draws to the right edge of the paper, around the back side and again onto the front surface. Drawing a portrait of himself in a baseball jacket (fig. 1b), he uses quite a different system where only frontal surfaces are depicted (Smith, 1987). These differences aren't accidents or artifacts—they are symptomatic of a wider body of drawings (including houses, animals, vehicles) in which Max provides evidence for having preserved—either within a particular drawing or across drawings—a repertoire of drawing systems or languages for representing his visual experience. His skill lies only partly in being able to make the contoured portrait. It also lies in his ability to choose among the drawing systems at his disposal.

These examples do not illustrate that children are covert artists or scientists highly skilled in visual representations. Instead, the illustrations argue for a revision in conventional accounts of drawing development which emphasize a kind of linear evolution from "purposeless pencillings" to illusionistic line drawings. The examples illustrate that what children develop is a repertoire of different drawing systems and an incipient knowledge of how each is powerful. In this light, drawing skill lies less in using the most recently acquired system than in selecting the system that is apt. While the particular examples used here come from children, this kind of repertoire model clearly applies equally to more sophisticated graphic work. Artists like Cézanne or Picasso choose fluently between realistic and cubist systems for rendering figures, jugs, and tables. In Matisse's *Still Life on a Green Buffet* (1928) the artist combines a number of drawing systems—the Delft jug is realistically rendered, the green buffet is partly flat-

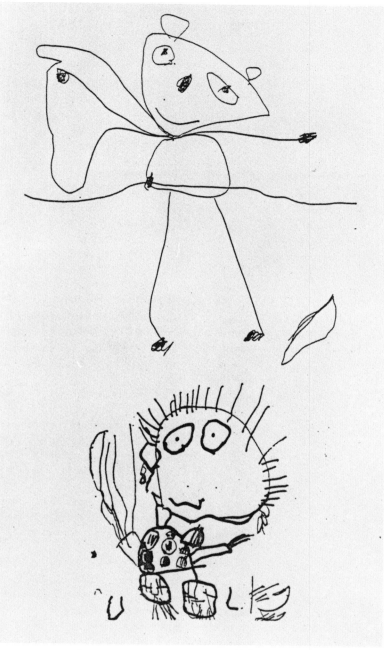

Fig. 1a-b. Figure drawings by a preschool child.

tened to show both front and lid, the peaches lolling on the checkered cloth are painted as flat, contoured shapes.

A Repertoire of Genre Skills: The Case of Drawings and Maps

While we possess different geometries or systems that underlie pictures, it is also true that we save, inquire into, or share our visual experience in forms other than pictures. We also make diagrams, maps, and graphs. Each of these genres provides a distinct cultural language for conceptualizing and recording the nature of visual experience. Each genre focuses on a characteristic kind of information, level of detail, and format for display. Consider, for instance, how differently that city dweller might render visual information about the "same" landmarks in a map or a drawing of his neighborhood. If he is making a sketch, he will include much of the visual information about landmarks in their natural setting as seen from a particular point of view. In that drawing the building at 23 Union Street might appear as a thirty-story, gray-granite, Art Deco structure with a tile frieze and aluminum-sculpted doors. However, if the same person were making a map of the neighborhood, he would set down a different set of visual "facts" in a distinct format. In all probability, the maker would draw the area as seen from a birds-eye perspective and strip down the information to the building's size and location among other major buildings, landmarks, and thoroughfares. The building at 23 Union would appear as a square, set back one half-inch from the double line labeled "Union." No tilework, no granite, no aluminum doors.

Clearly, then, the process of becoming visually sophisticated involves learning to discriminate among the varied graphic formats our culture lends us to record our concepts or knowledge, whether that information is carried in graphs, diagrams, drawings, or maps (Davis Perry & Wolf, 1986; Downs, 1985; Liben & Downs, 1987). Thus, in understanding what a drawing is, children have to grapple with its particular qualities and obligations. Part of understanding those qualities and obligations may rest on grasping the differences between drawings and other genres of visual representation. By way of illustrating the developmental course of such distinctions, it may be helpful to consider some contrasts between maps and drawings and the ways in which those contrasts emerge.

To begin, maps and drawings differ in *faithfulness*. In at least certain kinds of drawings, a maker is free to select among landmarks and even to invent features. In most maps, a maker must render all major landmarks and may not introduce fictional items. Moreover, the two types of spatial renditions differ in the way they depict the height and area of landmarks, as well as the distances between them. In many forms of drawing, the maker has the option of playing with the way in which she or he repre-

sents the relative size of items and areas. This is not the case in the majority of maps, where objective proportional representation of sizes is crucial. From this follows the map-maker's customary use of birds-eye perspective which insures against the confusions which might come from overlap. Further, in some drawings, a maker may play with the spatial relations among landmarks and their orientations, creating a scene which is most commonly anchored to the bottom of the page. In most maps, the spatial arrangement of items and the distances between them must not be distorted.

Maps and drawings also frequently differ in *economy*. For instance, in most maps, only major landmarks and geographical features are represented, whereas in many drawings grass, trees, fences, and mailboxes appear. Moreover, even the representations of major landmarks are likely to differ across drawings and maps. Within a map a hill might be rendered by using a stylized curve, a house might be designated with a simple square. In a drawing these items might include a rich amount of detail. Consequently, in many drawings, items "speak for themselves," while mapmakers often provide labels and legends to insure the clarity of their representations. What is crucial here, however, is the relative nature of economy and faithfulness in maps and drawings. It is not that a map is x degrees economical whereas a drawing is x-10 degrees economical. Rather, we understand what it is to make a map partly by virtue of its contrast with a drawing—a map is more streamlined and less detailed than a picture, more accurate about locations and distances, and indifferent to qualities like color and decoration (Liben & Downs, 1987).

However, recent research shows that the ability to make effective use of these two visual genres emerges slowly. To investigate the details of this distinction, researchers from Project Zero presented children in first and third grades with a small model terrain and asked them to make both maps and drawings of it (Davis Perry & Wolf, 1986; Wolf et al., in press). Across the several years of the study, children's responses showed an increasing ability to treat the map and the drawing as separate genres. For example, on the dimension of what is included in the map, children became increasingly "faithful" to the model. Not only did they include all major landmarks, but they also resisted the temptation to invent compatible but fictional ones. With respect to depicting the relative size of buildings and hills, children increasingly followed a system of proportional representation. In creating the spatial arrangements within their maps, few third graders arranged items in local groups, clustered them at the bottom on the page, or took liberties in the placement of items, as they might have done in their drawings. Instead, by age eight, almost all of the children also came to approach drawing perspective in quite distinct ways. Across the three years, they exchanged their reliance on frontal views for the more efficient serial perspective. Their renditions of terrain items also

became more economical, as they gradually reduced the amount of detail in their symbols to one or two defining features. Houses, for example, came to be rendered as squares marked with an address or a single defining feature. Thus, across a number of measures there is evidence that children gradually distinguish genres for rendering the visual and spatial information contained in a landscape or terrain.

This process of the mutual definition of genres is not restricted to maps and drawings. By way of illustration, consider the several different renditions of houses and hiding places made by a seven-year-old and reproduced in figure 2. Although her work may not yet be fully conventional, this child already understands the constraints and potentials of a range of different visual *genres*. She records the "same" information about "hiding places" differently depending on whether she is using a text (fig. 2a), a bar chart (fig. 2b), a map (fig. 2c), or a drawing (fig. 2d).

It would be myopic to describe this child's graphic skills simply in terms of her cross-section map *or* her drawing of the house. Not only does she have a repertoire of distinguishable *genres* for recording her visual experience, she also has some understanding of what each of these genres highlights about experience. Thus, while her drawing and map denote the same house, in her drawing she emphasizes visual detail (sun, sky, and flowers), while in her map she strips detail off, highlighting the position and size of the rooms.

Here, too, the understanding of different visual systems continues to evolve. For example, in early adolescence, children become sensitive to what the philosopher Nelson Goodman (1968) has called the "symptoms" of aesthetic drawings. Between the ages of seven and twelve, children's completions of example drawings indicate that they are sensitive to the ways in which graphic qualities such as brightness, line variance, and shading were used to create effects. At slightly older ages, children understand how the more metaphorical or expressive aspects of drawings, such as drooping lines or angular forms, can be used to express particular moods (Carothers & Gardner, 1979). With this kind of understanding, preadolescents' range of drawing systems once again multiplies. Consider the three drawings of a bird shown in figure 3. They were made by a twelve-year-old in the same sitting, in response to a variety of instructions. The highly simplified and schematic bird (fig. 3a) came in response to the direction, "Make a sign which would show the way to the bird house at the zoo." The realistically drawn woodpecker in figure 3b was drawn in answer to the request to "draw a picture of a bird which you might put in your science report." When asked to make a drawing of a bird that might be seen in a museum, the child created the richly detailed and somewhat fantastic bird in figure 3c. As the three birds clearly indicate, a maker can not only create a variety of birds, she can match a particular version to a particular purpose (Wolf, 1984; 1986).

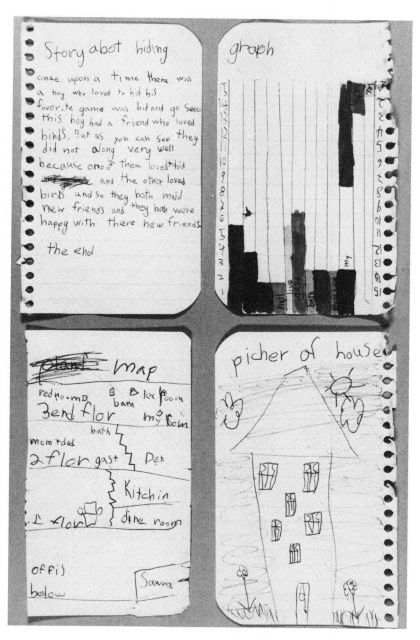

Fig. 2a-d. Information about hide-and-go-seek in different genres.

Fig. 3a-c. Different renditions of a bird.

Making Renditions

In the early years, children make selective use of varied drawing systems. Work from a number of quarters suggests that as early as six, children have some feel for the particular obligations of different types of renditions. Winner, Blank, and Gardner (1983) have shown that school children will supply a rounded, volumetric arm onto a rounded, volumetric body, while adding a highly stylized sticklike arm onto a similar body. Parallel work on drawings made from direct observation shows that children as young as five, who typically make relatively spare drawings from memory, can also create highly detailed renditions, concerned with idiosyncratic volumes, textures, and proportions (Smith, 1987). Beginning in their middle years, children define a variety of graphic genres such as drawings and maps.

Perhaps it is on the basis of this kind of sensitivity to different kinds of visual languages that individuals come to understand the nature of visual art as a particular kind of image making. Central to this understanding is the concept of *rendition*—the idea that an individual maker can vary not just *what* he draws, but the very texture of *how* he draws. This concept has two parts. First, it involves understanding that variations in the way we draw need not be tied to some kind of external task—such as making a map, an illustration, or a painting. They can be a way of exploring what is visually possible, engaging, or beautiful. Second, it includes understanding which visual and referential qualities a particular culture at a particular time understands to be the raw materials of rendition. For young artists working now in a Western tradition, these qualities might include emotional force, the exploitation of the physicality and sensuousness of materials, and the deliberate use of powerful images and symbols (Csikszentmihalyi & Robinson, 1986).

An initial sensitivity to rendition can crystallize in early adolescence, if students continue to take visual art seriously. Where it appears, it affects the way adolescents respond to the works of others as well as to their own drawings and paintings. For example, it is during early adolescence that students are able to "look through" the representational content of works, recognizing that two Degas paintings are alike, even though one pictures a horse race and the other portrays a dancer (Gardner, 1971; Machotka, 1966; Parsons, 1987; Parsons, Johnston, & Durham, 1978). These judgments are more than simple recognitions or labels; they signify at least an initial understanding of what makes for the style of an artist, the visual *zeitgeist* of a period, or the force motivating different schools or movements. By way of illustration, figure 4 contains several figure completions by the same adolescent. Clearly, the student has a generative rather than a simply imitative understanding of what it is to make a rendition of a human figure. Without such an understanding, it would be impossible to draw out the implications of the head and shoulders for the torso, limbs, and costume.

Fig. 4a-c. Figure completions showing an adolescent's understanding of different styles of rendering.

This attunement to the way in which particular images are rendered makes it possible for an individual to conduct prolonged, if intuitive, experiments, to locate and refine a personal idiom—a kind of visual signature. The images in figure 5 come from the portfolio of an adolescent artist. The drawings come from her sketchbook—a kind of visual journal in which she records and refines ideas. These drawings document the evolution of

a personal style based on an increasingly interpretive use of traditional calligraphy forms and brush strokes (Brown, 1987).

Fig. 5a-d. Samples from an adolescent's portfolio.

But it is essential to stress that the concept of rendition is not limited to an understanding of or a search for style. While adolescents who continue to work in the arts certainly develop an understanding of styles, they also come into a sharpened awareness of other factors which produce versions of an image. Here an adolescent thinks aloud about the ways in which subtle changes in line quality within a drawing of the same object permit variation or rendition:

> Last term I started drawing shells. I wanted to learn to draw things from life, so I decided to draw the same object over and over and over. While I was working on them, I started to see a lot about different kinds of lines. Shells force that. As you move around drawing one of them, you have sharp edges, folds, flaps, round shoulders. I went from pencil to charcoal because I couldn't get the pencil line to do all that, but with the charcoal you can get a hard edge and a blurry soft form. The more I worked, the more I saw each one of the lines as a story. It would start at the front edge all clear and hard and then travel up towards one of the shoulders and I would have to change it, make it thicker and softer as it went. (Wolf, 1986)

Here an adolescent reflects on the different "world" or "ambience" created by each of several print-making techniques:

Each one of them is different. I didn't especially like the mono-prints. You can't get much precision, just sort of smokey, round forms. Etchings give me the creeps, all those scratchy little lines. They look nervous, sort of frantic to me. I settled into doing block prints because I liked the kind of line you get—rugged. So my prints are strong, but they aren't always pretty, not so easy to look at.

As with drawing systems and genres, this understanding of renditions yields a field of choices. Figures 6 a-c illustrate this point. They are three prints, made within a few months of one another. While they are tempor-ally sequenced, they are not a progression so much as an effort to explore how images "work" when they are conceived and executed in different visual idioms.

As with earlier moments in the development of drawing skills, this tink-ering with the final state of a work is not simply the artifact of a tentative understanding of what it is to make a rendition. Once the notion of rendi-tion has been achieved, it becomes a permanent part of an individual's repertoire. Nothing reveals this as clearly as the work of artists. For ex-ample, in the late 1880s in Brittany, Gauguin and his circle surprisingly devoted much of their time and effort to printing rather than painting. "It was the documentary nature of these prints enabling the artists to see the evolution of their imagery via the printing of successive states that so attracted them. Variations in the manner of inking, in the pressure under which the matrices were printed, and in methods of hand coloring pro-duced wide ranges of effects in works printed from the same plate" (Mu-seum of Modern Art, 1987).

Conclusion

In this paper we have reviewed three points in the development of graphic symbolization—the onset of representational skills, the emergence of dis-tinct genres, the appearance of renditions. At each of these points we have argued that individuals construct a range of visual languages with which to portray their experience or ideas. While in this culture children may even-tually evolve the projective geometry and control of pictorial realism that permits them to draw chair rungs or torsos correctly, this does not mean that earlier-emerging drawing systems atrophy. On the contrary, even as accomplished draftsmen, children (as well as adults) elect to represent their visual or conceptual experience with points or stick figures or flat shapes when those forms serve their ends. Similarly, between five and twelve, children learn the nature and uses of different genres of visual images: drawings, maps, diagrams, or graphs. Here, too, what matters is not just the learning of diverse genres, but the ability to recognize when each is called for. As late as adolescence, individuals define the particular qualities which make for the style or mood of particular renditions. Thus,

Fig. 6a-c. Samples from an adolescent's pursuit of a particular style.

without losing our sense for the progressive refinement of particular visual languages, we recognize that drawing development exhibits another dimension entirely. This is "repertoire"—the capacity to generate and use well an entire range of visual languages.

REFERENCES

Arnheim, R. (1974). *Art and visual perception*. Berkeley: University of California Press.

Brown, N. (1987). Student journals in art class. A presentation at the annual meeting of the National Art Education Association, Boston.

Carothers, T., & Gardner, H. (1979). When children's drawings become art: The emergence of aesthetic production and perception. *Developmental Psychology, 15*(5).

Chen, M. J. (1985). Young children's representational drawings of solid objects: A comparison of drawing and copying. In N. Freeman and M. V. Cox (Eds.), *Visual order: The nature and development of pictorial representation*. Cambridge, England: Cambridge University Press.

Cox, N. V. (1985). One object behind another: Young children's use of array-specific or view-specific representations. In N. Freeman and M. V. Cox (Eds.), *Visual order: The nature and development of pictorial representation*. Cambridge, England: Cambridge University Press.

Csikszentmihalyi, M., & Robinson, R. (1986). Culture, time, and the development of talent. In R. J. Sternberg and J. E. Davidson (Eds.), *Conceptions of giftedness* (pp. 264-284). Cambridge, England: Cambridge University Press.

Davis Perry, M., & Wolf, D. (1986). Mapping symbolic development. Paper presented at the annual meeting of the Jean Piaget Society, Philadelphia.

DeLoache, J., Strauss, M., & Maynard, J. (1979). Picture perception in infancy. *Infant behavior and development, 2*, 77-89.

Downs, R. (1985). The representation of space: Its development in children and in cartography. In R. Cohen (Ed.), *The development of spatial cognition* (pp. 323-346). Hillsdale, New Jersey: Lawrence Erlbaum Associates.

Dubery, F., & Willats, J. (1983). *Perspective and other drawing systems*. London: The Herbert Press, Ltd.

Freeman, N. (1980). *Strategies of representation in young children*. London: Academic Press.

Freeman, N., & Cox, M. V. (Eds.) (1986). *Visual order: The nature and development of pictorial representation*. Cambridge, England: Cambridge University Press.

Gardner, H. (1970). Children's sensitivity to painting styles. *Child Development, 41*, 813-821.

Gardner, H. (1971). The development of sensitivity to artistic styles. *The Journal of Aesthetics and Art Criticism, 29*(4), 515-527.

Gardner, H. (1980). *Artful scribbles: The significance of children's drawings*. New York: Basic Books.

Goodenough, F. (1926). *The measurement of intelligence in drawings*. New York: World.

Goodman, N. (1968). *Languages of art*. Indianapolis: Bobbs-Merrill.

Hagen, M. (1986). *Varieties of realism*. Cambridge, England: Cambridge University Press.

Harris, D. B. (1963). *Children's drawings as measures of intellectual maturity*. New York: Harcourt, Brace & World.

Hochberg, J., & Brooks, V. (1962). Pictorial recognition as an unlearned ability: A study of one child's performance. *American Journal of Psychology, 75*, 624-628.

Kellogg, R. (1969). *Analyzing children's art*. Palo Alto, California: National Press Books.

Liben, L., & Downs, R. (1987). Maps as symbols: Beginnings and boundaries of children's understanding. Paper presented at the biennial meeting of the Society for Research in Child Development, Baltimore, April.

Lowenfeld, V. (1957). *Creative and mental growth*. New York: Macmillan.

Machotka, P. (1966). Aesthetic criteria in childhood: Justifications of preference. *Child Development, 37*, 877-885.

Museum of Modern Art (1987). Gauguin and his circle in Brittany: The prints of the Pont Aven School. Exhibition, Spring to July 26.

Parsons, M. (1987). *How we understand pictures*. Cambridge, England: Cambridge University Press.

Parsons, M., Johnston, M., & Durham, R. (1978). Developmental stages in children's aesthetic responses. *Journal of Aesthetic Education, 12*(1), 83-104.

Philips, W. A., Hobbs, S. B., & Pratt, F. R. (1978). Intellectual realism in children's drawings of cubes. *Cognition, 6*, 15-33.

Pratt, F. R. (1983). Intellectual realism in children's and adults' copies of cubes and straight lines. In D. Rogers & J. Sloboda (Eds.), *The acquisition of symbolic skills*. New York: Plenum.

Shotwell, J., Wolf, D., & Gardner, H. (1980). Styles of achievement in early symbolization. In M. Foster & S. Brandes (Eds.), *Symbol as sense: New approaches to the analysis of meaning* (pp. 115-199). New York: Academic Press.

Smith, N. R. (1987). Drawing systems in children's pictures: Contour and form. Paper presented at the annual meeting of the American Psychological Association.

Willats, J. (1977). How children learn to draw realistic pictures. *Quarterly Journal of Experimental Psychology, 29*, 367-82.

Winner, E., Blank, P., & Gardner, H. (1983). Children's sensitivity to aesthetic properties of line drawing. In J. Sloboda & D. Rogers (Eds.), *The acquisition of symbolic skills*. London: Plenum.

Winner, E., McCarthy, M., Kleinman, S., & Gardner, H. (1979). First metaphors. *New Directions in Child Development, 6*, 29-41.

Wolf, D. (1984). Drawing conclusions about children's art. Paper presented at the symposium "Vom Kritzeln zur Kunst," Ichenhausen, Germany.

Wolf, D. (1983). Representation before picturing. Paper presented at the annual meeting of the British Psychological Association, Cardiff, Wales.

Wolf, D. (1986). All the pieces that go into it: The many stances of aesthetic understanding. In A. Hurwitz (Ed.), *Aesthetics: The missing dimension*. Baltimore: Amereon House.

Wolf, D., Davidson, L., Davis, M., Walters, J., Hodges, M., & Scripp, L. (in press). Beyond A, B, and C: A broader and deeper view of literacy. In A. Pellegrini (Ed.), *The psychological bases of early education*. London: John Wiley & Sons.

Wolf, D., & Grollman, S. (1982). Ways of playing: Individual differences in imaginative play. In K. Rubin & D. Pepler (Eds.), *The play of children: Current theory and research*. New York: Karger.

Fiction for Children: Does the Medium Matter?

LAURENE KRASNY BROWN

Whenever a new medium of communication becomes available to children, its effect on their well-being is debated. When motion pictures became popular, parents feared that seeing movies would degrade their children's conduct and morals. (In 1928, the Motion Picture Research Council invited a group of psychologists to measure the movies' effects on children. For results, see Charters, 1935.) More recently, television has come under similar scrutiny. People worry that television drama is too violent and sexual and that watching television robs children of time, imagination, and the ability to concentrate in school.

Bad press about a medium's effect on children is one thing and evidence of harm often quite another. As researchers concerned with cognitive development, we wondered not so much whether learning from one medium was more beneficial than another, but rather whether children learn differently depending on the medium. And if so, how and why?

Many researchers look at content to account for the important learning from a medium. Concern over television's displays of violent behavior generated many of the early studies with children. These studies documented that children do learn and sometimes perform aggressive behavior from observing television characters (Pearl, 1982). Children are likely to absorb considerable other content from television performances as well, including what to buy, what to wear, and how to behave in various social situations. Educational programs like "Sesame Street" have verified television's ability to teach academically relevant subject matter. (For discussion of early summative research, see Lesser, 1974.) Medium content is a fickle thing, however. It changes along with the tastes of its producers and audiences. Content also regularly crosses media boundaries: children's books are rewritten as screenplays, and television characters are licensed for use in print and other nonbroadcast formats. Important as medium content is, its impact on children's learning should not be exaggerated.

Others who study media effects on children have focussed on how children use a medium like television. Most often documented (and decried)

are the impressive number of hours many children spend at home in front of television. Needless to say, time spent viewing television (and possibly learning "X-rated" content) could instead be spent doing (and possibly learning) something else. But patterns of medium use change too. When children view programs on video cassette recorders, fast forwarding over boring parts and rewinding to review more exciting moments, their use of video more closely resembles the control exercised when reading a book. Moreover, television viewing seems to replace use of other enter-tainment media like comic books; children deprived of television do not instead choose to spend hours curled up with a nonfiction text.

What persists in distinguishing one medium from another is the form its content assumes. We reasoned that the most profound differences in children's learning from media might well be associated with a medium's particular way of presenting information. Marshall McLuhan popularized this idea in the 1960s: "All media are active metaphors in their power to translate experience into new form" (McLuhan, 1964). But he had little experimental evidence to support his claims.

What constitutes a medium's form? First, every medium has a physical makeup of sound, pictures, or print. Radio delivers its content using strict-ly auditory means, whereas audiovisual media like television combine sounds (speech, music, and sound effects) at a fixed pace with moving images. Where paint, canvas, and brushes serve as an artist's physical mate-rials, analogous technical means for a television director include cameras, microphones, lights, and actors. Second, each medium represents its con-tent using a characteristic profile of symbols like verbal language and drawn images (Gardner, Howard, & Perkins, 1974). For example, radio uses oral language, music, and sound effects. Books use language too—in written rather than oral form—and static pictures as well. Television applies every one of these to some extent, but with the resources of moving images and sound at hand, television's use of written language and still pic-tures is limited. Symbols differ in what they reveal about their referents: pictures are well suited for depicting visible aspects of stories such as how characters look or where they are in a setting, whereas language readily conveys nonvisible content like what a character is thinking. Third, each medium adopts certain rules and conventions for handling its physical and symbolic resources. Although both film and video are capable of repeating shots, only television uses the instant replay to give viewers another chance to see dramatic moments in live sports broadcasts.

If form is responsible for more profound, enduring differences among media, then how might children's learning reflect a medium's distinct manner of delivery?

For one thing, children seem to be doing different mental work deci-phering each medium's symbols and production techniques. Where stories

in print require a reader to decode written words, television stories demand a kind of literacy too—the ability to extract meaning from television's montage of moving pictures and sound. As one example, children's comprehension of television's narratives depends in part on the complexity of its editing techniques (Smith et al., 1985). It also has been argued that specific cognitive operations such as the spatial skill of relating parts to a whole are needed to understand certain forms of editing, and camera techniques make different demands on children's prior mental skills (Salomon, 1974 and 1979).

In addition, research indicates that the presence of certain formal features affects children's attention to television. Features positively associated with increased visual attention include children's voices, sound effects, and visual movement. Conceivably, children may learn better content conveyed via these attention-enhancing elements.

Taking into account this evidence of different mental processing of various media, we hypothesized that the information each medium's delivery highlighted would be reflected in children's learning.

Learning from Television versus Picture Book: Initial Study

We first addressed this premise by asking, "What might children learn from a television story that they don't learn from a story in print and vice versa?"

We began by considering how each medium tells its stories. Print fiction can explore the possibilities for human action, but the movements are at best mental images that the reader constructs out of words. If a book is illustrated, the pictures can further suggest or imply movement, as with figures drawn with bent limbs, though each image remains static and discrete. In contrast, the illusion of movement is inherent in the continuous display of film and television images; when one still picture is quickly superseded by another, just slightly different one, the eye interprets the change as movement.

How does this change from printed page to moving picture affect the story content? Moving pictures depict some parts of a plot more readily than others. Most conspicuously, once pictures move, we can see exactly what characters are doing and how they look as they move through space. In comparison, dialogue relies much less on visible movement. Poetic language such as rhyme, refrain, metaphor, and onomotopoeia tends to elude illustration altogether.

Our initial study investigated these medium differences by comparing children's apprehension of an African folktale presented either as a televised cartoon or read aloud from a picture book (Meringoff, 1980). In order to measure the impact of animating the story, the two versions

being compared needed to be similar in other respects. Fortunately, existing story materials needed only minor changes to achieve this level of comparability. The same text, narration, and illustration style were used in the book and the cartoon. Some film and video production companies go to great lengths to preserve maximum consistency with the literature they adapt (Deitch, 1978). In the designing of such media comparisons, however, there is always a conflict between achieving enough comparability across presentations to permit their comparison and having each medium version take sufficient advantage of its physical resources and production means. Early instructional television is a classic example of too little use being made of television as a medium in its own right. Many directors sat a teacher before a stationary camera and filmed the lesson. No wonder little evidence of medium effects was found when television and live classroom instruction were compared. (For discussion of effective programming for instructional television, see Schramm, 1972.)

There were forty-eight children participating in the study, twenty-four younger children (six- and seven-year-olds) and twenty-four older ones (nine- and ten-year-olds). They were randomly assigned to one of the two medium conditions and individually presented the story. To determine what children remembered of the story, their verbatim accounts were analyzed in both free and aided recall. To tap learning beyond the explicit content, we asked children to make story-relevant inferences about such things as the characters' traits and feelings. In addition, any behavior displayed by children during the interview was monitored, such as acting out story content and initiating conversation during the story.

The results of this study revealed a different learning profile for each medium. Despite the similarity between the story versions, both younger and older children's memory for story events improved upon seeing characters perform the actions: children who saw the folktale as a cartoon reported more character action in their story accounts than did youngsters presented the picture book. (Unless otherwise indicated, the reported differences are statistically significant at P, \leq .05.) Viewers also voluntarily mimicked more of what they saw characters do.

Television viewers based more inferences on what characters looked like and how they behaved. For example, children were asked whether hanging the leopard in a tree was easy or hard for the protagonist. The two audiences, cartoon and book, based their inferences on different evidence. Cartoon viewers typically called on observed behavior: "It was hard because it looked like he [the hero] was struggling," or "by the way he was pulling the rope." The way an action is performed often suggests its ease or difficulty. Picture book audience members more often imported evidence from outside the story: "Hard because leopards are awful heavy," or "They could bite you!" They also referred more to dialogue: "Hard because the Sky God *said* he was weak."

On the other hand, live reading of the picture book prompted children to remember more poetic language. Compared to viewers, the picture book audience correctly identified more of the story's onomotopoetic sounds (shouts of "eee eee"), repeated words ("It's raining, raining, raining"), and elaborative phrases (the fairy whom-men-never-see). Listeners more often referred to characters by their formal names, "Ananse the spider man," whereas viewers made vaguer references to "the man" or just "him." The book audience also included more of this vocabulary in their retelling of the story.

These and other observed medium differences provided support for the hypothesis that differences in media form influence what content is conveyed more effectively to children. (For more complete discussion of medium effects on children, see Brown, 1986.) The consistency of findings across different tasks added to their validity: for example, the television audience stressed the story's depicted events in free recall, in inference making, and in unsolicited gestures. Identifying such layered evidence of learning is one advantage of using multiple response measures in a study.

Learning from Pictures: Follow-up Study on Visual Imagery

If children remember especially well and use depicted actions and other moving picture content to help them interpret the narrative, then one function the illustrations must serve is to provide children with a repertoire of mental visual imagery. To explore this premise, a study was conducted to compare children's picturing and inference making for a Grimms' fairy tale presented as an animated film or as an audio recording (Vibbert & Meringoff, 1981; this research also appears in Meringoff et al., 1985). We hypothesized that children exposed to vivid film imagery would include observed characters, settings, events, as well as camera angles, points of view, and other cinematic features in their own drawings of story content. We also predicted that film viewers would make more appropriate inferences about pictured scenes than children who had this content described to them in the audiotape.

We selected an animated film version of "The Fisherman and His Wife" that made good use of pictorial and cinematic techniques. Then we produced audio recordings of the film soundtrack, inserting verbal descriptions of selected content visible on screen.

There were forty-five nine- and ten-year-old children participating in the study. They were randomly assigned to one story condition and individually presented the tale. After the story both nonverbal and verbal tasks were administered. For example, once cued to specific points in the story, children were instructed to "draw, as best you can, how (this content) looks to you in your mind." Following each drawing, children could describe in words any discrepancy between their drawing and the way they

imagined things to look. Another group of children had no exposure to the tale but drew "baseline" pictures to give us examples of how children this age depict subject matter like that in the story.

Admittedly, we cannot equate children's pictures with their mental imagery (Kosslyn et al., 1977). Nonetheless, we felt it essential to offer children opportunities to report learning from drawn animation in a similar modality. Drawings do give us an inkling of the content of a remembered visual image; they automatically include information—about spatial relationships, scale, visual details—rarely described verbally by children. Drawing also is accessible to most children, and we were concerned with the potential effects of highly visual media on children's own forms of expression.

When children's pencil sketches and verbal responses from the story were compared across media, some significant differences emerged. As predicted, film viewers included in their sketches film content ranging from setting details to details of camera shots. For example, a number of film viewers drew the wife in close-up at one dramatic point in the story (as did the film) as opposed to the more conventional full-figure drawing favored by listeners and those making baseline drawings. When filling in the wife's facial features, more film viewers opened her mouth and exposed bare teeth, instead of rendering a happy, smiling face as did most of the other children. Assessing the wife's feelings at this moment, most children seeing the film correctly identified her as being angry, whereas the majority of the listeners labeled her feelings as happy. In substantiating their inference, film viewers relied almost exclusively on picture content from this moment in the story; in contrast, listeners roamed the plot for text information about her feelings.

These and other observed medium differences suggest two ways that remembered film imagery informs children. The first relates to story understanding. As in the previous study, children who screened the cartoon used its visual content to make appropriate inferences about characters and events. Even a single film image can supply young viewers with compelling, memorable evidence about a character's feelings. In comparison, children who heard this story tended to base sometimes mistaken inferences on text drawn from across the story.

The second function of remembered film imagery relates more to children's artistic development. In all the production tasks, pictures made by film viewers tended to differ most from baseline drawings. These differences usually could be explained by noticing similarities between film viewers' drawings and the cartoon images. The film did indeed supply children with ready-made images, which to some extent they used as models for their own story sketches. In comparison, listeners tended to base more picture content on remembered personal experiences with

similar people, places, and objects or on other illustrated versions of the tale. In this sense, hearing a story does encourage children to exercise their imagination.

These attempts by children to reproduce what they have seen on film may be dismissed as imitative; taken by itself, such evidence seems to fuel arguments that film or television viewing removes the initiative to conjure up more personal imagery. But such an interpretation fails to take other evidence into account. Imagination can use only what imagery has to offer. Listeners' pictures were limited by their prior experience with the story's content; having repeatedly heard that the fisherman fished with a net, most listeners still proceeded to draw him with a pole because that was more familiar to them. Moreover, the baseline drawings suggest the prescribed ways of rendering people, situating them in space, making them happy, etc., that many school-age children adopt. Access to a single cartoon stimulated children to stretch their picture schemes and try doing something different. These findings are consistent with our notion that children exposed to vivid films have at their disposal a rich mental store of visual images.

Learning from Sounds: Follow-up Study on Auditory Learning

If children who hear stories read aloud are more prone to remember poetic language, we wondered whether our story-related sounds contributed to children's learning from fiction. After all, listening to a richly produced radio drama involves attending to much more than language.

To address this question, a study was conducted in which thirty third and fourth graders and thirty sixth graders listened to one of two audiotapes of *Treasure Island* episodes (Char with Meringoff, 1982). One version used a strictly verbal narration, the other used the same verbal text plus sound effects and music. We hypothesized that the inclusion of nonverbal sounds would offer the children additional clues to help them understand the story.

After hearing either audiotape, children were individually interviewed, and response measures were used that varied in the degree to which they focused children's attention on the story's sounds and music. The most unstructured task simply asked children to retell the story. This allowed us to see whether children recalled story content better when it was accompanied by sound effects. Next, open-ended and multiple-choice questions were asked about content accompanied by sound effects or music. For example, one episode is described in the text as occurring during winter: "It was a bitter cold winter, with long hard frosts and heavy gales." In the sound effects version, an extended sound of blowing wind is

added. Children were asked during which season the scene took place and about their rationale for deciding on a response. Children hearing the story and another group of story-naive listeners also identified sound effects compiled on a separate audiotape. Responses to these sound effects, both from the story and from other sources, allowed us to test how well children derive meaning from sounds alone and how well they recognize sounds as being previously presented in or appropriate to a story.

Results indicated that sounds and music do contribute to children's story understanding. In the wind example, children exposed to the elaborated audiotape as compared to those hearing only the text were a little more likely to mention the season or weather in their story retellings. When asked directly about this episode's setting, these children also were better at identifying the season as winter and used sounds heard at that point in the story as evidence. Children listening to the text alone either based their assessments of the season on the script or they guessed. Children hearing the elaborated version used other sound effects as well to interpret the story's actions, settings, and props. Older children also used music as a clue to the story's locale; the sailor song suggested such associations as pilgrims, England, and the sea.

Responding to the separate tape, children listening to the story could judge whether a sound heard out of context belonged to the story. They sorted out among the sound effects which ones were plausible and which inappropriate to include in this *Treasure Island* excerpt: yes, horse hoofbeats belonged; no, car traffic did not. They discounted the non-Western sound of percussive African rhythm as unsuitable for the story. Many subtleties emerged in their descriptions of these sounds. For example, hearing a door open and close, then footsteps growing fainter, one third grader said: "Someone slamming a door and walking away inside a hall." Notice her attention to how the door was closed (slamming), to the pace and direction of footsteps (walking away), even to the acoustical background (inside a hall).

This study suggests that sound effects and music do provide children with helpful story information. There are, however, two obvious but critical caveats. Children's repertoire of familiar sounds is limited. A child must have heard a sound before and be able to recognize it without seeing its source. For example, the identity of an old wheelbarrow rattling down the road went undetected among this modern urban audience. Second, sound effects and music used in an audio or radio dramatization are subtle elements. Direct questioning may be needed to determine what children know from their inclusion. Assuming they are properly selected for the age group listening, however, their presence assists children, offering, if you will, aural images of a story's content.

Conclusion

Evidence from these three studies supports our basic hypothesis that the information a medium highlights by virtue of its particular form is revealed in what children know of a story. For highly visual media like television and film, the dynamic quality of their picture content encourages children's attentiveness to characters' actions and appearance. Judging from youngsters' pictures of story content, all kinds of details and film images seem to be remembered as well, including elements of picture composition that children rarely describe in words. Conversely, the more aural formats where pictures are fewer or absent seem to facilitate children's listening to language whose sound is as important as its meaning, as well as to sound effects and music.

Results of these and other studies conducted in our six-year program of media research suggest educational implications for children's use of media. Conceivably, all storytelling media exhibit both strengths and limitations in what they "teach" about fiction. It is as if each medium treatment offers young audiences a somewhat different slant on a given tale. The more effectively a medium's formal means are exploited in production, the more likely it would seem that children will absorb this distinctive story incarnation. Moreover, according to other researchers, experience with a given medium implies practicing some mental skills and neglecting others.

Thus to ensure that children receive the fullest exposure to fiction, in terms of what they learn and how they learn it, it is advisable to provide diversity not only in the story content and genre, but also in the media used to present this fiction. In particular, our findings point to children learning useful information about stories from nonverbal sources, the very sources given low priority in most elementary curricula. Failure to acknowledge or cultivate such nonverbal learning may undermine important aspects of children's cognitive development.

REFERENCES

Brown, L. K. (1986). *Taking advantage of media: A manual for parents and teachers.* New York: Routledge & Kegan Paul.
Char, C. A., with Meringoff, L. K. (1982). Children's comprehension of radio stories and the role of sound effects and music in story comprehension. Technical Report 28, Project Zero, Harvard Graduate School of Education.
Charters, W. W. (1935). *Motion pictures and youth: A summary.* New York: Macmillan.
Deitch, G. (1978). The picture book animated. *The Horn Book Magazine,* April, 146.
Gardner, H., Howard, V., & Perkins, D. (1974). Symbol systems: A philosophical, psychological, and educational investigation. In D. Olson (Ed.), *Media and symbols: The forms of expression, communication, and education* (pp. 27-56). Chicago: University of Chicago Press.

Kosslyn, S. M., et al. (1977). Children's drawings as data about internal representations. *Journal of Experimental Child Psychology, 23*, 191-211.

Lesser, G. (1974). *Children and television: Lessons from Sesame Street* (p. 57). New York: Random House.

McLuhan, M. (1964). *Understanding media: The extensions of man* (p. 57). New York: McGraw-Hill.

Meringoff, L. K. (1980). Influence of the medium on children's story apprehension. *Journal of Educational Psychology, 72*(2), 240-249.

Meringoff, L. K., et al. (1985). How is children's learning from television distinctive? Exploiting the medium methodology. In J. Bryant & D. R. Anderson (Eds.), *Children's understanding of television: Research on attention and comprehension* (pp. 151-179). New York: Academic Press.

Pearl, D. (1982). Television and behavior. In *Ten years of scientific progress for the eighties*, vol. 1, Summary Report (pp. 36-40). Rockeville, Maryland: U.S. Department of Health and Human Services.

Salomon, G. (1974). Internalization of filmic schematic operations in interactions with learners' aptitudes. *Journal of Educational Psychology, 66*(4), 499-511.

Salomon, G. (1979). *Interaction of media, cognition, and learning*. San Francisco: Jossey-Bass.

Schramm, W. (Ed.) (1972). *Quality in instructional television*. Honolulu: University Press of Hawaii.

Smith, R., et al. (1985). Young children's comprehension of montage. *Child Development, 56*(4), 962-971.

Vibbert, M. M., & Meringoff, L. K. (1982). Children's production and application of story imagery: A cross-medium investigation. ERIC Document ED 210 282.

Ten Myths of Metaphor

ISRAEL SCHEFFLER

Various myths surround the topic of metaphor. I here criticize ten such myths, hoping thereby to open the way to a better understanding of the topic.[1]

1. The Myth of Falsehood

Only literal statements are true, according to this myth. All the rest distort and falsify. The poets (as Plato taught us) lie; only the scientists tell the truth. To describe an unreliable, cowardly, or sickly person as a weak reed is just to speak a falsehood, which becomes a truth through negation: obviously, the person referred to is *not* a weak reed.

But it is *obvious* that he is not a weak reed only if "weak reed" is taken *literally*, for it is, indeed, obvious that no person is literally a reed, weak or otherwise. And it is utterly trivial to say that a metaphorical statement, *taken literally*, may be false. Taken metaphorically, however, the statement may well be true: he is indeed a weak reed, and it is false to deny that he is. To be sure, metaphorical assertions are eligible for falsehood. But they are not, any more than literal assertions, always false.

2. The Myth of Embellishment

If not always false, then metaphors are always, at any rate, cognitively contentless; so runs the present myth. Rhetorical adornments merely, metaphors can (and, for the sake of theoretical clarity, should) always be stripped away, allowing the bare literal truth to shine forth.

But what remains after the metaphor is removed from the statement "War is hell"? Eliminating the predicate leaves a bare grammatical subject, not even a full sentence, true or false. Presumably, what is intended here is not mere removal but translation, or replacement by a cognitive equivalent. It is, notoriously, no easy task to specify criteria for such replace-

ment. But the more fundamental point is this: To concede that the metaphorical attribution *has* a cognitive equivalent is to admit that it possesses cognitive content, after all. It is of course not in any case true that metaphors with cognitive content always have literal equivalents.

3. The Myth of Emotivity

Metaphors are, according to this myth, emotive and not at all, or not primarily, cognitive. Whatever may be said of cognitive equivalents, metaphors surely have no emotive equivalents. It is their high emotivity that sets them apart from literal statements, making them irreplaceable.

But is "a sparkling intelligence" or "a pedestrian analysis" highly emotive? Is, indeed, the doctor's metaphorical "You face an uphill struggle for your life" more emotive than "The tests show that you have cancer"? Whatever criteria may be specified for the elusive property of emotivity, literal expressions, too, may have it in abundance, as witness "neutron bomb," "Chernobyl," "leukemia." Emotions develop in the most intimate connection with cognitions; feelings respond to things as apprehended and comprehended. Why should literal accounts of things be any less related to the emotive life than metaphorical accounts? Why should emotional response to things cognized be better expressed by metaphorical than literal reference to such things?

4. The Myth of Suggestiveness

Metaphorical statements are false or contentless, but at least they are distinctive in their suggestiveness, according to the present myth. Cognitively deficient themselves, they nevertheless stimulate associations of ideas which may terminate in useful truths.

Why literal statements are thought to be poorer than metaphorical ones in their suggestive capabilities is not explained by this myth. Associations of ideas, after all, occur in response to all sorts of verbal (let alone nonverbal) stimulation. They are even set off by pure nonsense, for example, Jabberwocky; why are literal statements, in particular, deficient?

What this myth overlooks is that metaphorical statements that initiate new classifications and categories do so not, as nonsense syllables stimulate, by adventitious means, but through their own novel assertive content. They may indeed begin as metaphorical hypotheses, but they often (and without change of content) end as acknowledged truths, their once startling attributions now congealed into new literal references. That the table is a swarm of atoms, that we live at the bottom of a sea of air, that the mind processes information or forms images—these are by now literal clichés, the same statements having started life as bold metaphors.

5. The Myth of Communication

Such examples refute the myth of metaphors as exclusively devices of communication. This myth supposes that the thought is fully available to the thinker in purely literal terms, but that its communication requires, or is facilitated by, the use of metaphors. Metaphor is the packaging of literal thoughts for transmission to others, but forms no part of these thoughts themselves.

What is thus denied is the patent fact that metaphor serves the seeker and not alone the transmitter of truth, that scientific theorizing, for example, thrives on metaphorical description put forth in an investigative spirit. The theorist typically does not know in advance the detailed basis of the metaphorical description he proposes, guessing that a certain deliberate crossing of categories may be found increasingly significant with further inquiry. The metaphor embodying this guess does not require a prior determination of such significance. On the contrary, the metaphorical description itself serves as an *invitation*, to its originator and to others, to develop its ramifications. Its challenge is not to receive a fully substantiated message, but to find or invent new and fruitful descriptions of nature.

6. The Myth of Ownership

The present myth supposes that the author of a metaphor has exclusive rights or privileged access to it. As an instrumental device of communication, it is wholly under the control of its creator, shaped exclusively by his intent. Interpretation of a metaphor requires, ultimately, appeal to such intent.

What is here left out of account, as already noted in the last section, is the exploratory or heuristic role of metaphor. What this role implies, in particular, is that the author of a metaphor has no special key to its import, no privileged access, no rights of ownership. In creating a metaphor, one may surprise oneself. The invitation presented by a metaphorical utterance may lead us to rethink old material in the light of new categorizations or to consider newly discovered phenomena in terms already available. Whether the task be to incorporate the novel or to reorganize the familiar, metaphor serves often as a probe for connections that may improve understanding or spark theoretical advance.

7. The Myth of Metaphorical Truth

This myth holds that there are two species of truth, the one literal, the other metaphorical. "The match flamed" is held to be true in a way quite

different from that in which "His eyes flamed" may be true. Adherents of this myth are thus seduced into a fruitless hunt for the special character- istics of metaphorical as distinct from literal truth, yearning for an essen- tial difference between poetic and scientific utterance.

That the above two sentences differ may be readily admitted. But that their difference is to be located in the duality of truth is dubious. For each sentence is true under the selfsame general condition: ". . . " is true if and only if Thus, "The match flamed" is true if and only if the match flamed, and "His eyes flamed" is true if and only if his eyes indeed flamed. That the first "flamed" differs in its extension from the second is a fact about these two replicas in particular, not a fact about what it means for their respective sentences to be true. Nor, *a fortiori*, does it require the postulation of two species of truth.

8. The Myth of Constancy

This myth holds that once a metaphor, always a metaphor. Contrary to the view that the literal is primary while the metaphorical is mere embel- lishment, the present myth declares the metaphorical to be primary, since every term in use has indeed a metaphorical lineage. All speech is thus declared metaphorical.

A consequence of this myth is that the notion of the literal is emptied of content; correlatively, the notion of metaphor, as contrasting category, loses its point. This consequence is, however, avoidable, and without deny- ing the pervasiveness of metaphorical lineage: What needs only to be acknowledged is the historical dimension—the fact that the literal-meta- phorical contrast is effective not absolutely but relatively to time.

Given two extensionally divergent replicas of a term, i.e., two tokens of a certain type at a given time, we deem the one metaphorical whose inter- pretation is typically, or optimally, guided by an understanding of the other, which we take as literal. A coextensive replica of this metaphorical expression occurring *at a later time* may quite properly, however, be judged to be literal. The term, construed as the type, has altered in its metaphor- ical status over time. The first description of an electronic device as a *cal- culator* was metaphorical; nowadays such a description is literal.

9. The Myth of Formula

How nice it would be to have a simple formula for decoding metaphorical expressions. The myth that there is such a formula is an old one, often criticized but never eliminated. Indeed it is likely to gain a new life with the aid of current computer technology and associated models of the mind.

The fact is that metaphorical expressions are not coded. They have no

recipes, nor can they be exhaustively enumerated in dictionaries or code books. Understanding a metaphor requires interpretation and investigation in context.

The most popular candidate for a formula to shortcut such interpretation and investigation is the concept of similarity. It is, however, a vacuous concept, there being too many similarities to choose from. Similarities abound wherever one looks, but few will support true metaphorical descriptions. On the other hand, to supplement the notion of similarity with that of importance (i.e., to seek important similarities) introduces an ineradicable contextual reference which cannot itself be compressed into a formula. Here inspection of the context, ingenuity, and wit are required to take up the slack. In place of an automatic read-out from a code book or the routine application of a formula, we have an interpretive process of search and discovery.

10. The Myth of Objectualism

Comparison of objects, as suggested in the foregoing references to similarity, is certainly involved in metaphorical description, but it is a myth to suppose that only comparison of objects is involved. According to this myth, one compares the objects denoted metaphorically by a term with those denoted literally by that term. For example, in "Men are wolves," "wolves" is metaphorically applied to men, while literally denoting members of Canis Lupus. Abstracting the features common to both sets of objects, one interprets the metaphor as attributing certain of these features, e.g., fierceness, to the metaphorical referents.

This myth is misguided not only because comparison and abstraction are too broad, requiring restriction by what wants attention in context. The further point is that metaphor is not wholly objectual in outlook. Its routes of comparison are often circuitous, touching not only on the objects in question and their features, but also on various representations of these objects. That wolves are, it is said, rather more pacific than their familiar stereotype will allow does not disqualify "Men are wolves" as a metaphorical attribution of fierceness to men. It is the stereotype representing wolves rather than features of the wolves themselves that give the clue to this attribution. Nor does "The boss is a dragon" lack all sense in consequence of the fact that "dragon" has no objects at all to denote. Again, representative stereotypes (in this case, dragon images, descriptions, models, and portrayals) come to the rescue. For the term "dragon" serves not only as a denoting unit that in fact denotes nothing, but also as a caption for dragon-mentions, which are in fact, as indicated, plentiful. Such 'mention-selection' aids the understanding of metaphors. We live, after all, in a world of symbols as well as other objects. Our view of objects

and our knowledge of their representations serve alike as resources for interpretation.

NOTE

1. This article is reprinted from *Communication and Cognition*, *19*, nos. 3/4 (1986), 389-394. An account of various theories of metaphor is given in my book, *Beyond the Letter* (London: Routledge & Kegan Paul, 1979). Some passages in Sections 3, 5, and 6 above are taken from my book. The notion of 'mention-selection' referred to in Section 10 is introduced and discussed in my book as well as in my 'Four questions of fiction,' *Poetics*, *11* (1982), 279-284, reprinted as well in my *Inquiries* (Indianapolis: Hackett, 1986). I thank Catherine Z. Elgin and V. A. Howard for critical comments on the present paper.

Children's Understanding of Nonliteral Language

ELLEN WINNER, JONATHAN LEVY, JOAN KAPLAN, and
ELIZABETH ROSENBLATT

Even the most ordinary of conversations is likely to be sprinkled with metaphorical and ironic uses of language. Consider the following situation. A weary couple at a restaurant try unsuccessfully to keep their cranky four-year-old daughter from throwing food across the table.

> Husband: "She's just too young to sit still at a restaurant."
> Wife: "Things are coming apart at the seams."
> Husband: "This is what I call a peaceful way to spend the evening."

The first remark is literal, but the two that follow are nonliteral: the wife's remark is an example of metaphor; the husband's is an example of irony.

Metaphor and irony also pervade literature. Metaphor is central to both fiction and poetry, while irony is more often restricted to fiction, appearing either in characters' dialogue or authors' voice. One must be competent to recognize and understand these two forms of language in order to carry out ordinary verbal tasks such as having a conversation or reading a newspaper as well as more complex ones such as reading works of literature.

Metaphor and irony are discussed together in this paper because they are the two chief forms of nonliteral language. Although similar by virtue of being nonliteral, they also differ in interesting respects. By juxtaposing them we hope to clarify what they have in common which distinguishes them from literal language as well as what is unique about each.

In what follows, we first discuss the similarities and differences between metaphor and irony. Next we consider the skills needed to make sense of these two forms of language. Finally, we examine the errors children make in understanding metaphor and irony in order to test the hypothesis that these two forms of nonliteral language call on different kinds of cognitive skills and hence yield qualitatively different kinds of misinterpretations.

Metaphor and Irony Compared

Metaphor and irony are alike in being nonliteral uses of language. In liter-

al language, the speaker means what he says, though he also may mean more than what he says. In the first remark in the opening example, when the husband says, "She's too young to sit still at a restaurant" (a literal utterance), he means what he says as well as such implied meanings as: I'm sorry we did this; We should have left her with a sitter; In the future we should eat at home; and so forth. In nonliteral language, the speaker does *not* mean what he says but means something different. When the wife says that things are coming apart at the seams, she means that the child's behavior is growing out of control; when the husband calls the evening peaceful, he means it is stressful.

In literal utterances, the relation between what is said and what is only implied is one of consonance: the speaker's implied meanings are clear, logical extensions of the literal sentence meaning. In nonliteral utterances, including both metaphor and irony, the relation between what is said and meant is one of striking divergence. What is meant is not a logical extension of what is said, and either appears unrelated to what is said (in metaphor) or clashes with what is said (in irony).

Now consider the differences between metaphor and irony. Most importantly, they differ in function. Metaphor is mainly used to clarify, illuminate, or explain: some metaphors are the most informative way to explain something; others provide more vivid, parsimonious, and memorable descriptions than their literal "equivalents." Irony is used to comment upon, usually critically. Because irony is an indirect form of negative evaluation, it is less confrontative than a literally phrased attack. Thus, metaphor functions to describe, irony to evaluate, though, as we shall make clear below, either may do the other peripherally.

A metaphor brings to light certain attributes of an object, event, or situation and thereby conveys new information about it. In the opening example, the wife's remark is more descriptive than evaluative. The particular metaphor chosen to describe the child's behavior illuminates certain aspects of the topic rather than others. The aspect illuminated here is *lack of control.* Had another metaphor been chosen, such as "She's only being a clown," the aspect of *playfulness* would have been emphasized.

Any new or striking metaphor highlights infrequently remarked upon (or previously unnoticed) attributes of its referent. In so doing, the metaphor describes the topic in what the speaker considers to be an illuminating way. It is because of their descriptive power that metaphors are so often at the root of scientific theories and serve thus to reshape our knowledge (cf. Turbayne, 1970).

Irony does not usually help to explain or illuminate. Instead, it functions to convey the speaker's attitude toward a situation, and this attitude is almost always negative. In the opening example, the husband's final comment expresses irritation at the situation; it does not clarify or explain

the situation. It is because of irony's evaluative rather than descriptive power that it usually arises in some kind of interpersonal situation, whether this be between living individuals, fictional characters, or author and reader.

As mentioned above, metaphor and irony can fulfill each other's primary function as a peripheral, nonnecessary function. Thus, along with its descriptive function, a metaphor can (but need not) also comment critically on a situation. Suppose the wife in our example had called her daughter "a little tyrant." In this case she has not only illuminated an aspect of the child's behavior (domineering) but has also expressed anger. In similar fashion, irony can (but need not) function to describe a situation. Suppose that the husband in the example had sarcastically described his evening at the restaurant as "really peaceful" to someone who had not witnessed the child's misbehavior. In this case the utterance not only conveys his irritation but also conveys the information, new to the person spoken to, that the child had been impossible at the restaurant. In brief, what metaphor *always* does, irony *may* do; likewise, what irony always does, metaphor may also do.

Metaphor and irony differ not only in primary function and intention but also in structure. At the heart of metaphor is the principle of *similarity*; at the heart of irony is the principle of *opposition*. In metaphor, the relation between what is said and what is meant is a relation of similarity in dissimilarity. The wife in the example says that a seam is coming unstitched to mean that her child's behavior is growing out of control. Seams on clothing and controls on behavior belong to very different categories but also bear some analogical relation to each other. In irony, the relation between what is said and meant is a relation of opposition between a positive and a negative tone. The husband says something positive (peaceful) to mean something critical (stressful).

To the extent that metaphor and irony are similar, the comprehension of each should call on the same kind of competence. And to the extent that these two forms of language differ significantly, understanding them should call on very different kinds of abilities. Below we develop some hypotheses about the similarities and differences between the processes of understanding metaphor and irony.

The Skills Needed to Understand Metaphor and Irony

To understand metaphor, it is necessary to understand both halves of the comparison. To understand what the wife in the example means, one must know about the function of stitching in keeping clothing together, and one must know that an individual's behavior can become disorganized, unreasonable, and uncontrolled. One must also be able to see the point of simili-

tude between the two referents being linked. If there is more than one point of similitude, the more points the hearer understands the fuller his understanding. To understand irony, it is necessary to understand the situation in which the ironic remark is made— i.e., that it is a situation of which a speaker might be critical—and that the particular speaker has reason to be critical of this situation and wants to convey this to his hearers.

Thus, understanding metaphor is primarily a logical-analytic task in which the hearer must recognize a match between two divergent aspects of experience. Understanding irony is essentially a social-analytic task, in which the hearer must recognize the speaker's attitudes.

We have postulated three steps in the comprehension of metaphor and irony:

1. *Detection of nonliteral intent.* At some level, whether consciously or not, the hearer must recognize that the utterance is nonliteral: he must realize that the speaker does not mean what he says and that the speaker means something very different from what he says.

2. *Detection of relation between what is said and meant.* The hearer must discover the relation between what is said (but not meant) and what is meant (but not said). If the utterance is a metaphor, the hearer must recognize that the stated proposition bears a relation of similarity to the implied proposition. If the utterance is ironic, the hearer must recognize that the stated proposition bears a relation of opposition to the implied one. As with step 1, this step need not be carried out at the level of conscious awareness.

3. *Detection of unstated meaning.* The hearer must infer the message that the speaker intends to convey, and he does this on the basis of the relation that he infers to exist between what is said and what is meant. If the relation is judged to be similarity, the hearer must imagine something similar to what the speaker refers to explicitly. The husband in the opening example must ask himself what in the given context could be similar to clothing coming unstitched. If the relation is judged to be opposition, the hearer must transform a positive evaluation into a critical one. The wife in the example must transform "peaceful" into something negative such as "stressful."

In our studies, we have examined how children understand metaphor and irony in order to determine whether the comprehension of these two forms of nonliteral language is a function of the same underlying ability or whether these two forms of language call on different kinds of competencies. We studied children rather than adults because we used comprehension errors as evidence for the types of difficulties that these two forms of language pose. Since adults do not ordinarily misunderstand metaphor and irony, they could not provide us with the kind of evidence we sought.

We hypothesized that the three steps described above pose different degrees of difficulty for children in the comprehension of metaphor and irony. For reasons to be explained, we expected steps 2 and 3 to be more difficult for metaphor than irony, and step 1 to be more difficult for irony than metaphor. Thus, we expected errors in understanding metaphor to occur at steps 2 and 3, and errors in understanding irony to occur at step 1. To the extent that metaphor and irony yield qualitatively different kinds of misunderstandings, we can conclude that different underlying competencies are used to understand these two forms of language. But to the extent that similar errors occur in the same steps, we must treat the comprehension of metaphor and the comprehension of irony as one and the same ability.

Step 1—the detection of nonliteral intent—should be easier for metaphor than irony because a metaphor taken literally makes a highly implausible statement. No reasonable person could think that the wife in the example really refers to stitched seams that are ripping. In contrast, irony makes a fairly plausible mistake or lie, two forms of *literal* falsehood. For example, the wife might think that the husband called the evening peaceful because he is absent-minded and has failed to notice the child's behavior. In this case the wife will think, among other things, that her husband is mistaken. Or the wife might think that her husband is lying. If her husband was the one who wanted to take the child in the first place, she might reason that he is trying to convince her that things are going smoothly even though he himself knows they are not.

In summary, a metaphor taken literally is very implausible; irony taken literally is less implausible. The degree of implausibility should serve as a warning not to take the utterance literally. Hence, the hearer is more likely to avoid a literal interpretation of metaphoric rather than ironic utterances.

Step 2—the detection of the relation between what is said and what is meant—should be easier for irony than metaphor. This is because in irony what is said always refers to what is going on. Thus, if one understands the situation and the statement, it is usually fairly clear that the statement is roughly the opposite in tone from what the situation calls for. In metaphor, what is said is not relevant, on the surface, to what is going on. Hence the hearer may be unable to discern any relation between what is said and meant; or he may infer some kind of relation that was not intended, such as *association*.

Step 3—the detection of the unstated meaning—should, like step 2, be easier for irony than metaphor. Given that the hearer realizes that the ironic speaker means something opposite in evaluative tone to what he says, there is little room left for misunderstanding. The hearer will then know that the speaker means something critical (even if he fails to judge

the precise degree of criticism the speaker intends). But in the case of metaphor, even if the hearer realizes that the speaker means to convey something similar to what he says, there is still a large space for misunderstanding to occur. For example, there are many things that can be likened to seams coming unstitched—not only unruly behavior but also an argument falling apart, faith destroyed, or something physical such as glass shattering. If the husband takes the wife to mean that the child's food is dripping out of her mouth, for instance, this would be an interpretation based on similarity but it would be the wrong interpretation in this case. Further, the husband may simply have no idea what the wife means. In response to a metaphor, the hearer can solve step 2 but remain stuck there, as if to say, "I know that she is referring to something similar to what she says, but I can't figure out what she is referring to."

Errors Children Make in Understanding Metaphor

In our initial studies, we asked children to make sense of psychological-physical metaphors—i.e., ones in which a psychological trait is illuminated by reference to a physical attribute of an object. For example, one could describe a person as a hard rock (signifying coldness), a tightly sealed envelope (signifying shyness), or a jagged piece of glass (signifying nastiness) (Winner, Rosenstiel, & Gardner, 1976; Winner, Wapner, Cicone, & Gardner, 1979). Our youngest subjects, six-year-olds, at times took these utterances as literally true, hence failing at step 1. Thus, a person who is a hard rock, we were told, really is made out of stone, perhaps because a witch cast a spell on him. But children seemed uncomfortable when they took our metaphors as true statements. It is likely that they simply did not know what to make of the utterances and hence fell back on a literal strategy, inventing a fairy-tale explanation. Interpretations of metaphors as literally true were rare, probably because such interpretations are so implausible. For similar reasons, we believe, children rarely took our metaphors as literal but false: a metaphor taken as an error or lie is simply bizarre.

Much more common among six-year-olds were errors based on inferring a relationship of association rather than similarity. A person who is a hard rock was said to be someone who works in a rocky prison; a person who is a tightly sealed envelope was someone who seals envelopes tightly. Such interpretations are evidence that the child has failed at step 2. Instead of inferring a relation of similarity, he has inferred a relation of association between what is said (hard rock) and what is referred to (person). Once again, however, we had the impression that children were not confident of these interpretations but offered them only because they were stumped and this was the best they could do.

Failures at step 3 were typical of eight-year-olds: children inferred something other than what was intended because they based their interpretation on a wrong kind of similarity. For instance, a hard person was someone with lots of muscles; a tightly sealed person was someone who kept his lips pressed together; and a jagged person had sharp teeth. In these examples, the children found something that was truly similar to what was mentioned. The problem was that they took the metaphor to be about something physically similar to the physical object mentioned in the sentence. Between eight and ten, children realized that the utterance referred to a psychological dimension of the person, but they sometimes inferred an incorrect psychological dimension. A hard person was said to be silly, a sealed person mean. In these paraphrases, the children found something that was not truly similar to the physical property mentioned in the sentence. A physically hard object and a silly person are not quite an appropriate match. Yet *silly* is not totally off either, since it is a negative characteristic, as is the intended one of heartlessness or lack of feeling. In these incorrect psychological interpretations, the child has made the wrong match to the right domain. In the previous physical interpretations, the child has made an appropriate match but to the wrong domain. By ten, errors of any kind were rare.

If failure between ages eight and ten is most common at step 3, ought we to conclude that misunderstanding metaphor is due to some fundamental inability to perceive the kinds of nonsensory similarities on which such metaphors are based? We do not believe so. There is ample evidence that children have the capacity to perceive any kind of similarity, providing of course that they are familiar with the elements being linked. Even infants can perceive similarities as nonsensory as those on which psychological-physical metaphors are based. For example, they can detect the similarity between bright colors and loud sounds (Lewkowitz & Turkewicz, 1980), and they can detect a similarity between a static dotted line and an intermittent sound, and a continuous line and a continuous sound (Wagner, Winner, Cicchetti, & Gardner, 1981). Evidence from language acquisition also attests to the early ability to perceive nonsensory similarities. It is well known that children often apply words too broadly when they are first learning language (Anglin, 1977; Clark, 1973, 1983; Nelson, 1974). The bases of these overgeneralizations are often nonsensory similarities. For example, one child used "too tight" for anything unpleasant done to her such as having her ears washed (Bowerman, 1977); another used "uh-oh" for anything that was unexpected or needed to be rectified, including a broken cookie, a diaper that needed to be changed, and a cup that had rolled out of reach (Winner, unpublished observations).

If misunderstanding metaphors at step 3 cannot be attributed to an inability to perceive the underlying similarities, can it be attributed to a

lack of familiarity with one (or both) of the halves of the comparison? After all, if a child does not know about unfeeling people, how can he understand what it means to call a person "hard"? We believe that this is the crux of the problem. The child offers a physical interpretation of a psychological-physical metaphor, or he misaligns the physical and the psychological, because he does not yet have an articulated knowledge of the psychological trait in question. When the child links two physical objects (e.g., hard rock, tough muscles), he does so correctly; but when the child links a physical object to a psychological trait (e.g., hard rock, silly person), he does so incorrectly. The child must have a richer knowledge of what unfeeling people are like to be able to go correctly from hard rock to unfeeling. Thus, the problem for children is not that they lack the ability to discover the similitude between the two halves of the comparison, but rather that they often lack full enough knowledge of one of the halves of the comparison. Hence, children often have less trouble in understaning sensory metaphors in which two physical elements are compared than in understanding psychological-physical metaphors in which a psychological trait is described (Gentner & Stuart, 1983; Shantiris, 1983; Winner, in preparation).

Errors Children Make in Understanding Irony

In more recent work, we have asked children to make sense of simple ironic utterances spoken in sarcastic intonation. In one of our studies, children heard a story about a boy named Jay who had just received an unflattering haircut. As he leaves the barbershop, he sees his friend Mike, who snickers and says, in mocking intonation, "Your haircut looks terrific" (Demorest, Meyer, Phelps, Gardner, & Winner, 1984). We asked children three questions to assess their understanding: (1) Was the haircut good or bad? (a question about the truth of the utterance); (2) Did Mike think it was good or bad? (a question about the speaker's attitude); (3) What did Mike want Jay to think about his haircut? Did he want him to think it was good or bad? (a question about the speaker's intentions toward the listener).

In general, the errors children made occurred at step 1. Six-year-olds sometimes simply took the ironic utterances as literally true. Or they recognized the utterances to be false but failed to recognize the speaker's actual attitudes (and hence took the utterances as literally intended but wrong). Nine- and even thirteen-year-olds recognized the utterances as false and realized that the speaker did not believe what he said—and hence detected the speaker's critical attitude. Their problem was with the speaker's intention. They took the utterances as lies—false, known to be false by the speaker, but intended to be taken as literally true. The children

explained that Mike wanted to make Jay feel better about his haircut and hence were telling us that Mike had uttered a white lie.

As checks, we also included utterances that were in fact lies (Mike says that the haircut is terrific using a sincere tone of voice) and utterances that were false but spoken in flat intonation so that they could be either deceptive or ironic. We found that children had little trouble with the lies. And the flatly spoken utterances were much more likely to be taken as lies than as instances of irony. This latter finding suggests a bias in the child's tacit expectations about behavior: children seem to expect people to say X to *hide* Not-X, but not to say X to *mean* Not-X. Perhaps this is because the *motivation* to say X to mean Not-X is not clear to the child.

Thus, children may take irony as deception because the motive to lie makes more sense to them than the motive to be ironic. A second reason why children take irony as deception may be that when literal content and paralinguistic cues conflict, as they do in irony, children pay less attention to the cues (such as intonation) and more to the words themselves. This conforms with Greene's (1982) finding that, given a message whose content conflicts with the speaker's intonation and facial expression, children attend more to the literal content than the paralinguistic cues. When we asked children to justify their interpretations, children mentioned the paralinguistic cues of intonation and behavior only when they had correctly understood the irony. When they had misunderstood it, they appealed only to the literal words. Thus, when children realized that Mike wanted Jay to know that his haircut was bad, they justified this by referring to *how* Mike spoke; but when children wrongly thought that Mike did not want Jay to realize that the cut was bad, they justified this by saying that Mike *said* the cut was good.

Although in our studies six-, nine-, and even thirteen-year-olds took irony as deception, there is also some evidence that even six-year-olds can tell the difference between irony and deception. We timed how long it took six-year-olds to decide whether a speaker was making a mistake, telling a lie, or teasing (the term we used for irony) (Winner, Erwin, Joyce, & Kennedy, in preparation). Children took considerably longer (an average of 0.9 seconds) to decide that an ironic utterance was a lie than to decide that a lie was a lie (0.2 seconds, on average). Thus, children at some level apparently discern the difference between ironic and deceptive utterances even though they call both such utterances by the same name.

(Note that when irony is taken as a lie, it is not always taken as a white lie. Children take irony as a white lie only when the victim of the irony has performed inadequately [e.g., he has tripped, belly-flopped, looks terrible, etc.]. But when the victim of the irony has been nasty, children do not perceive the irony addressed to this person as a white lie. For example, in one of our items a child deliberately threw sand in his playmate's face

at the beach. The victim of this attack said, "That was a really nice thing to do." Although children took this remark as a lie, they were unable to explain its motivation [Winner et al., in preparation]. Hence, children take irony as a white lie only when there is a plausible motivation for the speaker to utter a white lie.)

We decided to test directly our claim about the differences in the comprehension of metaphor and irony. That is, we wanted to determine whether in fact irony comprehension is most likely to fail at step 1 (with children taking irony as literally false—as either lie or error), while metaphor comprehension is most likely to break down at step 3 (with children taking metaphor nonliterally but inferring the wrong meaning). We asked six- and eight-year-olds to make sense of utterances which in one context were interpretable as metaphors ("There sure isn't any pepper in the soup," said about two children too tired to play) and in another context were interpretable as irony (the same utterance said after a customer at a restaurant was served soup with pepper after he had specifically requested no pepper) (Andrews, Rosenblatt, Malkus, Gardner, & Winner, in press). We asked children about the speaker's intent (i.e., was he making a mistake, telling a lie, teasing, or saying something in a different way?). We also asked children about the speaker's meaning through multiple choices (e.g., for the metaphoric usage, above, the correct choice was "The children weren't excited"; for the ironic usage, "There was pepper in the soup").

As we predicted, we found that irony was often taken as a literal falsehood (a step-1 error). In contrast, children realized that the metaphors were a way of "saying something in a different way" probably because the metaphors were highly implausible as errors or lies. We also found for metaphors a disjunction between understanding the speaker's intent and understanding his meaning. This did not occur for irony. In the case of irony, once children realized the speaker was teasing, they understood the speaker's meaning. That is, once they made it past step 1, they solved steps 2 and 3. For metaphor, even six-year-olds realized the speaker was talking in a different way, but they often remained confused about the speaker's meaning. Thus, they succeeded at step 1 but failed at steps 2 and 3.

This study confirms our hypothesis that for irony the problem is in detecting the nonliteral intent—the reason for uttering a falsehood. Hence, the problem is to avoid taking the utterance as an error or a lie. For metaphor, it is easy to detect the nonliteral intent (because metaphors are irrelevant to the context and hence make implausible lies and errors). Instead, for metaphor the problem inheres in determining the relation between what is said and what is meant (similarity) and, even once this is determined, in finding the intended meaning. Thus, for children, detecting that there is a divergence between what is said and what is meant is more difficult for irony than for metaphor. But once recognized, it is easier to grasp

what is meant for irony than for metaphor.

There is some evidence that six-year-olds grasp what is meant in irony even *before* they note (or can reproduce) the distinction between what is said and what is meant. In one study (Rosenblatt, Winner, Kaplan, Levy, & Gardner, in preparation), we modelled irony for six- and eight-year-olds using two characters (shown in pictures). One character, the victim, boasted and then failed to live up to his boast. The other character (named Max) commented ironically to the boaster. For instance, in one situation, the victim boasted, "I'm the strongest kid in the class." He then proceeded to drop a tray of milk cartons. Max comments, "Yeah, you're real strong." We then read children stories in which a character boasts unjustifiably and asked children to complete the stories the way Max would have.

Six-year-olds offered literal criticisms (e.g., to a diver who belly-flopped after saying he was a great diver, "You really can't dive well at all"). This suggests that these children grasped the underlying negative meaning of the irony we modelled through Max. Either they ignored the sentence meaning and perceived only the inferred speaker's meaning, or they recognized both meanings but could not reproduce the linguistic structure of irony, in which the overt sentence meaning clashes with the speaker's implied meaning.

One might argue that if children grasp the underlying negative meaning of an ironic remark, they understand the irony. But this contention cannot be upheld. Critical to understanding nonliteral language is an awareness of the utterance as a different form of language, one in which the speaker says something that must be discounted (Olson, in press). If all one perceives is the speaker's meaning, nonliteral language is not experienced as different from literal language. This kind of comprehension occurs with overused metaphors, such as *leg* of a table, in which we do not notice the literal meaning of *leg* and hence do not notice that the word is used metaphorically. It also occurs with overused forms of irony, such as "Thanks loads." Six-year-olds may be responding to simple forms of irony in this way. It is only when children can understand the speaker's meaning in nonoverused forms of irony that we can credit them with the ability to understand irony.

Why Don't We Just Say What We Mean?

It is clear why we use metaphor instead of literal speech. Sometimes a metaphor is the *only* way to illuminate what we mean. But sometimes it is not the only way, and one could say what one means using only literal language. However, to the extent that a metaphor can be explicated in literal language, the metaphor's payoff is in parsimony and impact. Thus, even when it is possible to paraphrase a metaphor fully, to do so is much

less vivid and much more belabored than to use the metaphor (Ortony, 1975).

It is far less clear why we would ever favor irony over literal usage. Why not just convey our negative evaluation directly? To determine why people think we use irony, we have asked children and adults to compare the motives and effects of ironic utterances and their literal equivalents (e.g., "You sure are smart" vs. "You sure are dumb" said to someone who just flunked a test).

We have found that irony is perceived as *less* critical than a literal paraphrase. Irony is indirect and is therefore less confrontative. Irony also allows the possibility of saving face on the part of the listener and the speaker, both of whom can pretend that the literal, positive meaning was intended (Kaplan, Rosenblatt, & Winner, in preparation). We have also found that irony helps to define the image of the speaker. Speakers who use irony are perceived as more unflappable than those who express their irritation directly. The ironist is seen as able to maintain his distance in situations in which others might "lose their cool" (Winner, Gilligan, & Labore, in preparation).

We have argued here that metaphor and irony are the two chief ways that language is used nonliterally. While these two forms of usage are alike in being nonliteral, they seem to differ enough in function and in structure that their comprehension requires different kinds of abilities. For metaphor, the critical problem is to come up with a correct interpretation of an utterance recognized to be nonliteral. To do so, the hearer must find the right connection. For irony, the critical problem is to recognize the utterance as nonliteral. To do so, the hearer must discover the speaker's private attitudes and the intention behind the utterance.

Metaphor and irony may be manifestations of a more fundamental nonlinguistic distinction. Metaphor may reflect a focus on the external world, the attributes of things, what they are like; irony may reflect a focus on the subjective world, one's attitude toward the attributes of things in the world. One can talk about attributes and attitudes using literal language, but it is the particular genius of metaphor to inform vividly about unexpected and unappreciated attributes, and that of irony to inform subtly and memorably about attitudes.

Because metaphor and irony are so central to literature, children may often miss the point of a poem or story. They may recognize a metaphor as an attempt to describe how something really is but not know what is meant; they may take characters' ironic dialogue as deceptive or mistaken; and they may miss an author's ironic voice altogether. Teachers of literature need to be sensitive to the specific kinds of problems children have with metaphor and irony in order to steer children toward appropriate interpretations of these major forms of nonliteral language.

REFERENCES

Anglin, J. (1977). *Word, object, and conceptual development*. New York: Norton.
Andrews, J., Rosenblatt, E., Malkus, U., Gardner, H., & Winner, E. (in press). Children's abilities to distinguish metaphoric and ironic utterances from mistakes and lies. *Communication and Cognition*.
Bowerman, M. (1977). The acquisition of word meaning: An investigation of some current concepts. In P. Johnson-Laird & P. Wason (Eds.), *Thinking*. Cambridge, England: Cambridge University Press.
Clark, E. (1973). What's in a word? On the child's acquisition of semantics in his first language. In T. E. Moore (Ed.), *Cognitive development and the acquisition of language*. New York: Academic Press.
Clark, E. (1983). Meanings and concepts. In J. Flavell & E. Markman (Eds.), *Handbook of child psychology*, vol. 3, *Cognitive development*. New York: Wiley.
Demorest, A., Meyer, C., Phelps, E., Gardner, H., & Winner, E. (1984). Words speak louder than actions: Understanding deliberately false remarks. *Child Development*, *55*, 1527-1534.
Gentner, D., & Stuart, P. (1983). Metaphor as structure mapping: What develops. Paper presented at Society for Research in Child Development, Detroit.
Greene, R. (1982). Now you mean it—now you don't: An exploratory study of children's sensitivity to consistent and discrepant message meaning. Paper presented at annual meeting of Boston University Language Development Conference, October.
Kaplan, J., Rosenblatt, E., & Winner, E. (in preparation). Sensitivity to the motivation behind irony.
Lewkowicz, D., & Turkewitz, G. (1980). Cross-modal equivalence in early infancy: Auditory-visual intensity matching. *Developmental Psychology*, *16*, 597-607.
Nelson, K. (1974). Concept, word and sentence: Interrelations in acquisition and development. *Psychological Review*, *81*, 267-285.
Olson, D. (in press). Or what's a metaphor? *Metaphor and Symbolic Activity*.
Ortony, A. (1975). Why metaphors are necessary and not just nice. *Educational Theory*, *25*(1), 45-53.
Rosenblatt, E., Winner, E., Kaplan, J., Levy, J., & Gardner, H. (in preparation). Children's productions of ironic utterances after modelling.
Shantiris, K. (1983). Developmental changes in metaphor comprehension: It's not all uphill. Paper presented at Society for Research in Child Development, Detroit.
Turbayne, C. (1970). *The myth of metaphor*. Columbia, South Carolina: University of South Carolina Press. Revised edition.
Wagner, S., Winner, E., Cicchetti, D., & Gardner, H. (1981). "Metaphorical" mapping in human infants. *Child Development*, *52*, 728-731.
Winner, E. (in preparation). *The point of words: Children's understanding of metaphor and irony*. Cambridge: Harvard University Press.
Winner, E., Erwin, S., Joyce, M., & Kennedy, K. (in preparation). The role of identification in children's understanding of irony.
Winner, E., Gilligan, K., & Labore, M. (in preparation). Adults' perceptions of the social effects of irony.
Winner, E., Rosenstiel, A., & Gardner, H. (1976). The development of metaphoric understanding. *Developmental Psychology*, *12*, 289-297.
Winner, E., Wapner, W., Cicone, M., & Gardner, H. (1979). Measures of metaphor. *New Directions for Child Development*, *6*, 67-75.

"Happy Birthday": Evidence for Conflicts of Perceptual Knowledge and Conceptual Understanding

LYLE DAVIDSON, LARRY SCRIPP, and PATRICIA WELSH

Just as we don't expect children to be able to read or add without knowing numbers or words, we don't expect a high level of musical performance without some experience with musical notation. But our own experimental investigations have turned this expectation upside down. We have discovered that untrained children and adults can use their performance knowledge of well-known songs to make surprisingly rich notations. In contrast, many music students make surprisingly inaccurate notations of simple tunes. We argue here that the type of training students receive (whether strongly perceptual or conceptual in orientation) makes a significant difference in their ability to represent their musical knowledge accurately.

We chose as the musical focus of our study two of the first songs children learn to sing, "Row, Row, Row Your Boat" and "Happy Birthday." These songs make ideal probes with which to explore the relationship of performance to representation. By the age of six or seven, everyone sings these songs very well. Only when we asked individuals to make a drawing, representation, or notation of the song did we begin to see differences between performance knowledge and knowledge reflected through notation. We asked over four hundred children, adolescents, and adults to make representations of these songs. Roughly half of the participants had no musical training; the rest had at least four years of private lessons, some ensemble experience, and one year of some type of class instruction in music theory.

Musical Representation without Training

Between the ages of five to seven children invent increasingly effective ways of representing many features of a song. Their notations capture the structure, the number of notes, the pulse and grouping of the song's rhythm, as well as information about its contour and the relative height

of the notes of the melody (Davidson & Scripp, 1986).

Children's comments while making their notations show that they draw on their perception of their performance, not on a concept of musical norms. For example, when asked to explain her notation of "Row, Row, Row Your Boat" (see fig. 1), Janet says, "The long lines show low notes and the short lines show high notes." She is able to demonstrate what she knows about her performance in her notation. After representing her performance of the song, she sings it back and then discovers that the first and last phrases are the same, "The last part [pointing to the last phrase] is the same as the first part [pointing to the first phrase], they're twins!"

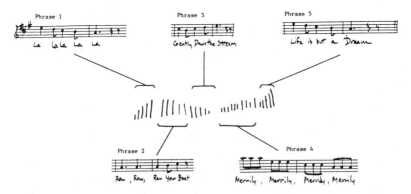

Fig. 1. Notation of "Row, Row, Row Your Boat" by a musically untrained seven-year-old showing many musical dimensions.

These early notations are important because they show *enactive reflection*, i.e., the ability to reflect on performance knowledge. In making a notation of a song, a child attends to her performance of the song in a new way. It becomes the occasion of reflection and analysis. She transforms her musical performance into a notated object, and this process enables her to attend to the music in a different way.

Surprisingly, we find that when notating "Happy Birthday," ten-year-olds and untrained adults make notations comparable in every way to those of the seven-year-old writing down "Row, Row, Row Your Boat" (see figs. 2 and 3). Using symbols similar to those of young children, adults without formal musical training are not able to represent any more of their performance than are children. Knowing that notational development reaches a plateau around the age of seven or eight, we can better assess the effect of subsequent musical education and training.

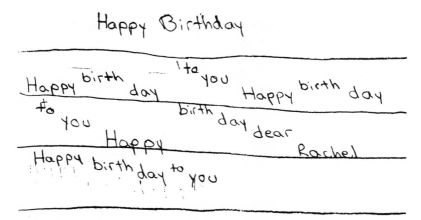

Fig. 2. Typical notation of "Happy Birthday" by a musically untrained ten-year-old.

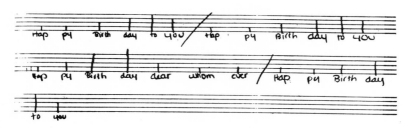

Fig. 3. Typical notation of "Happy Birthday" by a musically untrained nineteen-year-old comparable to children's notations (figs. 1 and 2).

Musical Representation and Training

In order to investigate the effect of one current type of training on musical representations, we asked groups of musically trained subjects—twelve-, fifteen-, and eighteen-year-olds—to sing and then notate "Happy Birthday." Their training consisted of extensive private instrumental instruction plus music theory classes primarily focusing on terminology, analysis, and written exercises.

When asked to read what they wrote, the music students sang the tune correctly, regardless of what they had written. Most students were extremely curious to know how their notations sounded when played by another. Very few were prepared for the shocking results of their efforts

as a disturbingly high percentage were inaccurate (over 90 percent). Curiously, in all cases they were able to perceive errors easily only when the notations were played back. Although these students possess advanced performance ability and use musical symbols in their practice, they are unable to integrate their perception of the graphic symbols and their vocal performance of the tune.

Why are musically untrained children and adults able to invent notations which show so many musical properties of the song, while musically trained individuals, using the standard music notation system, are able to show so little more? One important reason for the relatively small effect produced by training may lie in differences between invented notation systems and conventional formal systems. While the purpose and rules of the invented notation are defined by the inventor, the conventional system is adopted as a whole by the trained musician. Furthermore, the end-states of invented notations are self-defined, i.e., defined by the individual inventing the notation. This means that each field of reference in a notation is shaped into its presented form. In sharp contrast, in the conventional music notation system all the elements are given, and their coordination is highly rule bound. Thus, conventional notation may contain more information than the user of the system can control. The user of that system must operate within it to the best of his or her abilities.

The importance of the difference between the two notational approaches is highlighted by music students' observations about their experience of inventing a notation. For example, "This side [conventional notation] was easier to do because I have trouble *conceiving* written music without staff and notation. I think the other side [invented notation] is more accurate as to what goes through my mind *when I hear the music.*" In particular, a music student, who made both an invented and a standard notation of the tune, said that "the second [conventional notation] was easier to write, because I noticed a lot of things that I didn't notice when I wrote the other one. I think the second one was more accurate" (see fig. 4). When inventing the first notation, this student accurately represented the melodic contour. However, errors made in the process of specifying the exact pitches of the melody (when making the conventional notation) resulted in his going back and changing the contour of his more accurate invented notation (see figs. 4 and 5). Another student explains, "I think the actual music notation on the staff is more accurate, because on this one [the invented notation] you have to guess the intervals. But *this* one [the invented notation] is easier to do because you don't have to figure that exact intervals and can do it *just the way it sounds.*"

Finally, it appears that knowledge of musical practice, gained primarily through study of an instrument using conventional notation, produces a surprisingly limited understanding of musical representation. Why does

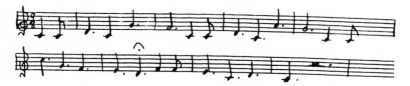

Fig. 4. Conventional notation used by musically trained subjects with errors in the final phrase (first and last notes are the same).

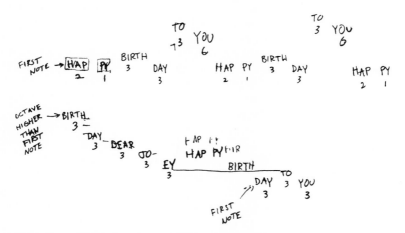

Fig. 5. Invented notation of "Happy Birthday" by the same subject (see Fig. 4) edited after making the conventional notation (similarly making first and last note the same).

instrumental training not produce a more dramatic increase in notational ability? The lessons learned by studying an instrument appear not to transfer to notation, particularly with regard to pitch. The study of an instrument often involves using the notation system to indicate when and where to put fingers on the string, the keyboard, and so forth. This does not build an internal representation system which can be used independently of the instrument. Evidently, it requires some program of ear training to develop the necessary skill to write out even simple songs correctly with the conventional music notation system.

Why might this be the case? Although perception usually leads production in most domains, David Olson (1970) suggests that at certain periods of development, changes and refinements in perception of an object occur as the result of working with the object. For example, he finds that chil-

dren's ability to draw (i.e., produce) a diagonal affects children's ability to perceive the diagonal in a drawing. In other words, in this case, production is a requirement of perception, drawing the diagonal becomes a central part of perceiving the diagonal. This sequence is like that in music, where additional musical training of a specific nature is required in order to reduce the distances among performance, perception, and conceptual understanding of music. Unlike Janet (fig. 1), these music students are unable to demonstrate what they know from their performance of the song in their notation.

Writing What We Hear vs. Writing What We Know

A comparison of music students' performances and notations reveals a conflict between what they perceive and what they know. As we saw previously (fig. 4), Jack distorted the last phrase of the song in order to represent what he knew about simple songs—that they usually begin and end on the same pitch. When he revised his previous (invented) notation—which originally more faithfully mapped the contour of the phrases (fig. 5)—he altered his notation to reflect that part of what he knew.

Looking across three different groups of music students (average age twelve, fifteen, and eighteen) we see the conflict between perception and conception becoming more severe as they get older. The youngest students make pitch errors because they misjudge interval distances they are attending to in the melody. The oldest students make pitch errors because they subjugate their perception of interval distances in favor of their knowledge of how songs begin and end (figs. 4 and 6). Additionally, they fail to integrate performance knowledge of the song into their representation. Every music student knew the song equally well. However, when they were forced to reflect on their understanding of the song in the act of representing their performance knowledge on paper, the oldest students drew information from a concept or theory of how songs end, not from their perception of how this specific song ends.

Fig. 6. Typical example of concept-driven error (that songs begin and end on same pitch) by musically trained student.

The conceptual source of the notation, or the top-down model which informs the choices of what to represent, appears to "deafen" the ear to the actual shape of the specific song. It is as though the conceptual knowledge clouds or overrides the ability to recognize the elements of patterns.

Thus, the final image produced reflects a general understanding of music, rather than perception of the specific musical shape. We will call the error produced when the conceptual understanding misleads the perceptual grasp a *concept-driven* error. *Percept-driven* errors occur, for example, when an interval distance or a duration is misjudged without distorting the boundaries of the basic shape of the melody.

This predilection to represent what we "know" rather than what we perceive is not unique to music (Carmichael, Hogan, & Walter, 1932). While cognitive psychologists report that children's early drawings reflect stages of intellectual growth (Piaget & Inhelder, 1969) and reveal "what children know about what they perceive," art teachers are concerned that intellectual development in other domains might interfere with visual perception and development in drawing (Edwards, 1979). Edwards asserts most adults do not perceive "in the special way required for drawing" as they superficially "take note of what's there" and "quickly translate the perception into . . . what they know about the perceived object" (p. 78).

What some arts teachers do to resolve this conflict in drawing is to structure ways of drawing objects which purposely bypass verbal or conceptual frameworks. For instance, by copying an image upside-down, students are more likely to cast off what they think they see and draw things as they really look (Edwards, 1979). In a manner reminiscent of notating the shape of melodies from one's perception of the notes themselves, other art teachers suggest a technique called "pure contour drawing" which focuses on observing and drawing the topological edges of what you see without monitoring the drawing itself (Nicolaides, 1941). In notating a song as in drawing, the power of conceptual understanding and the force of perceptual knowledge must be held in balance in order to allow the generation of an accurate representation.

In summary, it appears that in music one can isolate three phases in the process which leads the novice to mastery of the conventional notation system. First, there is an initial thrust of invented *enactive reflective* notations in which perception develops along with musical development without training. This rapid development quickly becomes stable and does not change with age. Second, with training, we find young music students making errors which are based on misjudged intervals and distances between notes (*percept-driven* errors). Third, we find entering conservatory freshmen experiencing difficulty using the standard notational sytem with accuracy, as theory increasingly directs and distorts perception (*concept-driven* error).

During the third phase, students become very frustrated as they waffle between perceptually driven and conceptually driven notations. This conflict may be a part of the "crisis" which Bamberger (1982) documents in her study of young musicians. In her words, "What before were relations

that were simply heard, become notes in search of connections" (p. 62). Is this crisis inevitable?

Thus far, we have considered notational development within one type of musical training—private instrumental instruction and music theory classes primarily focusing on terminology, analysis, and written exercises. To determine the extent to which notational accuracy in rhythm, pitch, or the error types might be dependent on a specific training program, we looked at another trained group of music students whose theoretical instruction focused exclusively on learning to sing conventional notation at sight. While this new group of music students received the same type of instrumental training as our previous groups, they were engaged in a qualitatively different approach to music outside of their instrument.

Significantly, this new group of music students do not go through the third phase of development which we observed in the other music students. Compared to the first group of music students, these students' notations simply become more accurate. The few errors which they make are *percept-driven* errors. For example, in figure 7, although there is an error of pitch (see the first note of last phrase), the student does not abandon her perception that the last note of the song is higher than the first note.

Fig. 7. Typical example of percept-driven error by musically trained student.

As they get older, students notate pitch more accurately, make fewer false assumptions about meter, and are less apt to distort durations or ignore the placement of correct durations within false meters. In terms of pitch errors, the tendency to distort the third or fourth phrases toward a false final note (a *concept-driven* error) is practically nonexistent, a tendency disturbingly predominate with the oldest music students of the previous group (fig. 6).

Conclusion

Musicians, educators, and psychologists all seek a better understanding of the relationship between the development of the musical ear and the musical mind. Nadia Boulanger, perhaps the most famous pedagogue of this century, often voiced concern over the integration of musical perceptual and representational development. In her words,

The ear is everything. We must give children tones, pitch recognition, as we give them the words of language or the symbols of mathemat-

ics. And we must begin early. Americans often do not begin serious study of music until college age. In music, never is ear training started early enough. All children can be given an accurate ear whether or not they become musicians. (Brown, 1982, p. 50)

Viewing the development of musical representation we observe how musical "hearing" may or may not be integrated with musical knowledge. By asking both trained and untrained children and adults to make notations of familiar songs ("Row, Row, Row Your Boat" and "Happy Birthday") we better understand the interaction of development and formal training. Analyzing their notations we find three levels. On the first level musically untrained children and adults invent *enactive reflective* notations to show their perception of musical dimensions. Untrained seven-year-olds and college sophomores construct surprisingly comparable representations of familiar songs. The second and third levels rely on musical training and conventional notation.

It appears that a consistent and discrete notational system is essential for constructing a richer understanding of the dimensions of music. However, it is up to educators to make sure the symbol system of the domain is not taught in isolation of perception. At the beginning of notational practice, making invented notations is very useful. Such notational tasks do not require a student to represent more than he knows, and, as we have seen with young children, the discovery of musical relationships can occur spontaneously during the process of making a representation. On the other hand, when conventional notation is introduced too early, the advantages of a conventional notation system may be outweighed by certain disadvantages—one is forced to make choices beyond one's competence and may do so in contradiction to his perception.

In conclusion, our research shows that the trajectory of development leading to mastery of music notation does not under ordinary circumstances take a straight path. Different understandings support different kinds of notational errors. Without specific attention to encoding and decoding the elements of music and the notational system, notational ability does not simply "get better." Different programs of musical training in notation produce significantly different levels of notational development. Those students trained to sight-read music notation without their instrument "in hand" appear to have developed a more precise, perceptually driven understanding of music. It appears this group fulfills the promise of the rapid musical development of untrained children between the ages of five to seven: that is, they continue to draw on their perceptual knowledge when making notations of music, without being sidetracked by unintegrated conceptual understanding.

These findings also may shed light on a crisis in musical development reported by educators and psychologists in the arts (Bamberger, 1982).

Having to make transcriptions and take dictation can produce conflicts between what a student hears and what a student knows. This conflict can seriously undermine the student's self-confidence. It appears that early intensive and extensive instruction in a program which features the integration of the symbol sytem with musical perception is perhaps the best means for avoiding this "crisis" in musical development. Understanding the three phases of mastering music notation allows us better to comprehend the complexity of education in the arts—where we seek to integrate musical perception into our developing conceptual understanding of music.

REFERENCES

Bamberger, J. (1982). Growing up prodigies: The midlife crisis. In D. Feldman (Ed.). *New directions for child development: Developmental approaches to giftedness and creativity*, No. 17. San Francisco: Jossey-Bass.
Brown, Bruce C. (1982). Leçon de musique avec Nadia Boulanger. *Music Educators Journal, 69,* 49-51.
Carmichael, L., Hogan, H. P., & Walter, A. A. (1932). An experimental study of the effect of language on the reproduction of visually perceived forms. *Journal of Experimental Psychology, 15,* 73-86.
Davidson, L., & Scripp, L. (1986). Young children's musical representations: Windows on music cognition. In J. Sloboda (Ed.), *Generative processes in music.* New York: Oxford University Press, forthcoming.
Edwards, B. (1979). *Drawing on the right side of the brain.* Los Angeles: J. P. Tarcher.
Olson, D. (1970). *Cognitive development: The child's acquisition of diagonality.* New York: Academic Press.
Nicolaides, K. (1941). *The natural way to draw.* Boston: Houghton Mifflin.
Piaget, J., & Inhelder, B. (1969). *The psychology of the child.* New York: Basic Books.

The authors wish to thank all those who generously allowed us to look over their shoulders while they made notations of songs: students of Hayes Elementary School, Lakewood, Ohio; Boston College, Brighton, Mass.; the Preparatory and College divisions at the New England Conservatory, Boston; and the Longy School of Music, Cambridge, Mass. The project would have not been completed had it not been for the encouragement and assistance of many others, especially Howard Gardner, Joan Meyaard, David Perkins, and Joseph Walters.

Discerning Musical Development: Using Computers to Discover What We Know

LARRY SCRIPP, JOAN MEYAARD, and LYLE DAVIDSON

Hardly a day goes by that we aren't exposed to music of some sort: on the radio, television, or stereo, in stores, churches, restaurants, subway stations. And even when there is no music actually playing, we are apt to produce our own, humming or singing to ourselves or simply listening internally to some "tune I just can't get out of my head." We grow up listening to music, but, without more explicit musical training, do we actually grow in our ability to understand and express musical knowledge?

Psychologists of music have been investigating the issue of whether exposure leads to better understanding. In the presence of formal music instruction, musical growth is generally easy to predict and easily measured. Musical development does not prove as readily apparent, however, in individuals who have not been explicitly trained. Although we might intuitively presume adults capable of demonstrating increased musical understanding beyond that of comparably untrained children, such a pattern has in fact been very difficult to confirm. Indeed, until now the general consensus has pointed to a leveling off of musical development beyond the age of seven or eight (Gardner, 1973; Winner, 1982).

In order to demonstrate musical understanding, one must either be able to represent that information accurately (in notation or in performance) or demonstrate accurate musical discrimination in the perception of musical information. A number of studies have found musical development without musical training to be quite rapid in these areas in young children. For example, researchers in the areas of melodic perception (Dowling, 1982; Dowling & Harwood, 1986), performance of familiar and spontaneous song (Davidson, 1985; McKernon, 1979), and the representation of simple rhythms and familiar songs (Bamberger, 1980, 1982; Davidson & Scripp, in press) all report dramatic development with young children (ages six months to nine years old). Yet without formal musical training there is little to suggest that additional musical development occurs in adolescence or adulthood.

This has been confirmed in our own recent work at Project Zero. Untrained children and adults were asked to write down the familiar tune "Happy Birthday to You," allowing us to see how they understand the most musically salient features of the melody—its phrase structure, rhythmic grouping, and melodic contour. Looking at their invented notations (see figure 1) we see that adults and young children express a surprisingly comparable understanding of the rhythmic and melodic features of the song (see Davidson, Scripp, & Welsh elsewhere in this volume).

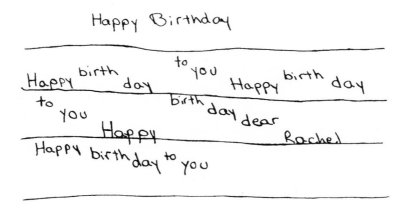

Fig. 1. Typical invented notations of the tune "Happy Birthday" by an untrained ten-year-old (above) and untrained adult (below).

Is it true that musical development peaks sometime in childhood, or have the measures simply failed to capture the full range of possible expressions for such development? Perhaps these tasks do not present a sufficiently rich or challenging environment for potential differences to appear. Traditionally, music psychologists have been reluctant to pose richer musical tasks such as musical composition to individuals who lack explicit musical training. However, it may only be the lack of a discrete or consistent notational system and the means of verifying the sonic results of such a system that effectively impedes the untrained individual's entrance to the musical domain in other than a superficial manner.

The Computer as a Possible Solution

With the advent of commercially available "note processing" software for microcomputers, these problems can begin to be addressed. The new software allows entry into the domain of music composition without prior training in musical performance or music notation. The computer screen becomes an *interactive* musical environment where the musical novice can manipulate standard music notation symbols and effortlessly monitor the resulting performance. By allowing users to explore the discrete and consistent musical symbol system linked with accurate performances of the notation, the computer offers untrained individuals a new arena for demonstrating their musical knowledge in music composition.

Introducing microcomputers and software for music composition into an investigation of musical development affords researchers new latitude in the examination of musical processes. The challenges of such an investigation prove as substantial as our research agenda. Specifically we wish to consider:

- Can a single measure of compositional ability prove engaging and understandable to musically untrained children and adults and simultaneously be nontrivial and informative for musically trained individuals?
- How useful is the computer for the musically untrained individual? Is it easy to use? To what extent can computer assistance in the representation and playback of musical information compensate the novice to the degree of the expert?
- How does the computer's unique integration of musical symbol and sound contribute to the understanding of the musical novice? What can novices learn about music through their interaction with a discrete and consistent representation of musical notation?
- What further support can the computer afford beyond assistance with the representation and performance of musical notation? Does this additional support engender further musical development?

- Can the computer assist researchers in identifying the *processes* involved in music composition? And if so, will these processes vary with problems which present varying degrees of novelty or challenge?

With the aid of the computer, the world of music composition can be approached by children and adults, trained or not in the intricacies of musical notation or a musical instrument. By posing interesting and challenging problems, we can now see musical novices, as well as musical experts, engage in compositional "problem-solving" tasks. As a result, computers allow us to view musical development independently of the various facets of musical training.

The Task: Harmonizing a Familiar Tune

In designing composition tasks we wanted to pose problems to our subjects which were simple enough to allow for easy comprehension of the task at hand. At the same time, we sought to elicit the nontrivial and "rich" interaction with the real musical domain we felt was lacking in many of the previous studies of musical development. A perfect model for such a task was available in the standard musical literature. As an adult, Mozart wrote the familiar tune "Twinkle, Twinkle, Little Star" with a single line of harmonic accompaniment. Mozart then used this deceptively simple little theme as the genesis for a number of harmonic and melodic variations, running the gamut of musical complexity. In a similar manner, our tasks also exploit the generative characteristics of this familiar tune.

We asked a variety of individuals to complete two simple composition tasks using the Macintosh computer and MusicWorks (Macromind) music notation software. Included were four groups of subjects: adolescents and adults without musical training and adolescents and adults with musical training. Before beginning, each individual was introduced to the user-friendly, direct manipulation environment of Macintosh software. Ten minutes were spent practicing the use of the mouse (a selection device) to choose notes from a "palette" on the screen; to place notes on an empty musical staff; and to perform the resulting notation by pointing to a button on the screen marked "Play." While learning to manipulate hardware, subjects were also experimenting with the notational system and monitoring aids. By placing musical symbols on the staff (manipulating standard music notation graphically), playing back the results (producing accurate performances), and listening critically to the performance for flaws (exercising perceptual judgment), subjects experienced firsthand the powerful integration of musical activities afforded by the computer environment. As they practiced, they demonstrated the ability to match notes and decipher musical notation well enough to hear errors as well as locate and correct their occurrence within the notational display.

All participants quickly mastered these simple techniques and were ready to begin working on our composition tasks. Figure 2 shows the initial problem as composed by Mozart (A) and as posed to our participants (B).

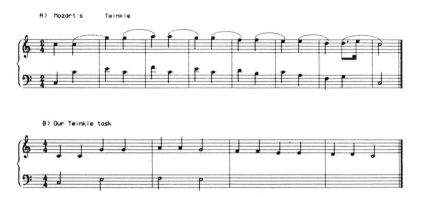

Fig. 2. Mozart's setting of the tune "Twinkle, Twinkle, Little Star" (A) and the composition task given to musically trained and untrained adults and children (B).

For our subjects, the familiar melody "Twinkle, Twinkle, Little Star" was presented in standard music notation, along with the first two bars of a possible accompanying duet. Participants were asked to complete the accompanying duet part, taking as much time as they needed and playing the given notation and their additions as often as they wished. All were encouraged to continue working until they were completely satisfied that their solutions resulted in a "Twinkle" which "sounded good." The task, as presented, effectively poses much the same conditions to musically untrained individuals as those experienced by any composer creating duets. After completing the harmony part of the tune on the computer, subjects were asked to listen to a "gallery" of five different sample solutions to the task and to rank order them according to the success of the solutions.

Compositional Development in Untrained Children and Adults

Although untrained children and adults both easily manipulated music notation symbols with the aid of the computer, only the adults were able to solve this simple composition task effectively. Adult solutions demonstrated effective voice leading (by creating duet parts that moved independently of the melody), controlled dissonance (by not letting "sour" notes interrupt the harmonic flow), and exhibited closure (by creating an effective ending to the music). In contrast, children's solutions generally failed on at least one, and often all three, of these measures.

Mark, age thirteen, provides a solution representative of the type produced by musically untrained children (see fig. 3). Although he has selected an appropriate rhythmic value to use in completing the duet, Mark's pitch choices result in unresolved dissonance and an overall weak melodic line or contour, and they produce an ineffective ending (lacking a strong reference to the key of the melody).

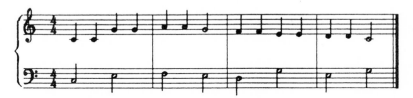

Fig. 3. Mark's (untrained thirteen-year-old's) solution to the "Twinkle" task.

Mark's method of reaching this solution is also representative of musically untrained children. Mark played through the entire example once before beginning to work. He then proceeded to place each of his note choices. With each note in place, Mark played the example once again and indicated that he was done. Asked if he liked the way his notes sounded, Mark smiled, shrugged, and said, "They're ok." Asked if he wanted to make any changes, Mark said, "No." Finally, when asked how he had decided where to place his notes, Mark replied, "I don't know . . . just puttin' them anywhere!"

When asked simply to listen to and judge the five solutions to the task, untrained children as well as untrained adults favored those solutions which contained smooth melodic contours, acceptable levels of dissonance, and standard cadential closing phrases. Yet, while musically untrained children demonstrated the ability to *perceive* good solutions to the "Twinkle" task, they were consistently unable to *create* good solutions on their own. Much of the unique support the computer offers for these kinds of tasks remains untapped because the machine's users have not yet harnessed the powerful tools and assistance available in the interactive environment. Most notably, the editing and revision strategies we observed in the composition processes of musically untrained adults were virtually nonexistent in the works of musically untrained children.

Like the children, untrained adults routinely play the "Twinkle" example at least once before beginning work. However, adults continue to listen to the example periodically as they are creating their solutions. Using the playback feature to monitor their notation choices, adults constantly judge their emerging solutions and revise in accordance with these

judgments. In contrast to the children, who were largely silent during the process and unable to articulate thoughtful solution strategies when asked, adults commented frequently on their work in progress: "I think it sounds dull"; "I like that"; "Oh, I do like that one!"

Comparing the children's and adults' processes, it may be that the adults' superior products were simply a result of better understanding of the problem or better task management. On the other hand, other evidence suggests that the difference may be due to musical development. Asked how they were making notational decisions, adults generally offered one of two strategies. Some stated they "heard" a note they wanted in their heads, then attempted to match it by experimenting with the notation and playback monitoring. Others reported they chose to make use of the visual patterns they perceived among the notes already present on the screen. This second strategy also involves revision after playback monitoring: adults frequently expressed surprise when the graphic patterns they visually repeated produced monitored results that did not confirm their musical expectations: "That last interval doesn't sound like I thought it would!" "Wait a minute! That sounds alright, but I'm not sure it's following the same pattern that it's supposed to!"

Figure 4 illustrates a solution representative of those produced by untrained adults through this process of trial, reflection, and edition. Where the untrained child's duet fails, the adult's solution exhibits a smooth harmonic line, a definite sense of closure, and no improper uses of dissonance.

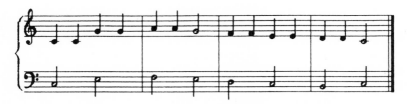

Fig. 4. Typical untrained adult solution to the "Twinkle" task.

As their expressive comments indicate, untrained adults became highly engaged with the composition process; a few even discovered that they were able to create more than one effective solution to the task. Adults expressed firm opinions concerning their satisfaction with their work ("No! That's not what I wanted!") and made extensive use of the computer's unique support system in reaching effective solutions.

In sum, there is a large gap between the type of products produced and the strategies used by musically untrained children and adults. Even when

exceptional children demonstrate some of the processes exhibited by adults, they remain ultimately unsuccessful in producing an acceptable solution to the task. For example, consider Philip, age thirteen. Unlike most of his peers, Philip frequently expressed his dissatisfaction with his various solution attempts. Upon listening to his first solution attempt, Philip proceeded to make over a dozen revisions to his work, monitoring after each change and often commenting on its acceptability. Asked at one point in his work to comment on how he was making his note choices, Philip indicated he was "using the same notes" as those found in the given melody, a strategy often employed by adults. While he demonstrated an articulated strategy and applied revision techniques in much the same fashion as adults, Philip was ultimately unsuccessful in solving this task in any musically effective sense.

In contrast to most previous studies of musical representation, we find differences between the majority of musically untrained children and adults are evident not only in the quality of their compositional products, but in their compositional strategies as well. Adults, while no more physically adept at manipulating the computer's hardware, appear to take better advantage of the computer as a tool for aiding in the monitoring and revision of their work. Adults bring explicit solution strategies to their understanding of the task and use their musical "ear" to assess the products of their labor critically. Dispelling the myth of the "more creative, computer-savvy" child, adult novices show us that (with the assistance of a powerful, notationally relevant tool) they can create solutions to musical problems far in advance of adolescents.

Trained vs. Untrained Adults: Mapping "Proximal Zones" in Music Compositional Development

This simple "Twinkle" task establishes the computer as a lens through which we can view the previously hidden musical development of untrained adults. What is unclear is whether this development was simply undetected without the computer or whether the computer provides a learning environment which catalyzes musical development. In support of the second hypothesis we may draw on Vygotsky's view of cognitive development. According to the Soviet theorist, two kinds of developmental levels must be recognized and considered. An individual's *actual* developmental level is "a result of certain already completed developmental cycles" (Vygotsky, 1978) and is determined by *independent* problem solving. A second, *potential* level of development may also be identified and is determined by problem solving accomplished with the collaboration of peers or the guidance and assistance of others. The distance between these two levels of development results in a "zone of proximal development." For our purposes, viewing the computer as a collaborative tool in the problem-solving

realm of music composition may lead to the observation of such "zones" in either trained or untrained individuals, or in both.

As discussed above, the solutions of musically untrained adults for this task differ substantially from the relatively unsuccessful products of musically untrained children. Indeed, musically untrained adults not only provide successful solutions to this simple composition task, but in many cases (nine out of fourteen sampled) those solutions are as sophisticated as those produced by conservatory-trained adults. However, while untrained adults appear as capable as trained adults of creating effective duet parts for the "Twinkle" task, their processes and the time they require to solve the problem distinguish their endeavors from those of trained musicians.

Consider Carol's approach to the problem. Carol, an untrained adult, listened repeatedly to the example before beginning work. Then, ready to begin, she set the playback button to "repeat"; this allowed the example to play continuously while she worked. In this manner, Carol continually monitored her composition, editing fourteen times before reaching her final four-note solution. Carol's processes are representative of the untrained adults we saw, "feeling" her way to a successful solution through a process of experimentation and revision.

In contrast, trained musicians (both children and adults) exhibit a very different approach to the task. Alice, who pursues professional training at the New England Conservatory of Music, did not listen to the example at all before beginning to work. Not until she had completed her solution did she listen to the piece, checking her work and pronouncing it "good." Gary, another musician, proceeded in much the same fashion, playing the example for the first and only time after completing his solution. Asked if he liked the way his solution sounded, Gary commented, "I knew how it would sound. It's very simple."

In sum, what is most surprising in this task is the relative sophistication of the solutions of many of the novices. Uninitiated in the use of standard music notation, these untrained adults had not previously considered the possibility of solving problems in composition. Yet by manipulating musical symbols and sounds directly, they are able to construct reasonable solutions to our tasks. Still, previous training makes a difference. While the final products are comparable, their experience with music notation apparently enables musicians to *internalize* the process of composing while working on simple duets. By observing a task that demands more musical skill in composition, we can see whether the computer will continue to guide the musical novice into higher terrains of musicianship.

A Second "Twinkle": Previewing "Zones of Proximal Development" in More Complex Compositional Problems

Just how far can the computer go in providing support for musical no-

vices? A second, more formidable version of the original "Twinkle" task was posed (see fig. 5). A portion of a duet part was again provided; however, this time the inclusion of more complex harmonic functions served to limit the number of possible good solutions to one of two types.

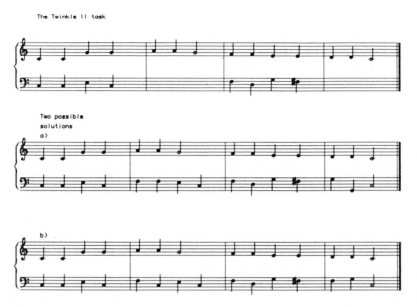

Fig. 5. The more advanced "Twinkle II" task (above) and two possible solutions (a and b).

This new task produced a striking difference between trained and untrained adults. Untrained adults were largely unsuccessful in solving the "Twinkle II" task; solutions resembled those of the untrained children for the first "Twinkle" task, with many instances of unresolved dissonance, poor voice-leading, and ineffective closure. Listening to the example before beginning, many subjects stated they felt the task to be unsolvable and that the given portion of the example was intentionally flawed. For example, after expressing her distaste for the given F# of the harmony, Lynn, an untrained adult, responded when asked if she thought she could produce a good-sounding solution anyway: "I don't know—I'll have to see. But I think even if this note [before the F#] sounds fine and this note [after the F#] sounds fine, if these two [the concurrent E and F#] sound bad I don't know if anything is going to change it."

As she worked, Lynn expressed mounting frustration and difficulty. When finished, Lynn appeared dissatisfied with her work, saying she was "not really crazy" about her solution and adding: "You know what's

hard? Every time I hear that note that's wrong [F#], it kind of like throws the whole thing—so the whole thing sounds weird."

Untrained adults demonstrated the same solution strategies and made comparable use of computer resources in their attempts to solve each of the two music composition tasks. Yet for the second, more difficult task these subjects were largely unsuccessful, appearing stumped and disoriented in their independent attempts to produce effective solutions. In particular they were unable to create acceptable resolutions to a harmony that demanded a more sophisticated resolution of new, less expected notes—suggesting a lack of "syntactic" understanding of the music. In this case only two of eight subjects were able to find acceptable solutions to the task, while seven out of eight conservatory-trained students had no difficulty in solving the task.

In surprising ways we again see the role of the computer in facilitating new "zones of proximal development." With the guidance of a particular musical intervention we find that adult novices are once again able to provide solutions comparable to those of trained musicians. Prior to beginning work, we presented half of the untrained adults with a "preview" of three successful solutions to the problem. Each individual heard, but did not see, three possible solutions to the "Twinkle II" task. Astonishingly, while only two of eight untrained adults were able to construct satisfactory duet parts to the more difficult task without preview, all six of the subjects receiving the preview presentation created acceptable solutions.

In accordance with the Vygotskian concept of zones of proximal development, it may be that the simple assistance of this brief, on-line help effectively alters the untrained adult's perception of the composition task. It appears that these individuals may be very close indeed to effective solutions which the computer can help draw out. None of these untrained adults simply created duplications of the solutions presented in the preview. This finding suggests that these novice composers were guided by some musical understanding culled from the previewed solutions rather than relying on their (probably undeveloped) ability simply to imitate the examples exactly. Somehow, the inclusion of this seemingly modest intervention admits these untrained individuals to a realm of compositional demonstration which exceeds their "actual" developmental level.

Development and Professional Training

Untrained adults—with the help of computerized notation and performance tools—and trained musicians achieve remarkably similar solutions to our two "Twinkle" tasks. Just as the tasks of previous studies appeared insufficiently rich to capture differences between untrained children and adults, so it may be that these simple composition tasks do not provide

a broad enough measure fully to portray trained musicians' penetration of the domain. The novelty of the "Twinkle" tasks for the untrained adult exposes processes required for solution and reveals their constructive nature. We found that posing novel or more complex composition tasks to trained musicians elicited a similar externalization of musical processes, affording further insight into development.

Contrapuntal practice is one of the compositional techniques required of musicians in training at Boston's New England Conservatory of Music. Problems posed in the counterpoint classroom provide a continuous source of "novel" tasks for the trained individuals of our study. By asking these students to compose solutions for these problems using the Macintosh computer and software, we secure a more detailed and differentiated perspective on the composition process.

In completing solutions for the simple "Twinkle" tasks, musicians made little use of the monitoring capabilities afforded by the computer. They claimed that they easily heard the problems internally and seemed confident in the presumed accuracy of these internalized representations. However, presented with the richer, more novel tasks of contrapuntal practice, processes among the musicians sampled began to diverge. Some continued to ignore computer-supported activities such as playback monitoring: "While the computer might be helpful for playback, I would rather rely on the internal ear." But others began to make moderate to extensive use of the option. For some, the novelty of the task impeded a confident internal representation of the notation: "I couldn't really hear [this part] in my head, [so] I didn't know if it would be ok." In addition, to perform these notation tasks adequately, a certain degree of keyboard skill was required; non-keyboard players found playing their exercises difficult. Experiencing difficulties of this nature resulted in more reliance on computer assistance and an appreciation of the beneficial and integrative nature of such support: "Usually I never get to hear it [my homework] until it's played in class"; "You link the visual with the sound"; "I think the computer really helps—you hear every note." Even when keyboard skills were equal to the task, students mentioned benefits in auditing the computer performance: "My hearing is aided by being separated from myself [as opposed to concentrating on producing the performance personally]."

We observed conservatory students wrestling with new demands in their musical training (formal exercises in counterpoint). Evidence for differing levels of musical development is revealed in an examination of the ways students use the computer to compose. There are music students who find no reason to use the computer—they may have already mastered musical notation and its relation to performance. On the other hand, as the tasks get progressively more complex, we observed more and more students depending on interaction with the computer. These students recall more the

behaviors of our musical novices in their entry into composition. In order to arrive at acceptable solutions, extensive revising and playback became increasingly essential to the process of musical problem solving. As these students were learning to compose beyond their level of musical development and training, the computer became progressively more indispensable to their learning.

Summary

An analysis of children's and adult novices' compositions provides powerful evidence of musical development without musical training. Although untrained adults do not necessarily improve in their performance or representation of familiar tunes after about the age of seven, we have seen that they are able to harmonize simple melodies in ways significantly different from children. Using computer software, adult novices are better able than children to construct harmonically sensical, independently voiced, and syntactically formed counterpoint. More surprisingly, on relatively simple composition tasks, there appears to be little difference between the *products* of trained conservatory students and adult novices when using the computer to compose.

Still, there are substantial differences between music students' and musical novices' use of the computer in the compositional process. The *process* of composing with notation appears to be highly internalized (less dependent on monitoring) for trained musicians. Additionally, as composition tasks become more difficult, trained musicians are better able to find solutions to problems, while musical novices quickly become discouraged with apparently unsolvable tasks. At this point we witness the role of the computer in a different light. After "preview" solutions are presented on the computer, musical novices are immediately better able to complete the task and appear to be able to operate on an entirely new level of musical problem solving. This "preview effect" on the computer reveals new "zones of proximal development" in musical development.

In conclusion, this research also suggests new ways in which the computer may better stimulate development and training in the musical arts. Besides demonstrating the presence of musical thought and ability in untrained adults, composing software can be used as a sophisticated *intermediary* tool in musical composition. Students using computer software to solve their counterpoint or harmony homework appear more likely to take advantage of the editing, revising, and playback functions of the computer without being distracted by the demands of musical performance beyond their level of proficiency. Musical composition can be more objectively related to its notation through computer playback, a noninterpretive rendering of the score.

With the incorporation of computer tools into the domain of music, we are closer to understanding how novices can exercise their musical thinking without the constraints of an imprecise notation or an inconsistent performance. And by rendering transparent much of the previously opaque process of musical composition, computers reveal to us a range of compositional behaviors encompassing both the musical expert and the novice. With this information we can begin to consider a broader definition of the compass of musical development.

REFERENCES

Bamberger, J. (1980). Cognitive structuring in the apprehension and description of simple rhythms. *Archives de Psychologie, 48*, 177-199.

Bamberger, J. (1982). Revisiting children's drawings of simple rhythms: A function for reflection-in-action. In *U-Shaped Behavioral Growth* (pp. 191-226). New York: Academic Press.

Davidson, L. (1985). Tonal structures of children's early songs. *Music Perception, 2*(3), 361-374.

Davidson, L., & Scripp, L. (in press). Young children's musical representations: Windows on music cognition. In J. Sloboda (Ed.), *Generative processes in music*. New York: Oxford University Press.

Dowling, W. J. (1982). Melodic information processing and its development. In *The Psychology of Music* (pp. 413-429). New York: Academic Press.

Dowling, W. J., & Harwood, D. (1986). *Music cognition*. New York: Academic Press.

Gardner, H. (1973). *The arts and human development* (pp. 187-198). New York: John Wiley & Sons.

McKernon, P. (1979). The development of first songs in young children. *New Directions for Child Development, 3*, 43-58.

Vygotsky, L. S. (1978). *Mind in society: The development of higher psychological processes* (pp. 84-91). Cambridge: Harvard University Press.

Winner, E. (1982). *Invented worlds: The psychology of the arts* (pp. 216-243). Cambridge: Harvard University Press.

Work reported here was supported in part by a grant from the John and Mary R. Markle Foundation. We are also grateful to the faculty and students of the New England Conservatory of Music and the Longy School of Music. For their invaluable comments and suggestions on earlier drafts we thank Joe Walters, Howard Gardner, and Dave Perkins.

Arts Education in the People's Republic of China: Results of Interviews with Chinese Musicians and Visual Artists

KATHRYN LOWRY and CONSTANCE WOLF

Introduction to the U.S.-China Arts Education Project

A number of Western visitors to China have been struck by the high level of artistic performance by Chinese children. In his trips to China in 1982 and 1985, Howard Gardner noted some important differences in arts education between China and the United States. First, the structure of arts education is centralized; policy and materials emanate from Beijing. Second, there is a strong agenda of moral, spiritual, and political goals for arts education in China. One often hears in China that music helps a child's overall development and is supposed to make him into a more harmonious individual; similarly, arts are a means to understand the "connections between things." Such explicit goals for learning arts are less pervasive in the United States. Third, music and art programs for young children in China stress skill building and technique. Arts curricula commonly focus on rote methods, whereas classes for children of the same age in the United States encourage individual solutions and emphasize expression (see also Kessen, 1975; Sidel, 1972).

Arts are found everywhere, but what are the arts like in China? The West and China both have great traditions in art, and one premise of the U.S.-China Arts Education Project is that examination of arts education in two such different societies as America and China could provide insights into both artistic traditions. In addition to its intrinsic interest, such an inquiry may shed light on dramatic social and political shifts in Chinese society in this century and their effects on the arts and education. And it provides a different light—or perhaps a reflection—with which to view arts education in the United States.

In 1984 Project Zero undertook a comparative study of arts education in the People's Republic of China and in the United States. The study has two discrete components. First, we exchanged people to do research. We also compared the role of family, institutions, and evaluative mechanisms for the arts and arts learning in the United States and China. Interviews

have been our means of procuring information relevant to the comparisons. The present article summarizes findings from interviews conducted with Chinese musicians and visual artists.

The "China Project," as it has been nicknamed, has been supported by a three-year grant from the Rockefeller Brothers' Fund. It has been carried out jointly by Harvard Project Zero and by the Center for the U.S.-China Arts Exchange at Columbia University. This research and exchange in arts education are the offshoot of the longstanding interest of the Fund in China and of its initiatives in arts education in the United States. More parochially, the program also builds on earlier impressions of arts education in China (Gardner, 1982, 1985).

Methods

Sources

The research component of the China Project relies on three principal sources: (1) the hosting of three sets of exchange teams simultaneously in China and in the United States for residency periods of two to three months, during which each team of two music or arts educators or psychologists spent time observing classes and conferred with teachers, administrators, and students in the host country; (2) library research concerning traditional and contemporary Chinese society, arts practice, and education; (3) interviews conducted with Chinese musicians, visual artists, and educators, as well as with Chinese and American specialists in education and the arts.

Interviews

The study of arts education in China has an anthropological orientation that distinguishes the China Project from other ongoing studies at Project Zero. During 1984-1986 we conducted more than one hundred interviews. We surveyed forty-one Chinese visual artists: twenty-nine from the People's Republic of China (PRC), twelve from Taiwan (five of these responded to a questionnaire), and thirty-three musicians: twenty-eight from the PRC, four from Taiwan and Hong Kong, as well as one American-Chinese composer. The remaining interviews were conducted with Americans and Chinese who have taught, conducted research, or travelled in China. The Chinese artists we met in the United States are all from major cities—Beijing, Shanghai, Tianjin, or another of the metropolitan areas—where conservatories, art academies, and normal colleges or universities are located. They are professional artists whose achievements represent the heights of the system for arts education, rather than the standard experiences of arts students in China.

We posed the same series of questions to musicians and visual artists.

Our interview protocol addressed several issues: the role of the family in artistic development, methods for learning (e.g., rote vs. problem-oriented teaching in the arts), and the influence of politics on the arts. These topics, selected as a focal point for the interviews, highlight major differences between the two systems for arts education. In some respects, the interviewing resembles an extended fishing expedition; the three areas of questions were "bait" which enabled us to catch hold of other issues. Ultimately, we took an approach which draws on journalism as much as on scholarship, asking of each individual what his or her vocation was in the arts; when he took an interest in art; when he began study; why he chose to study; and how he became a professional artist in a given medium and style. Through our conversations, a picture emerged of the landscape of the arts in China.

Results of Interviews with Musicians and Artists

Four issues and sets of findings from the interviews are addressed in this article. They are: (1) What is arts education? That is, what are the preferred means and endstates of learning the arts? (2) What is the role of the artist's family? How are future artists reared and how socialized? (3) What are usual training methods and career paths in arts education? (4) What are the overarching goals and values of the system? We begin by comparing and contrasting China and the United States descriptively, and then, at the end, we take up big issues more focally. Observations of arts education in China and in the United States have led us to speculate about the different philosophies of the arts (and of education) in the two cultures. Also, we have been alerted to an agenda of moral, political, and spiritual goals for the arts in China which are fundamentally different from those which surround arts practice and training in the United States.

What Is Arts Education?

The premises of arts education in the United States and in China are essentially different. Visitors who have taught art or music in China label the system there "the Olympic-athlete method." Indeed, athletes in the United States are the individuals whose training regime most closely resembles Chinese artists' in rigor as well as in level and degree of competition.

Arts education in the United States is geared to the ordinary child and includes some art appreciation and exposure to basic skills and media in the arts. In China, arts training focuses on skill building. In music, rote means are used to achieve extraordinary polish and accuracy in young children's performances. In visual arts also lesson formats are restricted. A typical lesson might be to follow the steps displayed on the blackboard to create, for example, a painting of a goldfish which is exactly like the teach-

er's model. The two systems for educating artists have different endstates. United States arts education aims to educate a well-rounded, knowledgeable individual, whereas the focus of Chinese arts training is on technical proficiency.

Arts training in China is geared to early recognition of talented artists. Children are tracked in special programs for arts (or other subjects). The most talented children attend highly selective preschools and primary and middle schools that are attached to professional arts institutions and teacher colleges. A Chinese child may attend what is known as a "key school," which has exceptional facilities and highly qualified teachers. Alternatively, if a child passes the entrance test, he or she may enter extracurricular classes which are offered at children's palaces. The topics covered include music, calligraphy, painting, and academic subjects such as science and mathematics. Children who attend such programs may then be admitted to conservatory or normal school programs for music or for art.

A high degree of streaming of students takes place in China. There is a limited number of places to train artists, and graduates from those institutions are guaranteed one of a limited number of coveted positions as a teacher, composer, performer, or practicing painter. We asked people when they decided to become an artist—a question that makes sense in the United States, where a great deal of lateral movement in society is possible. In China this is virtually a nonquestion, since people rarely if ever change professions, and for the most part the individual does not initially have the option of choosing a profession.

The admiration for children's art as being naive or "primitive" seems to be shared by Chinese and United States artists, although Chinese children's art tends very early to follow orderly rules, as if being plugged into a formula. Often one may see a seemingly very original or charming work somewhere in China, only to encounter exactly the same work at a dozen other schools.

In the United States gifted young artists and musicians often develop a "mid-life crisis" in their early teens and may reduce their commitment to arts practice or stop altogether (Bamberger, 1982). This conflict does not seem to occur in China, perhaps because vocations in the arts are relatively, though not entirely, fixed. Gifted children who are outstanding performers go to the top institutions. Those who are not as talented, or who may have interests other than arts practice or performance, become art teachers or may be assigned administrative roles.

What Is the Role of the Artist's Family?

From the outset, the family plays a central role in recognizing and fostering artistic development. We wanted to find out whether the future artists were already trained at home. If so, we wondered whether their parents

were drawn from a broadened range of the population or, if parents were artists, whether they were drawn from the same art form as their children.

Parent's Influence. In the United States, the parents' role in a child's artistic career varies considerably, and the choice to become an artist is largely one's own decision. We found that most of the Chinese musicians' and artists' parents are highly educated or are themselves artists. A majority of the musicians are from musician families: seventeen of twenty-eight have at least one musician parent who could teach the child music from a young age. Other parents of musicians are engineers, filmmakers, and administrators. We found our visual artists are from quite different backgrounds. Some visual artists' parents are also artists (five of twenty-nine have an artist parent, and in two cases both parents are artists). Often visual artists have parents in fields having to do with literature, who enjoy painting as a hobby or who value arts practice.

Not only do family members encourage and support activities in the arts in the home, but parents' vocations also strongly influence opportunities to learn music and art. Within a context which is resource scarce, children of artists and intellectuals have access to arts, to performances, exhibitions, and films, and to the "tools of the trade" for the various arts.

Further, one's work unit, or *dan-wei*, is the basic locus of activity in China, and it features a network of artists, teachers, and others who live and work in close proximity to each other. Thus, like medieval craftsmen in the West, artists and writers, actors and musicians live in nearby housing blocks or quarters of a city.

At home, family members encourage and support activities in the arts. Parents generally initiate lessons with a private teacher or family member. Though a similar pattern also holds in the United States, there is a distinct contrast to China in that *guan-xi* or "relationships" are necessary for access to materials and to qualified teachers in the arts. The development of *guan-xi* depends on one's vocation and political clout.

Discipline. Family members are closely involved in a second aspect of arts training: the disciplining of children. We observed that discipline is a pervasive and insistent factor in arts training in China. For our purposes, discipline is broadly defined, consisting of (1) fixed practice time and set tasks; (2) punishments and incentives to study arts; (3) structured courses and supports for arts training.

In music, early practice is highly structured. Very few musicians enjoyed learning music at the outset. Some children of musicians (five of twenty-eight) started to learn when they were between four and six years old. With few exceptions, family members initiated lessons, enforced a practice routine, and provided support for music learning. Others began learning music when they were eight to ten years old, in formal institutions for music or in private lessons, with ample coaching from teachers. In gen-

eral, there was a fixed daily minimum practice time. While nonmusicians asked that their child practice for a matter of only fifteen minutes daily, musicians asked their children to play one to two hours a day. It seemed quite common for a parent or grandparent to set an alarm clock for the duration and to leave a child with the instrument. Several also contrived special tasks, such as transferring twenty paper strips arranged on the top-left side of the piano to the top-right side, moving them one at a time after each rendition of a piano exercise from the Bayer book. Although many of the musicians admitted that they surreptitiously moved the hands of the alarm clock forward or moved bunches of five paper strips at a time, the message of the seriousness of practice was not lost on them.

Discipline in music was strong, and beating was common. When children did not practice or perform well, the father would usually punish them. Yet, while the whip was in one hand, chocolates were in the other. The father was most often the disciplinarian. Mothers were supportive, "all apples and smiles." Mothers who had musical skills or who were musicians often taught the children or listened to lessons.

Early learning in visual arts contrasts with that in music. Visual arts activities for young children were often self-initiated. A number of painters recalled liking to draw "since [they were] very small." Many drew on the margins of their books or in the wet mud after a rainstorm. Until much later in childhood there was very little external pressure for young children to excel in drawing or painting or to practice in a systematic fashion. Gifted young visual artists are usually directed to school art groups or private or special art teachers around age ten or twelve.

Learning calligraphy is a different case and more closely resembles music in the rigor and discipline involved in study. We speculate that the two "performance" arts require a higher degree of manual dexterity and accuracy than other visual art forms. Where painting and drawing are creative arts, music and calligraphy can be seen as recreative arts which must be heavily rehearsed.

The question arises about reasons for the demanding discipline imposed on children studying arts. It seems that among professional music and artist families, discipline was used to enforce practice for the sake of discipline (and not primarily for the sake of art). The belief that music develops natural abilities (*su-zhih*) and intelligence is articulated in curriculums for ordinary aesthetic education and ordinary music texts. Educators explain that musical skills are cumulative, and the earlier a child takes up an instrument, the better.

Support offered by parents and teachers represents the flip side of physical enforcement of practice routines for music. The orderly system for music study, with unambiguous criteria and predominantly rote procedures, is in itself a kind of support. John Graham, an American violist

who taught in China, notes that people seem to approach learning music as "plugging in a formula," and the fact that they do that seems to relieve the child of responsibility for decisions (Graham, 1984; interview, 1985). Similar supports exist in formal tasks assigned young visual artists. The community of future artists, who interact closely with their parents as well as with teachers and with one another, represents a second, important type of support.

What Are the Usual Training Methods and Career Paths in Art Education?
We asked people how and where they learned in the arts and about their training later on. If future artists were taught at home, was the goal to transmit knowledge of the arts for pleasure? Or could artist parents give children an advantage, helping them acquire basic skills, so that they might gain entrance to formal arts programs? We were particularly interested to know whether—and how—these informal and formal motives and types of arts activity might dovetail.

Learning arts in China relies heavily on rote methods. However, in mastering the arts in China rote methods are no more evident than they are in learning calligraphy, math, biology, or English. The practice of learning formulas and of working in a single medium until the nuance of that medium has been mastered seems to be carried over from the master-disciple tradition in the Chinese arts. An eighteenth-century Chinese painting manual, the *Mustard Seed Garden*, prescribed steps for painters to follow. The method of learning outlined in that manual is similar to nineteenth-century European and American drawing manuals (cf. Korzenik, 1986). However, United States arts and arts education have changed radically along lines which now emphasize individual expression and exploration. While arts practice in China borrows liberally from Western, Soviet, and Japanese pedagogical models, the mode of learning has remained relatively unchanged for centuries.

Chinese arts training focuses on technique and skill building, even for young children. Much of early learning in the arts described in our interviews is restricted to a given context. For example, in learning to sight-sing, Chinese children learn notes embedded in a tune, rather than learning "abstract" triads or scales. Early music activities in general demonstrate this principle, combining simple melodies with dramatized lessons or story programs that are performed with prescribed gestures, dialogue, and facial expression. We speculate that while such multifaceted performances, contests, and task-oriented exercises enhance learning in music and calligraphy, especially in the early stages, these same procedures may actually hinder broader forms of learning in the visual arts in China.

Learning in the visual arts is initially somewhat flexible. But soon there is as rigid a regimen as in the musical area. This produces technical compe-

tence. However, ultimately everyone paints the same and, to a Western eye, this seems stifling. One sees little evidence of "problem finding" or of experimentation with form in the work of advanced Chinese students.

In effect, there is a multi-tiered system for the arts (as well as other professions), in which artists who will become professionals and leaders in the field follow different agendas from that of ordinary students of art. There is an unambiguous hierarchy of professional positions in the arts. The "best" artists are given sinecures and may perform or paint full-time, so long as they abide by guidelines for artistic expression. Their special status in society may be best compared to that of athletes in the United States. Ordinary music and art education, even though its products will become classroom teachers rather than public performers or full-time artistic practitioners, is driven by the professional model. In addition, a broad range of traditional and folk arts are practiced *outside* the professional arena. For example, in music numerous popular or "light" performing troupes and amateur music clubs continue to play traditional music that is not or cannot be taught in conservatories, for reasons of style as well as content.

What Are the Overarching Goals and Values of the System?

In the West, creativity in the arts implies innovation, and the content of artworks is left largely open for the individual artist to choose. The search for creativity *per se* assumes a relatively minor role in the arts in China, which tend to be more tradition oriented or convential in nature. To be sure, the traditions of Chinese music and art are by no means unvaried or unexpressive. However, in general the highest stated goal in China is to express the spirit of the Chinese people or to capture the essence of traditional concepts in the arts.

We speculate that the range of expression in the arts in China is muted, as is expression in other areas of life. The skill- rather than expression-oriented focus of Chinese arts education testifies to different underlying goals for the arts and for arts training. Within the context of the lengthy arts tradition, where mastery or revitalization of classical models represents the highest goal, even the most dissident or "new" works of art reiterate elements from the tradition. To be sure, the sense of Chineseness and of Chinese aesthetics changes over time. Yet, there remains a degree of stability, unity, and continuity in the arts in China that is quite foreign to United States artists' conceptions of what art *is*.

The role of the artist in China is distinctly different from the artist's role in the United States. In the United States, the choice to become an artist, as well as the content of one's work, is largely a matter of self-decision. In China, artists' vocations, as well as the content and styles permissible for their works, are clearly designated. The arts education system is

set up to train a very limited number of professionals, who are assigned to fill existing places as practicing artists or art teachers. The situation in China affords economic security for practicing artists, which eludes many art practitioners in the West, yet imposes disincentives for those who might work on the fringe of established arts practice.

Conclusion

Each partner in our U.S.-China arts education exchange stands to learn from the other. Art educators in the United States can be informed by observing the skill, care, cultivation, and discipline with which training in the arts in China is carried out. Respect for tradition is one of the most important lessons we stand to learn from the Chinese. The use and refinement of conventional means of expression in the Chinese arts furnish a valuable model for us to consider. Further, our case studies of individuals in the arts highlight the tensions between tradition-oriented values and practice and innovative approaches to the arts in China and suggest that a far broader—and more positive—understanding of conventions in the arts might enrich American arts teachings.

Conversely, Chinese educators, musicians, and artists might possibly benefit in their endeavors by recognizing the variety of possible means and applications for training in the arts. The Chinese may learn questioning, taking a risk, and introducing more personal and frank questions into their aesthetic endeavors. A number of the Chinese artists and educators whom we interviewed shared our interest in cultivating creativity in the arts and in other disciplines. People invariably named broadening the means of expression through technical means as a central factor in artistic creativity. Nonetheless, the content or views expressed in their work are best characterized as "Chinese" or as bearing some relationship to the mood and spirit of Chinese society and the Chinese people. Even (perhaps even especially) those artists who have decided to stay in the United States for extended periods of time seem to retain a special lusting for knowledge about their roots. Their different view of how and why to promote creativity in the arts is telling.

To put such observations of methods and values in arts education into perspective, we need to take stock of the broader roles the arts play in education in China and in the United States. Significant lessons—besides aesthetic values—are conveyed in tradition-oriented arts teaching such as that of China. Arts education which is oriented toward problem solving, such as that of the United States, may enrich itself by borrowing from the Chinese and many varied arts traditions, but what substantive lessons and skills may the arts transmit in such a context?

To be sure, it is unrealistic to expect either participant in our exchange

to model itself (or its arts and music) upon a system oriented in a way basically different from its own. However, each side can perhaps learn to supplement its usual approach. A byproduct of looking at the strengths of training methods in the arts in China—for example, the context-restricted learning in music—is that we may see that such exercises facilitate motor ability and technical accuracy but limit ability to emote. On our side, American arts education is rich in expressive means and qualities, but students who have not been systematically trained, or who lack focus or discipline, cannot adequately express themselves.

Finally, by going *outside* our familiar context, we may also come to recognize better the values and themes of American arts education and to respect and understand the different traditions within American arts.

REFERENCES

Bamberger, J. (1982). Growing up prodigies: The midlife crisis. In D. Feldman (Ed.), *New directions for child psychology: Developmental approaches to giftedness and creativity*, *17*, 61-78.

Gardner, H. (1982). Some impressions of arts education in the People's Republic of China. Unpublished manuscript.

Gardner, H. (1985). Art education in the People's Republic of China: A second look. Unpublished manuscript.

Gardner, H., Winner, E., Lowry, K., & Wolf, C. (1985). The exchange in arts education. Report submitted to the Rockefeller Brothers' Fund.

Graham, J. (1984). A violist in China. *Musical America*, March, 33-37.

Kessen, W. (1975). *Childhood in China*. New Haven, Connecticut: Yale University Press.

Kiely, R. (1985). 'Pernicious,' 'pessimistic,' and 'foreign': The controversy over literary modernism in the People's Republic of China. In N. Cantor & N. King (Eds.), *Notebooks in cultural analysis*, vol. 2. Durham, North Carolina: Duke University Press.

Korzenik, D. (1986). *Drawn to art: A nineteenth-century American dream*. Foreword by R. Arnheim. Hanover, New Hampshire: University of New England Press.

Sidel, R. (1972). *Women and childcare in China*. New York: Penguin Books.

Sampling the Image: Computers in Arts Education

JOSEPH WALTERS, MATTHEW HODGES, and SEYMOUR SIMMONS

When personal computers first appeared in schools a few years ago, they were shepherded into the science and math classes; there, despite some false starts, they eventually found a number of promising applications. More recently, teachers of the humanities have begun to use some computers for word processing and data analysis. Still largely untouched, however, are the art and music departments. The time has come for teachers in these areas to consider carefully the use of computers in their curriculum.

Computer hardware has undergone an enormous development during the past decade. Sophisticated machines with high-resolution screens and powerful sound-generating capabilities have become inexpensive and accessible. And the declining price and reduced size of these machines are just part of the story; just as important are the changes in how computers are used. "Mainframe" computers, the large and expensive machines that can be used by many people at once, are owned by institutions, and how they will be employed must be a matter of institutional policy. The inexpensive microcomputers, in contrast, are "personal" computers. They are used by just one person, and that person actually makes the decision about what to use that computer for, where to put it, and so on. The buying power of these individuals has created a demand for a new kind of computer software.

Initially, this demand for software created the boom in video games, but as these new owners became more sophisticated, the software they demanded changed as well. Today, programs for microcomputers range from aids for selling real estate to page layout tools to programs that will manage a diet. This diversity has produced the intriguing programs in music and the visual arts that are prerequisite to a serious consideration of computers in the arts.

Meanwhile, techniques for controlling the computer have changed as well. No longer must the serious user learn a programming language or an esoteric command syntax in order to accomplish a task. Instead, the user chooses the desired action from a list of commands displayed at the edge

of the screen. Commands can even be given without typing; using a mechanical device, the user controls the computer through physical gesture. For example, with a pen that emits a beam of light, the user gestures across the light-sensitive screen; or with a small device that measures hand movement (called a "mouse"), the user can gesture across the top of the table. In either case, the computer senses the movement of the hand and translates that movement into analogous movement of a pointer on the screen. With these pointing devices and the on-screen list of commands, newcomers can use the computer productively with only brief instructions. And although typing is perhaps the most efficient method for entering text into a computer, movements of the hand are far superior for tasks like drawing an image or editing a musical score.

These technological breakthroughs in computer hardware, software, and interface allow us to consider seriously how computers can be used in arts education. This discussion demands both skepticism and open-mindedness. Skepticism is necessary to counterbalance that unrealistic euphoria that often surrounds computer technology—after all, even at best computers perform many tasks poorly. Open-mindedness, on the other hand, is required to see past the liabilities of computers and to identify the tools whose attributes are relevant to arts education.

In our consideration, we begin with a brief, nontechnical review of how computers deal with the materials of the visual arts and music. Then we will consider the features of these tools that show the most promise for innovation in arts education. These powerful features are balanced with a description of the limitations of machines. Both the promise and the limitations play a part in the consideration of the integration of computers into an educational program.

A Computer's Representation of an Image

Computers are tools. The unique power of these tools as well as their particular limitations stem from the special way in which computers treat the material of art and music. We begin with a brief digression to describe some mechanics of this treatment.

As humans, we perceive musical sounds and visual images effortlessly. Nonetheless, because the sensory information that comprises these images is extremely complex, we find it difficult to describe a sight or sound. In the realm of machines, the computer takes on the difficult task of creating a complete and precise description of sounds and images. To this end, the computer translates the sight or sound into a numerical form, using a process called digital sampling.

To illustrate, digitally sampling a sound wave, a continuous event, reduces that event to a series of discrete readings which in turn produce a

long string of numbers (see fig. 1). At each sampling point, the computer records as accurately as possible various features of the sound wave (its frequency and amplitude), and the resolution of that description depends on the rate at which these samples (or readings) are taken. Frequent samples produce a higher-quality description and infrequent samples a lower-quality one; that is, with fewer samples, the intervals between samples become longer, increasing the likelihood that those samples will miss some salient event. To reproduce the original sound, the computer converts the string of numbers into vibrations in a speaker, which in turn produces an approximation of the original sound.

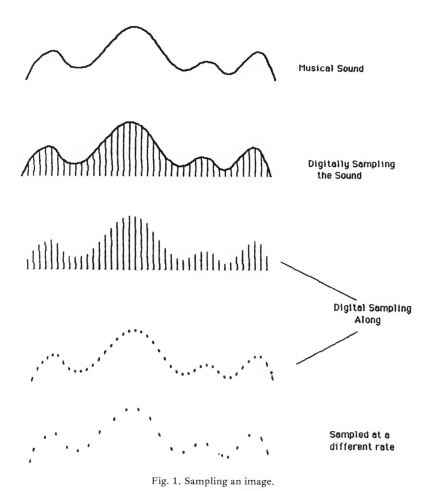

Fig. 1. Sampling an image.

The speed at which the computer takes these samples and the number of samples it can record set boundaries on the precision of the sampling. An important attribute of this complex process is the issue of resolution. Even the most sophisticated sample is only an approximation of the original sound, and the resolution of that approximation depends on the computer. This is another reason why the recent technological changes create a new environment for the arts—a resolution of images and sounds that required large, expensive computers a decade ago is now relatively inexpensive.

The computer can also produce sound synthetically. As with the sampled sound, the computer represents the event as a string of numbers; in this case, however, those numbers are generated by the computer itself, through a built-in computational procedure. A sound "designer" can alter that procedure to change features of the sound being generated, its wave forms, decay envelopes, timbre, and so on. It is this synthesized sound that we recognize as "computerized" music. Often the goal of the sound designer is to approximate the sounds of familiar instruments, but the computer can just as easily produce noises that have no recognizable equivalent. In short, the sound library of the computer contains numbers, and these numbers can come from two sources—they can be produced by sampling sounds in the real world, or they can be synthesized artificially by the computer itself.

A music composer, writing in musical notation directly on the computer screen, instructs the computer to perform these sounds. For example, if the notation calls for a "G" of a certain duration, the computer can reproduce a particular "G" from its library (a sample taken from an oboe player, for instance); or it can synthesize a "G" by producing an artificial wave form at that frequency. As the computer "plays" the notation, it misses many of the features added by a live performer that are not captured in the notation. These include the inflections of certain pitches or the subtle changes in tempo within measures—the "feel" of the music. When listening to a computer performance, one can recognize the song and pick out any wrong notes; but one can also recognize the difference between the computer's performance and human performance.

Similarly, in the domain of the visual arts, images are created and manipulated through a series of numbers. Using a sampling process, the computer transforms a continuous event (scanning across the image) into a numerical description. Each number describes a specific portion of the image, often capturing information about brightness and contrast. As in music sampling, the resolution of this process reflects sampling density: at higher sampling rates, there are more regions, and they are small; at lower sampling rates, the regions are larger. Higher rates produce highly resolved images, and lower rates produce grainy or blurry images.

The computer can also create the numerical description for an image

synthetically. For example, by following built-in drawing procedures, the computer can produce regular geometric shapes, straight lines, filled regions, and so on. Using the pointing device, the artist can directly control this synthesis. For example, the artist chooses the line-drawing tool and then moves the mouse across the table; the computer responds by drawing a perfectly straight line between the starting and ending points of the artist's gesture. Although the artist appears to be creating the images directly, in fact she is issuing commands, and the computer responds by synthesizing the specified images.

In both domains, the digital rendition is an approximation of the original—and that approximation is limited by the memory and the computational speed of the computer. At the same time, the computer's rendition of the original gives the artist a new means for controlling the visual or auditory image. Next we consider how this control might be used in the arts.

Control of the Image

Suppose an artist begins with a rendition in a traditional medium, a pen-and-ink drawing perhaps. The artist first uses the computer to scan the image to produce a digitized representation and then manipulates that representation. A digitized image of *Mona Lisa* is shown in figure 2. Each black dot in this picture represents a "pixel" (short for picture element) that the artist can control. For instance, by dragging the "eraser" tool across an area of the picture, the artist erases a portion of the image by turning every black dot in that portion white. To work at a finer level of detail, the artist can "zoom in" on a region of the picture. In this enlargement, she can change small clusters of dots and even touch up individual pixels. Figure 3 illustrates an enlarged area. This enlargement also dramatizes the digital rendition of the original picture.

Since the computer can manipulate each pixel in its notation of the original picture, the artist can create quite startling transformations with a single command. One such transformation, inversing a central area of the picture, is shown in figure 4. Here the central portion of the image has been inversed; in this rectangle, black pixels are displayed as white and white pixels as black. Other transformations produce high-contrast images, outline drawings of a figure, or displays of the contours within a drawing. The artist can "copy" a section and "paste" it back in repeatedly to produce a collage effect. In the traditional medium, global transformations like these are often impossible or at least highly impractical; even altering a photographic image requires a highly informed and time-consuming use of materials and equipment. With the computer's representation, on the other hand, these transformations are quite simple. Indeed, repeating a transformation or returning to the original image are just as easy. Finally,

each such transformation produces an image as precise as the first computer representation.

In music composition, similar transformations can be performed on the computer's representation of the music. Sampled sounds can be replayed at different tempos without changing pitch; or pitch can be altered without changing tempo. A piece can be played backward as easily as forward. Sections can be cut out and pasted into new locations.

To summarize, in the domains of music and art, the computer approximates the sights and sounds of each domain. The fineness of that approximation reflects the speed and capacity of the computer. In exchange for a simplified image, the artist or composer gains a new control over that image.

The Usefulness of Control

How might this control over a medium be used by an artist or by a novice? Over the past two years we have conducted a pilot investigation into this question. To observe the computer in action, we devised a set of simple tasks. In music composition, for example, these tasks involve completing the harmony line to a simple melody (see Scripp, Meyaard, & Davidson, this volume). In drawing, the tasks involve composition, perspective, and texture. By observing how individuals, both trained artists and novices to

Fig. 2. MacVision of *Mona Lisa*.

File Edit Options Windows Paint Font Size Style

Fig. 3. FatBits of Mona's smile.

Fig. 4. Inverse of Mona; reverse of Mona.

the domain, work with these tasks, we have begun to document several features of the computer that seem to play important roles in the arts.

We find in both domains that the computer provides the individual with a set of tools for controlling a song or image. These features are of two types: rapid translation and flexible content.

1. Rapid Translation. The computer can translate rapidly between two forms of representation. In music, for example, it can translate notation into sounds. For novices, this rapid translation is vital; with the computer, novices can listen to the sounds that their notations produce and make compositional decisions accordingly. Without the computer as translator and lacking skill with a keyboard, novices cannot successfully engage these problems.

Musical experts, on the other hand, may opt for a different translation. They can perform the composition at the keyboard and have the computer translate that performance into musical notation. The computer can also transpose a piece from one key to another; or it can perform the piece on different instruments, at various tempos, with different dynamics. By juxtaposing these performances, the composer can experiment quickly with alternatives.

In visual art, the computer can translate rapidly between different points of view on a single work. For example, a particular drawing can be created as seen from one vantage point, and then, with slight changes, it can be recreated from a slightly different point. A shape can be viewed from the front and then from the side. As with musical composition, the computer engineers an immediate contrast between different views of the same problem. The computer can also make effortless translations in the color palette used to create an image; by systematically manipulating this palette, the user can experiment with the relationships among colors in a composition.

When the computer samples a visual image taken from the video signal produced by a television camera, it draws a two-dimensional image from three-dimensional space, another form of translation. The process is similar to that of photography, except that the image is captured and viewed very quickly.

2. Flexible Material. Once an image (or composition) has been digitized through a sampling or synthesizing process, the computer describes that image in terms of its individual elements. This description of the image facilitates editing, because with the computer the composer can alter any of these individual elements. The contents of the piece can be moved, erased, duplicated, transposed, and so on. The material is flexible.

Since the computer version is a digital representation, any change in that representation does not alter its repleteness. Changes can be simple and local, or they can be complicated and global. Whatever the change,

composer or artist does not lose the "finished" quality of the computer rendition. For example, the composer can change individual notes or entire passages. She can transpose the entire piece into a different key or write an entire line for a different instrument. The artist can touch up small areas one pixel at a time or transform entire regions. In either case, these changes are relatively easy to perform, and they do not affect the integrity of the overall product. This flexibility can have a significant and subtle effect on the willingness of the artist to experiment with the medium.

In a different way, the flexible medium encourages experimentation with images. For example, a computer "sketch" can be made of a three-dimensional space by sampling the video image of that space. This two-dimensional representation can then serve as the basis for experimentation with the perspective, balance, mood, and so on. With the digital image as a starting point, lines of perspective can be added; the image can be cropped; and the overall contrast and brightness altered. The goal of this experimentation is not to produce a finished product, but to compare the impact of alterations on the overall design; such experimentation is facilitated by the flexibility of the medium.

Taken together, rapid translation and flexible content suggest that the computer may be a unique tool for working within a domain. With these tools individuals can quickly consider alternative versions—different views of the same problem can be placed "side by side." They can also "discover" many principles of the domain through experimentation. As they manipulate the objects on the screen, the computer responds immediately and consistently to that manipulation. This direct manipulation of the symbols together with consistent feedback combine the best features of considered composition and spontaneous improvisation.

Limitations of the Computer's Rendition

Using the computer, the artist can change a product quickly and translate freely from one view to another. However, these features must be weighed against the limitations and liabilities of the machine. We will describe these limitations as an impoverished medium and indirect control.

1. Impoverished Medium. Although the computer can perform a musical composition from the notation of that composition, its performance lacks inflection. For example, expressive rubato can be difficult or impossible; the range of accents on particular notes is often quite limited; and the actual sound of the "instrumentation" on the computer is, even in the best cases, only an approximation of the true sound. Even in the notation itself, certain conventions of good music notation are ignored to simplify the computer's task. In short, the medium is impoverished—the composer

is forced to make concessions because of limitations in the computer.

Just as the music programs simplify, so do the drawing programs. The artist gets precision at the expense of nuance. The computer can control brightness to an extremely fine degree, and it offers a palette of millions of colors; even so, the computer does not provide a means for applying these elements in a manner that resembles oil painting or water coloring. For example, colors cannot overlap, and it is often difficult and tedious to blend two colors together. Again, to work with the computer one must recognize these limitations.

2. Limited Control. In both domains the computer medium allows only an indirect control over the domain. For example, artists usually control their materials directly; the ink flows out of the pen directly onto the paper. When drawing with the computer, on the other hand, the artist makes a movement across the desk top, and that movement is rendered in a line or shape on the computer screen. Perhaps the awkwardness of this arrangement can be remedied with practice and improved technology, but in the interim, drawing with the computer will be an unusual and indirect experience.

Often the computer limits the artist's view of the product. Because of the limitations of screen size and resolution, the computer can only display part of a large image at once. This means that the artist or composer cannot "step back" from the details and view the work in its entirety. When using a computer, the artist is more inclined to construct an image piece-by-piece or note-by-note. This limitation can be frustrating for the experienced artist and can develop a piecemeal approach in novices.

Three Uses of the Computer in Arts Education

The desktop computer presents traditional artistic materials and problems in a new light. It offers a unique set of tools for engaging these problems and it gives the user, whether artist or novice, a new form of control over these problems. These computers are easier to learn and cheaper to buy than computers of the past. For these reasons, then, they warrant consideration for inclusion in art education. At the same time, the use of computers in the arts must take into careful account the limitations of these machines; we must choose applications that capitalize on the strengths and minimize the weaknesses. We will suggest three such uses.

Today's computers ought not substitute or replace the traditional media of musical instruments, oil paints, sculpture, photography, and so on. Instead, the computer can be mobilized as an interim step in the compositional process, a place where the artist or composer experiments freely with ideas, changing them, discarding them. The speed with which the

artist can alter the composition and the cleanness of the edited result make an ideal forum for this experimentation. In this case the computer becomes a sketchpad; and just as the sketchpad bears a resemblance to the final product but is not mistaken for it, so the computer provides a flexible and efficient medium for experimenting with work in progress.

Second, in the classroom the computer can be used as a demonstration device to focus the attention of students on particular features of an image or composition. Because the computer's rendition is impoverished by its removal of certain features of the original image, it automatically highlights those features that remain. For example, in music, the computer's performance of a piece removes many of the nuances of the live player and focuses attention on the notes themselves. With the computer's performance, the teacher can be assured that all students are hearing the same thing; interpretation is minimized.

In the visual arts, the computer's rendition highlights certain attributes. For example, the drawing teacher can use the construction tools to fashion powerful demonstrations and experiments with the principles of perspective. In these demonstrations, students can construct vanishing points, horizon lines, and lines of perspective directly over the computer's stripped-down image of three-dimensional space; by moving, editing, or duplicating these constructions throughout the image, the student can experiment with the underlying principles. A painting teacher, on the other hand, might focus on the computer's rendition of the various planes of a three-dimensional object. The digitized image reveals these values quite dramatically; the teacher can use the enlarged view of the image to illustrate the subtle changes in value throughout the image. Finally, the teacher can use the cut-and-paste features of the computer to draw attention to the design of a composition.

Finally, the computer performs—it plays the music or draws the picture. Using a computer, the novice, who is often preoccupied by the demands of performance, can begin to engage deeper problems of aesthetics, can develop a feeling for the overall structure of a composition, or can explore how individual variables alter the composition as a whole. Again, the computer does not eliminate the need for performance by an artist. Instead, it creates an environment in which one can engage artistic problems quite apart from performance; and in so doing, the computer differentiates performance from other compositional considerations.

Concluding Remarks

The potential of the computer must always be described in light of its liabilities as well as its assets. For many tasks, computers are still clumsy,

slow, and even "stupid." For other tasks they are quite efficient. In this paper we have tried to describe some of the features that give the computer its unique capabilities.

The computer can provide an entry into higher levels of artistic problem solving, especially for beginners. It provides the user with a flexible "sketchpad" on which ideas can be quickly sketched and changed, where experiments can be conducted, and in which contrasts can be drawn. The computer also reduces the artistic image by simplifying certain elements; this produces an impoverished image, but one in which certain details actually come into sharper focus. Again, in the instructional setting, this focus can be used quite dramatically.

Finally, it should be evident that computers do not address all areas of arts education, but that within selected areas, they suggest an interesting and perhaps vital potential. And yet serious and effective incorporation of these machines into the arts curriculum will require creative construction of tasks that mobilize these features most effectively. Without the proper context, illustrative problems, and appropriate instruction and critique, computers cannot be meaningfully incorporated into the curriculum. Development of this curriculum appears to us as the appropriate next step.

We are using the Macintosh computer from Apple in our investigation. It has the required high-resolution screen and music synthesizer, and it is well supported by computer programs for a variety of art forms. The computer programs we are using include Deluxe Music Construction Set (Electronic Arts) and Music Works (Macromind), MacDraw (Apple), Thunderscan (Thunderware), MacVision (Koala Technologies), and Superpaint (Silicon Beach Software). We found that indeed, as advertised, the Macintosh is easy to learn. With a little guidance and support from us, our subjects, most of whom were inexperienced in the use of computers, could work independently with the Macintosh in a few minutes.

The research described in this article was supported by a grant from the John and Mary R. Markle Foundation, New York. We wish to thank Howard Gardner and David Perkins for their comments on earlier drafts.

Art as Understanding

D. N. PERKINS

Why do people bother with art at all? When you think about it, dealing with art is often hard. Was Hamlet really hung up on his mother? How do we tell, and does that way of looking at things really help us to grasp the play better? Who is this guy "Godot" we seem to be waiting for? The *Mona Lisa*'s smile means just what? How does Picasso's *Nightfishing in Antibes* speak to us? How does Bartók's *Music for Strings, Percussion, and Celesta* make sense to our ears?

Of course, we could avoid hurting our heads by sticking to easy art—sitcoms and comic strips, paintings of puppies with big eyes. But even so, why bother with art? Unless we are professional artists who put food on the table through our art, what does art really buy us? To get biological about it, not mates nor territory nor den. Art seems to be a thoroughly loopy pursuit with no natural place in the physical or biological universe. Sure, one could say simply that art is enjoyable. But why should such a blatantly nonbiological pursuit be enjoyable?

Anyhow, we seem to be stuck with it. Every civilization has it in one form or another. So, if the disease is incurable, we might as well ask another question too: What does it take to bother with art *well*? How do we unlock the secrets of Shakespeare, Beckett, da Vinci, Picasso, Bartók? In general, what do we do to unwrap the impact and meaning packaged in works of art? If we ourselves engage in the making of art, how do we package impact and meaning in ways unwrappable by at least a few other fellow human beings?

Of course, such questions are a little like Rorschach inkblots: they allow answers as different as demons and daisies. The answers offered here will spin out the implications of one theme: art as understanding. Indeed, the title phrase has a double sense, one for each of the two questions addressed. Why do we bother with art at all? The suggestion is: art engages our psychological resources of understanding. Second, what does it take to bother with art *well*? The suggestion is: attention to how we understand

the endeavors of appreciating art and making art. With sound understandings of these endeavors, chances of success are greatly increased. Unfortunately, a number of wrong understandings tend to get in the way, for understandable reasons.

The theme of art as understanding also provides an occasion to look at several strands of thinking and research pursued by me and my colleagues at Project Zero during two decades. The crosscutting character of understanding—as relevant to science or mathematics as the arts—suits my own interests particularly well. Sometimes the arts have been the principal focus, as in the edited book of Project Zero work *The Arts and Cognition* (Perkins & Leondar, 1977) and in Perkins (1978, 1979, 1983). On other occasions, inquiries have ranged into such areas as informal reasoning in everyday life (e.g., Perkins, 1985; Perkins, Allen, & Hafner, 1983), the programming of computers as a cognitive skill (e.g., Perkins & Martin, 1986; Solomon & Perkins, in press), and the development of general skills of thinking and learning in artistic and nonartistic contexts, as in *The Mind's Best Work* (Perkins, 1981), *The Teaching of Thinking* (Nickerson, Perkins, & Smith, 1985), and *Knowledge as Design* (Perkins, 1986). Most of the research, whether on art or not, has dealt in one way or another with how individuals understand what they are doing and how they try to guide their efforts by way of those understandings.

Two Oddities and a Sort of Parallel

If understanding is so important here, what is understanding itself? Actually, not cases of understanding but cases of misunderstanding yield the most insight, because they illuminate understanding by showing how it can go wrong. In recent years, a prime resource for investigators of understanding has been a field of inquiry commonly called "physics misconceptions." Research has disclosed that many high school and college students, even after considerable conventional instruction in physics, give mistaken answers to simple qualitative questions about physical situations. While they may nimbly manage the mathematics of standard textbook problems, their replies to qualitative questions often disclose profound misconceptions living side by side with their technical skills (e.g., Clement, 1982, 1983; McCloskey, 1983).

Consider this case in point. Suppose you present a student with a curved line representing the trajectory of a thrown ball—it rises in a parabola, peaks, and descends again (Clement, 1982; McCloskey, 1983). You ask the student to indicate the forces at work on the ball when it is halfway up, at the crest, and halfway down. At the position halfway up, students commonly draw two arrows. One pointed downward represents the force of gravity, which is gradually stealing motion from the ball; the other,

pointed upward, represents the upward force of the toss, gradually getting worn away by gravity. From the standpoint of Newtonian dynamics, this reply is grievously wrong. Only one force operates—gravity. There is no upward force reflecting the original toss and sustaining the ball's motion, but only the momentum of the ball. Yet the student feels that two forces are somehow at work.

One can easily see where the spurious force comes from. It is intuitive to think of motion as somehow sustained. An object does not just move along by itself, but needs an agency to keep it moving along. So the students' replies certainly merit some sympathy and empathy. What is surprising, though, is that they have not edited out of their problem-solving activities this intuitive response, because it is directly contrary to a principal insight of Newton that the students know and can apply to textbook problems: an object *does* keep moving all by itself unless a force intervenes. So, faced with the ball problem, the students should realize that there is no need for a second force to account for the ball's continued although dwindling upward motion.

Now consider an example from the arts, and indeed reported elsewhere in this collection: the response of musically naive and sophisticated individuals to a request to notate a simple melody (Davidson, Scripp, & Welsh, this volume, with personal communications about the details of students' errors). These investigators report that in certain ways students in the midst of conservatory training perform the task *worse* than naive students, both youngsters and adults. To be sure, the musically sophisticated students use formal music notation whereas the musically naive participants invent their own notations, which may lack precision and consistency. Nonetheless, the sophisticated students often make mistakes not present in the novices' efforts, mistakes where notational habits and presuppositions override attention to the music itself.

For example, in notating "Happy Birthday," sophisticated students often show the piece beginning and ending on the same note. Many musically naive subjects, on the other hand, properly represent the melody as ending on a higher note. The sophisticated students may say something like, "A piece begins and ends on the same key." This rule actually distorts the correct rule—a piece generally begins and ends *in* the same key, say C major or G minor, but not necessarily *on* the same key (that is, the same note). For another example, the conservatory students often project onto "Happy Birthday" a 4/4 time signature, perhaps because it is so common. Unfortunately, "Happy Birthday" follows 3/4 time. Unfamiliar with this trend in formal notation, the naive students generally indicate some kind of grouping by threes.

What can we make of these two cases of misunderstanding from two such different domains? For some similarities, in the examples from phys-

ics and music alike, a notational system has been mastered. Moreover, in each example another level of experience figures—what might be called a perceptual or even "gut" level. In the case of physics, this apparently has to do with a kind of kinesthetic sense of what motion in space ought to be like: a ball moves through the air as though there were an invisible hand pushing it. In the case of music, the perceptual level has to do with the learner's discriminating response to the pitches and rhythms of the melody. In both the music and physics examples, a mistake is made in coordinating the perceptual with the notational.

While these similarities obtain, the mistake occurs in different directions in the two examples. In the ball problem, the perceptual intuition dominates over notation and linguistic rules, the students failing to see that a central principle of physics known to them conflicts with the perceptual intuition. In the music task, notational habits dominate over perception, the students failing to recognize that the melody they hum and hear conflicts with the notes they jot down. Let me suggest that this difference in direction of error does not mark any deep contrast between physics and music in general. By choosing examples appropriately, one could no doubt devise physics tasks in which notation blindly applied overrides a correct physical intuition, and musical tasks in which a misleading perception overrides sound notational practices. The point to take to heart here is that notation and perception can be out of synch, with either one correct depending on the circumstances. Understanding what you are doing seems to have something to do with being *in* synch.

An Outline of Understanding

With these examples in mind, it's possible to make some general points about the nature of understanding and misunderstanding. Five characteristics of understanding are highlighted below: relations, coherence, standards of coherence, generativity, and open-endedness.

The Role of Relations in Understanding

What is it to understand something? In the physics and music examples, *relations* between notations, perceptions, and the world itself—the actual behavior of the ball or music—were crucial. In general, one might say that understanding is weblike. Understanding involves knowing how different things relate to one another in terms of such relations as symbol-experience, cause-effect, form-function, part-whole, symbol-interpretation, example-generality, and so on. Broadly speaking, understanding something entails appreciating how it is "placed" in a web of relationships that give it meaning. At the highest level of generality, there do not even seem to be very many of these relationships—those listed and perhaps a dozen more.

It is easy to show by example how this makes sense. To stick close to art, consider the artist's paintbrush. What does understanding this simple tool amount to? Basically, knowing what it is for (thing-function relation), how it works in various ways (form fits function relations), where it comes from (cause-effect relation), and so on. Curiously enough, understanding something as abstract as Newton's laws involves a similar web of relations— what are they for (thing-function relation), how do they serve their purpose (form fits function relation), why do they hold (evidence-conclusion relation)? For another example, understanding a work of art also seems to involve a web of relations. Your understanding of a poem, for example, involves apprehending what it symbolizes in the broadest sense (symbol-meaning relation), how it goes about doing that (form fits function relation), where it sits in relation to other poems and other genres (comparison and contrast relations), and so on.

The Role of Coherence in Understanding

If understanding something is a matter of seeing how the something sits within a web of relationships, one measure of adequacy of understanding becomes how well this web hangs together. For instance, the examples of misunderstanding discussed earlier both involve broken webs. In the physics misconception, a person has a set of rules well coordinated with the way objects in free fall behave, and a set of rules well coordinated with the way objects in contexts of high friction behave, but little coherence between the two parallel systems. In the case of the music example, the person has rules that govern notational practices not well coordinated with the sounds the person hears, or ought to hear. In general, understanding something involves building a web of relations coherent in itself and with the world outside the organism.

The Role of Standards of Coherence

A poem may be full of paradoxes, but a theory of physics had better have none. What are we to make of this, especially considering the emphasis on coherence in understanding? Do the paradoxes in a poem disqualify it as a vehicle of understanding? Of course not. Rather, the kinds of coherence that count vary from context to context. A poem ought to be coherent in its symbolism, for the sake of unity and impact, but can revel in paradox, because, for one thing, the paradoxical dilemmas of human existence may be just what the poem examines. Where the business of a psychological science may be to make sense of those paradoxes of human existence, dissolving them in some overarching coherence, the business of a poem may well be to make sense of them in quite another way—presenting an amplified and intensified image of the human condition.

The Role of Generativity in Understanding

Of course, merely knowing a coherent web of relations is not enough. Imagine a person who had memorized the symbolisms, mechanisms, causes, and so on, of an artist's brush, Newton's laws, or a poem. It would be odd to say that this person understands, since the person might be able to do no more than parrot the rehearsed relationships.

Suppose, on the other hand, that the person selects a brush suited to the occasion, wields it more or less appropriately if clumsily, matches his or her handling of the brush to the demands of the moment. When the person's web of relations about the brush plays out in action in response to the demands and opportunities of the moment, then we are readier to say that the person understands the brush. Indeed, this playing out in action—whether physical as with the brush or symbolic as in derivations using Newton's laws or novel commentaries about the poem—seems a much more relevant test of understanding than reciting relationships from memory. An inarticulate person who could say nothing about the brush could show sound understanding of it through generative use.

The Open-ended Character of Understanding

If understanding is a matter of knowing and playing out a web of relations about something, then when do you understand it all? What is it to "fully understand"? Plainly, this is an endless quest. What is it to understand the sun? As a child, I learn the word that stands for the presence in the sky. I learn some effects of the sun—warm days, cold nights. Later, I learn some physics of the sun: the earth rotates around it, it's a big, continuously exploding hydrogen bomb. I also learn of metaphoric and symbolic uses. "Juliet is the sun" teaches me by example about the sun as a well of resonant associations; Van Gogh's sunflowers bind joy to sun to flower to wilting and death. Thus the web grows. When we say we understand the sun or anything else, the most we could mean is that we understand some things about it adequately for certain purposes.

The Origin of Understanding in Sapience

The account offered of understanding emphasizes the importance of relations, coherence, varying standards of coherence, generativity, and open-endedness. The examples given illustrate how understanding involves these characteristics. But why? Why is understanding the way it is?

A rough answer comes from considering the job understanding is supposed to do and, hence, what understanding has to be like to do it. To start with, imagine an unintelligent but mobile organism living in a complex environment. Inevitably, this organism faces dilemmas about its conduct. What should it do first, next, and later to evade danger, feed, keep healthy, and reproduce? Evolution answers such questions primarily

through genetic programming. The organism does not understand anything about its lot, but displays an array of behaviors "designed" by natural selection to keep it on a successful track of survival and reproduction. Those organisms not so well programmed for this track are selected out, and their programs die with them.

Now imagine a *sapient* organism in the same situation. What do we mean by "sapient"? Not to hang a lot of baggage on it, simply that the organism can know and come to know things—can in various ways represent things to itself about the world—potential courses of action, likely consequences, and so on. The question is: What sorts of knowledge and knowledge processing would this organism need to go about its business of living? The plausible answer is: relational knowledge. The organism needs to know what causes what in order to do itself good and avoid harm, what things are made of to make the things it must have, what generalizes what to forecast likely events in unfamiliar circumstances, and so on. To keep track of things, the organism needs to symbolize to itself, and perhaps to others of its kind, all this and hence needs to make up, or learn from others, symbol systems. In other words, the sorts of relations mentioned before are inevitably important for this sapient organism.

What about the other characteristics of understanding—coherence, standards of coherence, generativity, open-endedness? As to generativity, a web of relations that just sits in an organism's head will do it no good. The organism builds a web of relations principally to play them out in actions (including symbolizing actions). Moreover, the inherently open-ended character of this enterprise should be clear. The organism can always build deeper and wider models of the way its world works; there is no intrinsic limit.

As to coherence, the web should be coherent with the world to ensure sound predictions. It should be coherent within itself to ensure well-coordinated action; otherwise, conflicting counsel could come from different parts of the web, with consequent delays and possible disaster. Therefore, upon detecting incoherences in its web of understanding, the sapient organism will be moved to try to sort them out, weaving a web not so flawed. At the same time, it's worth noting that incoherent elements are not shunned when isolated from one another or when they actually serve the purpose at hand. Thus we have Sunday Christians who are cutthroat used-car salesmen and poems that celebrate paradox. That is, from the different enterprises an organism engages in emerge different degrees and kinds of demand for coherence—different standards of coherence.

Art as Understanding

So the characteristics of understanding highlighted earlier are no accident; they follow from the needs of an adaptive sapient organism. However, this

functionalist view of understanding does not imply that understanding always directly and doggedly serves pragmatic purposes such as survival and reproduction. We human beings often spend our resources of understanding on exotic quests into the nature of black holes, non-Euclidean geometries, quarks, prime numbers, and quasars. Although the causal roots of understanding may be functional, understanding plainly has a life of its own as a human motive.

That point in turn helps to explain one of the two questions that began this essay, Why do people bother with art at all? When you think about it, through and through the arts engage our mechanisms of understanding. In looking at a painting, reading a book, listening to a symphony, we encode, anticipate, project, ponder, conceive—constructing and operating on and through webs of relationships. When we make works of art, we also deal with such webs, crystalizing them into overt symbols such as paintings, poems, or symphonies. In other words, the appreciation and making of works of art inevitably and profoundly involve the application of our apparatus of understanding in various modes and directions. We bother with art, and many other "impractical" pursuits, because such activities play out our powerful motive as sapient organisms to operate our understanding system (cf. Goodman, 1976, Chapter 6).

This broad replay does not, of course, forbid acknowledging a number of other motives that apply here and there in fostering attention to art. For example, economic motives have an obvious role—art is a way of earning a living for those who have the talent, luck, training, and fortitude. On the audience side, considerable literary, visual, and dramatic art concerns such primary drives as sex, survival, and the acquisition and defense of territory. Presumably, this art attracts in part because it taps into these strong currents of human nature. However, if economics and primary drives were all there were to it, art would be a much more reductive enterprise than in fact it is. Pornography and Mickey Spillane would be all the art we had. Instead, we make and enjoy art that is subtle, abstract, alarming, depressing. Plainly something far beyond self-gratification is at work. The "something," as Nelson Goodman (1976) urges in *Languages of Art*, is the engagement of our mechanisms of understanding. Nothing else seems to have the breadth to account for the diversity of art.

Perhaps this offers a serviceable answer to the first question raised; but what about the second, What does it take to bother with art *well*? The concept of understanding might help with that one too. The key idea is this: In significant degree, we act out of our understanding of an activity. We try to proceed in accordance with what we understand the activity to invite and demand. Applied to art, this principle argues that bothering with art well involves understanding well what the activity invites and demands. But how do people reach such understandings? In fact, do they

generally reach good understandings at all? It is not hard to imagine that activities as complex as making and appreciating art leave room for a variety of *mis*understandings that impede bothering with art well. The next two sections continue the theme of understanding, focusing on how the enterprise of art can be understood and misunderstood.

A Case in Point: Seeing the Art in Art

How do we look at a painting, sculpture, or other work of visual art? As just noted, surely how we look depends in large part on what we think the action of looking invites and demands. Such an understanding need not be verbally articulated, of course, but may rest in a tacit mental model of looking at art. Unfortunately, whether articulate or not, a seemingly adequate understanding can easily be incoherent in subtle ways. A tour of several understandings shows how.

Look and See

One common understanding of what it is to look at a work of art might be characterized and slightly caricatured as "look and see." The art is there. To see it, you just look at it. However naive, this stance nonetheless persists among populations only passingly acquainted with art. It also fuels disdain for any art that does not prove immediately beautiful or at least interesting. The attitude seems to be this: If one looks and does not see anything worth the effort, it must be that the work has failed.

We can better understand this understanding of the looking endeavor by examining its coherence and incoherence. The "look and see" understanding posits a simple causal relation between perception and the act of pointing the eyes. In this respect, the "look and see" understanding offers a strong coherence between looking at art and looking at many other things the world presents—barking dogs, clothes on a line flapping in the wind, a beautiful sunset, and so on. As a general rule, for the salient things of the world, pointing one's eyes suffices for seeing; indeed, this is virtually what we mean by "salient."

However, while coherent with this rule of thumb for everyday seeing, the "look and see" understanding of looking at art is incoherent with the realistic demands of the activity. Art often does not yield up its secrets to the casual look. While the surface of the painting proves visible enough, what might be called the art in the art is invisible (cf. Perkins, 1977, 1983). Looking is not enough; the art in the art must be looked *for*. One sees the cow in the painting, but misses how its brindled browns echo the patchy mountains; one sees the tree, but misses how its moody branches clutch at the sky; or, in an abstract, one sees the colors, but misses their dynamics, how they romp along left and right across the canvas.

How is it that this incoherence is not noticed and the "look and see" model survives? An explanation comes easily enough: until one understands what sorts of things one *might* find by deeper looking, one has no ready way of knowing that one is missing anything. Like H. G. Wells's invisible man, much of the art in art is an unsuspected presence. If you fail to see a stick on the street, you may trip over it and hence learn to look with greater care. But if you fail to see the art in the art, typically there is not much for you to trip over to alert you to what you have missed (in the absence of any sort of commentary from others to guide the eye). So you simply go along to the next painting. Thus, the logic of the circumstances speaks clearly for the importance of educating the eye.

Art-historical Looking

Another much more sophisticated understanding of looking at art emphasizes its art-historical context. Such looking "positions" the work in a web of historical relations -artist, genre, period, characteristics of brushstroke, theme, composition, and so on. The work is seen as defined primarily by its locus in that web. To make an analogy that, again, caricatures just a bit, one might ask, "What is Miami?" and answer, "Miami is a city in the United States located on the eastern coast of Florida toward the southern end." This tells you nothing about what Miami is like on the inside, but a lot about how Miami relates to the geography around it (assuming you know something about the general geography of Florida and the United States).

The analogy offers a clue to the coherence and incoherence of an arthistorical understanding of looking at art. The art-historical understanding celebrates what might be called the "outer relations" of the work, the relations of similarity and contrast, precedence and response, that connect it to other works of its time and earlier and later times. In this respect, good art-historical looking weaves a tight coherent web. On the other hand, art-historical looking pays much less heed to how a work of art works within itself. To be sure, part of seeing a work in its historical "position" involves looking into the work in considerable detail—but looking into the work in order to position it simply is not the same enterprise as looking into the work to see how *it* works.

This underemphasis on "inner relations" entails a certain incoherence between the work and the mental model the art-historical viewer builds of it. Works of art are not in general designed by artists to occupy particular positions in the landscape of art history (although sometimes works are fashioned to do just that). Most typically, works are constructed to work upon the viewer, engaging, provoking, informing, and moving the viewer through their internal structure (cf. Arnheim, 1964, 1969; Beardsley, 1958). Therefore, the categories of art history tend to be somewhat inco-

herent with the design of the work; they lead to a pattern of highlighting and underplaying that is out of synch with the work as it is meant to engage the viewer.

How is it that this incoherence survives? Well, in a way it does not survive. Many viewers feel uneasy with pure art-historical viewing and recognize its limits. Many viewers involved in art history are not *only* art-historical lookers but, simultaneously, viewers in other senses as well. In these respects, there is no great mischief to an art-historical understanding of looking at art, because quite commonly that understanding does not stand alone.

One gets uneasy, though, when an education for the eye entirely follows the path of art history. Such a practice leaves it to happenstance how the viewer will achieve other understandings of looking at art and gain entry to the inner relations that help a work of art engage the viewer. For just one illustration of a shortfall in practice, museum labels doggedly offer nothing but art-historical relations in their brief captions. Labels that also suggested what to look for would be welcome.

The Art in the Art

A few years ago, some colleagues and I conducted a teaching experiment under the name "invisible art" (Perkins, 1983). This experiment aimed to convey an understanding of looking at art that highlighted "the art in the art," which tends to be invisible for the novice viewer. We emphasized what we called "aesthetic effects." An "aesthetic effect" was any of several aspects of art that, we judged, carried the "kick" or "oomph" of works of art. The instructional experiment highlighted four categories of aesthetic effect—motion (and stillness), mood, personality, and surprise. The instruction encouraged youngsters (fourth to seventh graders) to look not just for literal but for "suggested" effects. For example, one might find in a superficially motionless night scene by Van Gogh a tumult of swirling motion conveyed by the brushstrokes, in a landscape a sombre or peaceful mood, in an abstract painting a frisky or aristocratic personality. The experiment also encouraged students to examine *how* the artists got their effects. The results were quite successful; the youngsters on the whole proved able to look for and find aesthetic effects in works, including the nonliteral "suggested" effects, and many had striking things to say about the varied works employed in the instruction.

This investigation of an "aesthetic effects" understanding of looking at art was an effort to get beyond the naive "look and see" understanding and, at the same time, to emphasize the "inner relations" of works rather than the "outer relations" highlighted by art history. More, the effort sought to focus on certain relationships judged especially important. For instance, although much can be said about relations of colors within

works—contrast of complementary colors, compressed spectrum of hues in certain works, and so on—we did not make this a primary category; rather, such matters were discussed in terms of how they helped a work to surprise, convey motion or stillness, project mood or personality. One might say that relations among colors were treated as part of the mechanism of a work, while matters like surprise, motion, mood, and personality were treated as payoffs of the work. We felt that this way of handling relations was highly coherent with the ways works in fact engage viewers.

Inevitably this emphasis carries its own narrowness. Deliberately neglecting an art-historical understanding, it certainly slighted that important way of looking and allowed incoherence with the wide world of an art-historical perspective. However, that could be remedied by an expanded program of instruction. More alarming to many people would be the analytical approach of the "invisible art" experiment, which collides with yet another way of understanding looking:

Holistic Looking

Part of many people's understanding of looking at a work of art is the notion that you can understand so much that you spoil the process. Looking becomes a dissective analytical exercise when instead one should always look holistically. This holistic understanding brings with it a serious dilemma. On the one hand, people commonly do not spontaneously see what works of art have to offer—the art in the art is invisible. On the other, the anti-analytical emphasis of a holistic view implies that to understand what to look for and try to look for it is to fall into a mode no more adequate, albeit inadequate in a different way. Caught between two hazards, what is one to do?

But perhaps holistic looking is not really needed to avoid the risks of analyticity. Here again, there is value in examining the coherence and incoherence in the holistic understanding. The fear of analysis has high coherence with several elements of culture and experience that consequently keep it entrenched. Various popular slogans echo similar concerns in other domains, for instance the well-known notion that a centipede who thought about what its legs were doing would trip all over itself. The notion that analysis does mischief also has high coherence with many experiences of art-historical analysis, since, though they may yield art-historical insight, they often seem to fall far from the agenda of experiencing the work as art.

An anti-analytical view also has high coherence with experiences of analyzing works according to numerous internal relations—such as the color relations mentioned above—where again the resulting account seems somehow to fall far from experiencing the work as art. Finally, imagine that one has attended with care to the sorts of payoff relations mentioned

above—evocations of surprise, motion, stillness, mood, and so on. Even then, one might find that analysis yielded a dry harvest, left as one is with a list of characteristics of the work. In sum, many familiar experiences appear to recommend holistic rather than dissective looking.

But there is a problem. The holistic understanding of looking at art is only superficially coherent, a self-consistent account of matters that however fails to be coherent with some important realities. Let us look at each of the concerns mentioned again. As to the "centipede" worry, this is simply an overgeneralization. Never minding centipedes, take human beings: is it true that if we think about our walking we will stumble? Try it. You can perfectly well introspect as you walk and discover interesting things about the process, while the process itself continues to run off as automatically and robustly as ever. However, perhaps what is at issue is not just thinking *about* but thoughtfully trying to *control* our walking as we walk. But when you walk on ice or climb a rocky hill, you exercise exquisite control, and yet stumble not more but less than you would otherwise (cf. Perkins, 1981, Chapter 1).

To be sure, if you try to direct your walking by controlling the individual muscles in your legs, your walking becomes somewhat more awkward. But this is only to say that certain very specific kinds of thinking about our walking mess things up a bit. To hold that thinking about what you are doing messes it up in general is a sweeping generalization easily disconfirmed by three minutes of personal experimentation. More broadly speaking, the coherence of a holistic approach with other popular beliefs is a coherence of myth, itself out of synch with reality.

Now what about the cases of art-historical analysis or analysis in terms of color relations? Consider the causal attribution a holistic understanding makes: it is the analytical character that causes the inadequate results. But this interpretation ignores an important distinction between analysis as a method and what gets analyzed: it can be argued that the *content* analyzed out—art-historical attributes or color relations—is not payoff content, at least not in terms of the way works of art function aesthetically. That is, not dissection per se, but a slice badly chosen for developing an aesthetic rapport, is the cause of the trouble.

Now for the more difficult case ; what about the person who attends to what were called payoff relations but still feels left out of the art? Here a key question needs to be asked: Does the person look at the work of art again or stop after identifying some payoff characteristics analytically? Let me suggest that identifying payoff characteristics yields a considerably amplified and intensified perceptual experience, *if* you continue to look at and reexperience the work rather than just jotting in your notebook or going off to write a short paper for the professor. In other words, it is not dissection that detaches one from the work, but failure to shift attention

back to the work as perceptual whole, having done the labor of dissection.

Taken together, what do these arguments suggest? They urge that a holistic understanding of what it is to view a work of art, which asserts that analysis offers no worthwhile entry into works, has a superficial coherence. Examined with more care, the "centipede" stories prove mistaken, and the experiences that seem to sanction a holistic understanding allow quite different interpretations. However, a holistic understanding none-theless proves robust because it has a simple surface coherence. Getting people beyond it involves getting them to understand something in a truer but more complicated way, always a difficult enterprise.

Mute Looking

A final understanding concerns the relationship between what we see and what we say (Perkins, 1977). There is a "mute" understanding of looking at art that says, roughly, "Talk about art is bound to be empty. Words sim-ply lack the precision and evocativeness to capture the intensity and nuance of deep engagement with a work of art."

By now, the method should be clear: One needs to examine how this understanding has a certain coherence, as all understandings must. Then one needs to probe for incoherence that the superficial coherence might hide. For a start, the "mute" understanding proves coherent with many of the experiences discussed above—finding art-historical discourse beside the point, feeling that an analysis of color relations misses the heart of the work, and so on. Where the holistic understanding places the blame on the analytical character of the procedure, the "mute" understanding places the blame on its verbal character.

The "mute" understanding shows coherence with another slice of ex-perience as well, the inadequacy of verbal accounts that try to recreate the experience of a work. Some critical writing, through metaphor, hyper-bole, and other tropes, seeks to evoke in the reader what it would have been like to stand before the painting itself. While such writing can be helpful (although at the extreme it becomes comic), actually standing in front of the work in question inevitably provides a quick demonstration of the shortfall.

With these aspects of coherence identified, it is easy to appreciate why the "mute" understanding survives so persistently. Yet, as with holistic looking, the coherence masks some serious incoherence. One example can be brought forward directly from the discussion of holistic looking: Mute looking attributes various shortfalls to words, just as holistic looking attributes them to analysis; yet most typically the problem is content rather than manner—a matter of attending to the wrong things rather than a matter of attending in a verbal or analytical manner.

Another incoherence concerns the presumption in "mute looking" that

the aim of discourse is somehow to capture the work in words. For all sorts of reasons, such an enterprise is bound to fail. Even if the work of art is *already* in words, as with a novel or a poem, someone else's words are likely to render it inadequately. Moreover, words do not suffer any special inadequacy here: repaintings of other people's paintings or recompositions of other people's symphonies are no more acceptable. Fundamentally, the phenomenon of "nonrecomposibility" traces back to the properties of repleteness and density characteristic of artistic symbols, emphasized by Goodman in his *Languages of Art* (Goodman, 1976; see also Perkins, 1977).

With this difficulty in view, it has long been recognized that the primary function of discourse about art should not be seen as one of recreating experiences of works. Rather, among other things, discourse serves to sharpen, amplify, and deepen experiences. The right word, when one is standing in front of a work or even has in memory an experience of it, may help one reorganize one's perceptual experience of the work, disclosing dimensions previously missed (cf. Ecker, 1967; Goodman, 1976; Ziff, 1964). This notion of the interaction between word and perception differs radically from the "words recreate the work" idea and offers compelling reasons why looking need not be mute; why, indeed, looking coupled with discourse that guides the looking will often see much more.

Why Understanding Better Is Hard

What perspective on looking at art results from reviewing these various understandings of the enterprise—"look and see," "art-historical," "aesthetic effects," "holistic," and "mute"? First of all, one realizes that understandings of the enterprise certainly matter in practice, because how one understands gets played out in what one does. The "look and see" understander will probably just look and see whatever handily presents itself. The "art-historical" understander will look through the categories of art history and may miss much of what the work has to offer, as well as feeling oddly put off for not finding more. The "aesthetic effects" understander will look for and find many aesthetic payoffs in the work, particularly if the individual takes pains to re-experience the work after the analytical hunt for particular effects. The "holistic" and "mute" understanders (often the same person) may acknowledge the value of experience and the trained eye, but will constrain their serious looking to a kind of mute spontaneity that leads to shallow engagements with works. Of course, similar hazards threaten the appreciation of any art—music, drama, poetry, novels, or whatever. It has simply been a convenience to discuss the context of the visual arts.

In addition to the consequences of various understandings, the stability of flawed understandings becomes comprehensible. All the understandings

of looking at art discussed have considerable coherence, else they would not survive as understandings. Treating the less adequate understandings as mere anomalous error would miss the coherence they possess. It becomes clear that reaching a more sophisticated understanding of looking at art involves not just organizing inchoate attitudes toward art, but, often, displacing fairly well-organized relational webs that contain stable philosophies of looking. As in mathematics, the sciences, and many other domains, conceptual advance calls for the breakdown and displacement of prior conceptual structures and the incorporation of pieces of them into webs with a new coherence. Often the new coherence is more complicated, although more deeply coherent, making the more sophisticated understanding less accessible and guaranteeing that the transition will come hard.

Art and Invention

The same perspective applied to appreciating works of art suits just as well the creating of them: creating works of art calls for understanding what the activity invites and demands. But creative thought, perhaps even more so than response to art, allows a number of misunderstandings that get in the way. In *The Mind's Best Work* (Perkins, 1981) I have written extensively about the misunderstandings that mar our grasp of creative thinking, so I will limit the present discussion to three quick examples.

Making Art Is an Intuitive Process

It is easy to see the surface coherence of this understanding. The term "intuitive" implies, roughly, lacking articulate reasons. Thus, the notion that making art is an intuitive process displays a strong coherence with the romantic image of the artist scribbling madly at a desk in the wee hours of the morning or struck by inspiration and rushing to the studio. More coherence emerges from the style in which many authors write about creative thinking (e.g., Grumbach, 1986; Koestler, 1964; Lowes, 1927). The notion also coheres well with much of our experience of art as audience members: we are often seized by works of art, pushed here and there by them without quite knowing what is happening unless we pause and reflect. We reason reflexively: like art, like artists, who must have proceeded similarly to produce the work.

However, all this is deceptive coherence. The romantic image is a historical remnant; while the tone of many authors' discussions of creative thinking suggests an "intuition" theory, what they actually say often is quite compatible with some skepticism about invention as pure intuition; and what it is like to experience a work may have little to do with how the work was made. Plentiful evidence argues that artists develop works with considerable intentionality and know and can articulate a good deal about

what they are trying to do and why (Getzels & Csikszentmihalyi, 1976; Perkins, 1981).

Genius Is Fluent

The play *Amadeus* highlights another prevalent understanding about the creation of art: genius is fluent; the truly gifted artist creates almost effortlessly. This understanding coheres well with the evidence that tends to come to our attention—tales of prodigious fluency propagate better through society than tales of painstaking labor. The understanding also is coherent with our experience of much art, which looks or sounds fluent, effortless, inspired. Unfortunately, as has often been pointed out, the latter often reflects the hard work of the artist striving for just such an effect. In general, extreme fluency in producing high-quality works seems to be quite rare, nor does any systematic relation between fluency and quality appear to emerge (Perkins, 1981, Chapter 6). The obvious counterfoil to Mozart, for example, is Beethoven, who is known to have labored mightily over his works.

Making Art Is Communicating One's Emotions

This understanding shows great coherence both with the romantic tradition and our experience of works of art. For instance, because we are moved by a work, it is natural to think that the artist was moved likewise and moreover that the very depth of the artist's feeling provoked the artist to create so moving a work. Furthermore, research shows what one would expect: artists are very personally invested in their work (cf. Barron, 1969, 1972; Getzels & Csikszentmihalyi, 1976), as indeed are scientists (Roe, 1952a, b).

But the fallacy is plain: many people feel all sorts of things very deeply without the least ability to construct works of art that convey those feelings. Also, because artists and scientists feel passionately involved in their pursuits, this does not mean that communicating these feelings is what they try to do. In poetry as in physics, the maker's agenda for the emotional tone of the product may be quite a different thing from the maker's feelings of involvement in creating the product. Indeed, it seems clear that artists often calculatedly craft works of art that move audiences powerfully. Moreover, some kinds of emotional impact seem particularly unlikely to be felt by artists. For instance, authors much of the time will already have decided what is going to happen at the end even as they write the middle chapters. In writing to create suspense, they need not feel suspense.

Finally, the distinction between feelings and expression needs making: because a work of art expresses sadness, this does not mean that either the artist or the audience need necessarily feel depressed (Goodman, 1976, Chapter 2). Although we as audience members "read" the work for its

expression and recognize its expressed sadness, how we feel is another matter. For instance, if you are already feeling down, a cheery work may make you feel even worse. In general, the notion that art recreates in the audience member the emotions of the artist is a very muddled one that nonetheless survives because of its simple surface appeal.

These examples suffice to illustrate how the same pattern exposed for looking at art plays itself out in the creation of art: there are many ways to misunderstand what the activity invites and demands. Moreover, the misunderstandings have adverse consequences for the activity. If you believe the making of art is intuitive and you catch yourself thinking about what you are doing, you may try to stop yourself or feel the results are somehow inauthentic. If you believe that genius is fluent and find that you are not, you may give up altogether. If you believe that art communicates your deepest feelings, you may search out the deepest feelings you have, supposing that you need only drain their energy out onto the page or canvas.

Finally and most crucially, the misunderstandings have coherence. They are not mere slips, like typographical errors, but highly patterned webs of relations sustained in multiple ways. Better understandings depend not only on more knowledge, but also on finer distinctions that the misunderstandings do not make. Better understandings are thus often more complex and so all the harder to achieve.

Toward a Pedagogy of Understanding

This exploration of art and understanding began with two questions: Why do we bother with art at all? Since we do, what does it take to bother about art *well*? The first question found an answer in the nature of understanding, in turn rooted in the nature of sapience. Artistic engagement emerged as a special case of engagement in the kinds of processes crucial to understanding—building and revising relational webs.

Now, what does it take to bother about art *well*? Clearly, this question has many answers—matters of training, talent, luck, and so on. However, chosen for emphasis here was the role of understanding. "Bothering well," it was urged, depends in large part on one's understanding of the nature of the enterprise, since in large part one acts out of that understanding. The catch is that a number of alternative understandings are likely to apply to any particular activity—for instance, appreciating or creating a work of art. Many of these understandings are coherent enough to have stability but house a subtle incoherence that stands in the way of bothering about art as well as one might.

So what might be done about this? The circumstances invite what might be called a "pedagogy of understanding," an approach to education

designed to take into account the role of understanding, and alternative understandings, in artistic (and other) activities and to help learners toward more deeply coherent and powerful understandings. Of course, desire for a pedagogy of understanding is hardly new. Most everyone wants such a pedagogy, and many educators seem to think that they have one. But it is hard to look at most of the approaches that exist and be impressed by their results.

With the present analysis of understanding in mind, what might such a pedagogy be like? The characteristics of understanding outlined earlier offer some clues. Since understanding something involves building relational webs emphasizing a few broad categories of relations—cause-effect, symbol-meaning, and so on—education in the arts and elsewhere might explicitly highlight such relations and webs built of them. Of course, education typically does no such thing. In practice, this might mean that students examining works of art or making them should directly engage issues of what causes what, what symbolizes what, what is a crucial part of what, what role the crucial part does play, and so on. Of course, in a tacit sense, such themes play a routine part in discourse about art. But the logical bones of the discourse are rarely seen. Moreover, discourse of this sort would promote two other characteristics of understanding: generativity and open-endedness.

In the themes of coherence and standards of coherence even more clues appear toward a pedagogy of understanding. In such a pedagogy, learners ought to learn to recognize and gauge the coherence of their own understandings. They also ought to learn to hunt for the incoherence and appraise its significance. Finally, they should come to appreciate how different contexts call for different standards of coherence, and why. To be sure, all this requires a remarkable degree of self-consciousness about one's understandings. Still, just such self-consciousness seems to be needed if learners are to stand back from the subtle incoherence in superficially coherent understandings and see the deeper coherence in more sophisticated understandings. The usual practice of education—overlaying the old understanding with a new one—is likely to create the anomalies characteristic of "naive physics" or the musical notation example discussed at the outset.

Of course, not nearly enough has been said here to give substance to a pedagogy of understanding anchored in the nature of understanding itself. What has been mentioned is like a sketch in search of a painting, a theme in search of a symphony, an image in search of a poem. This notion of a pedagogy of understanding is itself a relational web in the making and, like any such web, calls for much more spinning out. But perhaps enough has been said to show why we need to start from the nature of understanding itself. As already urged, that seems essential in developing what it takes to

worry about art well. It seems no less essential in developing what it takes to worry about learning well.

REFERENCES

Arnheim, R. (1964). *Art and visual perception*. Berkeley & Los Angeles: University of California Press.

Arnheim, R. (1969). *Visual thinking*. Berkeley: University of California Press.

Barron, F. (1969). *Creative person and creative process*. New York: Holt, Rinehart, & Winston.

Barron, F. (1972). *Artists in the making*. New York: Seminar Press.

Beardsley, M. C. (1958). *Aesthetics: Problems in the philosophy of criticism*. New York: Harcourt, Brace, & World.

Clement, J. (1982). Analogical reasoning patterns in expert problem solving. In *Proceedings of the Fourth Annual Conference of the Cognitive Science Society*. Ann Arbor, Michigan: University of Michigan.

Clement, J. (1982). Students' preconceptions in introductory mechanics. *American Journal of Physics, 50*, 66-71.

Clement, J. (1983). A conceptual model discussed by Galileo and used intuitively by physics students. In D. Gentner & A. L. Stevens (Eds.), *Mental models*. Hillsdale, New Jersey: Lawrence Erlbaum Associates.

Ecker, D. W. (1967). Justifying aesthetic judgments. *Art Education, 20*(5), 5-8.

Getzels, J., & Csikszentmihalyi, M. (1976). *The creative vision: A longitudinal study of problem finding in art*. New York: John Wiley & Sons.

Goodman, N. A. (1976). *Languages of art*. Indianapolis: Hackett.

Grumbach, D. (1986). The literary imagination. In R. M. Caplan (Ed.), *Exploring the concept of mind* (pp. 121-131). Iowa City: University of Iowa Press.

Koestler, A. (1964). *The act of creation*. New York: Dell.

Lowes, J. L. (1927). *The road to Xanadu*. Boston: Houghton Mifflin.

McCloskey, M. (1983). Naive theories of motion. In D. Gentner & A. L. Stevens (Eds.), *Mental models* (pp. 299-324). Hillsdale, New Jersey: Lawrence Erlbaum Associates.

Nickerson, R., Perkins, D. N., & Smith, E. (1985). *The teaching of thinking*. Hillsdale, New Jersey: Lawrence Erlbaum Associates.

Perkins, D., and Leondar, B. (Eds.) (1977). *The arts and cognition*. Baltimore: Johns Hopkins University Press.

Perkins, D. N. (1977). Talk about art. *Journal of Aesthetic Education, 11*(2), 87-116.

Perkins, D. N. (1978). Metaphorical perception. In E. Eisner (Ed.), *Reading, the arts, and the creation of meaning* (pp. 111-139). Reston, Virginia: National Art Education Association.

Perkins, D. N. (1979). Are matters of value matters of fact? In C. F. Nodine & D. F. Fisher (Eds.), *Perception and pictorial representation* (pp. 801-315). New York: Praeger.

Perkins, D. N. (1981). *The mind's best work*. Cambridge, Massachusetts: Harvard University Press.

Perkins, D. N. (1983). Invisible art. *Art Education, 36*(2), 39-41.

Perkins, D. N. (1985). Postprimary education has little impact on informal reasoning. *Journal of Educational Psychology, 77*(5), 562-571.

Perkins, D. N. (1986). *Knowledge as design*. Hillsdale, New Jersey: Lawrence Erlbaum Associates.

Perkins, D. N., Allen, R., & Hafner, J. (1983). Difficulties in everyday reasoning. In W. Maxwell (Ed.), *Thinking: The frontier expands* (pp. 177-189). Hillsdale, New Jersey: Lawrence Erlbaum Associates.

Perkins, D. N., & Martin, F. (1986). Fragile knowledge and neglected strategies in novice programmers. In E. Soloway & S. Iyengar (Eds.), *Empirical studies of programmers* (pp. 213-229). Norwood, New Jersey: Ablex.

Roe, A. (1952a). A psychologist examines 64 eminent scientists. *Scientific American*, *187*(5), 21-25.

Roe, A. (1952b). *The making of a scientist*. New York: Dodd, Mead & Co.

Salomon, G., & Perkins, D. N. (in press). Transfer of cognitive skills from programming: When and how? *Journal of Educational Computing Research*.

Ziff, P. (1964). Reasons in art criticism. In W. E. Kennick (Ed.), *Art and philosophy: Readings in aesthetics*. New York: St. Martin's Press.

Expression as Hands-on Construction

V. A. HOWARD

Expression as "Hands Off"

How do artists find expression through art? Commenting in *Art as Experience* on the "nature of spontaneous expression," John Dewey redirects some of William James's remarks on religious experience as follows:

> What William James wrote about religious experience might well have been written about the antecedents of acts of expression. "A man's conscious wit and will are aiming at something only dimly and inaccurately imagined . . . and his conscious strainings are letting loose subconscious allies behind the scenes which in their way work toward rearrangement, and the rearrangement toward which all these deeper forces tend is . . . definitely different from what he consciously conceives and determines. It may consequently be actually interfered with (jammed as it were) by his voluntary efforts slanting toward the true direction." Hence, as he adds, "When the new centre of energy has been subconsciously incubated so long as to be just ready to burst into flower, 'hands off' is the only word for us; it must burst forth unaided." (Dewey, 1934, p. 72).

It is commonplace, not only among philosophers and psychologists, to think of expression in ways suggesting that "subconscious maturation precedes creative production in every line of human endeavour" (Dewey, 1934, p. 73). Still, without denying that acts of expression may often *feel* incogitant, Dewey *via* James's words manages to evoke a number of troublesome corollaries of expression as a "hands-off" affair.

First is the notion that expression is less a matter of what one *does* than of what one *undergoes*, a subliminal happening, as it were, that eventually overwhelms the paltry results of conscious effort. "The direct effort of 'wit and will,'" says Dewey, "of itself never gave birth to anything that is not mechanical" (1934, p. 73). Second is the view that expression is entirely subjective, emotional, as well as passive in its maturation and essentially noncognitive, i.e., having little to do with "understanding" as such. Third, and following from the preceding, is the idea that expression is not

something the artist *controls* and manipulates (for that would be "mechanical"), but rather something that *inspires* or that the artist takes in (like a breath of fresh Muse). Finally, there is the suggestion that the artist is no less a surprised *discoverer* of what he or she has done in a work of art than any other onlooker—rather like being a blind seer of one's own accomplishments—"Oh, look, what I've said!" "See what I've painted!" "Hear what I've sung!" uttered in genuine surprise at the outcome.

Certainly we do often feel ourselves possessed by a task, subjectively immersed in it, propelled by it, surprised by our own achievements, and not only in art. Nevertheless, and without hanging this albatross on either Dewey or James, exclusive stress on the subjective roots of expression yields a portrait of the expressive artist as a mindless media mechanic whose primary goal is to get Mind out of the way of the flow of the Muse. For artists and audiences alike, on this view, finding or understanding expression is not something to be deliberately worked at; rather, left properly alone, it will work *on* you.

Now no one who has witnessed serious artists at work, tried to get a feel for their work, or, better yet, experienced firsthand the rigors of training in virtually any artistic domain can consistently hold to such a view. Each of the aforementioned corollaries of "hands-off" expression, I maintain, is a partial truth parading as a whole truth, the kernels of which do yet deserve being allowed to germinate in a more comprehensive view of expression that reconciles mystery with mastery both in works of art and in the work of artists.

So far I have been deliberately mixing talk of expression by artists and by their works. Now I want to disentangle such talk in an attempt to place expressive process and expressive product in mutual perspective. That is a tall order for a few pages, so I shall need to harken back occasionally to previously published studies of mine examining aspects of expression as a symbolic function of works of art. Those studies drew heavily upon Goodman's notion of expression as metaphoric exemplification within a variety of symbolic systems (Goodman, 1972, pp. 45-95; Howard, 1971, 1978).

For me then, as for Goodman, expression was viewed from the standpoint of the finished work of art (the product) as something a work of art itself *does*: namely, it exemplifies within a syntactically and semantically dense symbolic system. The basic idea was that a work of art functions symbolically in certain ways to express a range of its metaphoric properties. For reasons of space I must take much of that work for granted without the details of supporting distinctions and arguments.

Herein I want to consider the other side of the coin: what the *artist* does to produce an expressive effect, broadly speaking, notwithstanding the fact that artworks can go on to speak for themselves in ways often out-

stripping the artist's intentions. I shall argue that performing expressively, finding expression in a work of art, or producing a work that is expressive in some way are all "hands-on" constructive activities directing rather than following the rush of feelings.

Expression as Hands Tied

Expression is usually thought to be *of* emotion and, therefore, to have its deepest origins somewhere in the unconscious. So, to be an expressive performer, to express oneself in an art form, even to grasp the expressive outpourings of other persons through their art, requires being "in touch" with those upwellings. And that means getting out of their way, letting them happen, and avoiding obstructions such as "thinking" or doing too much. It's "hands off" in the sense of "hands tied" while the emotions work their way upon us.

This notion of expression as passive affection has a long history going back to Plato's description in the *Ion* of the poet as a "light and winged thing, and holy, and never able to compose until he has become inspired, and is beside himself, and reason is no longer within him" (*Ion*, 534 b). The suggestion is that emotional inspiration bypasses reason and understanding both in its origins and expressive functions. Either as god-given gift or as native talent, the artist's powers of expression appear as nonrational "inspirations" (literally, breathings in) from a mysterious place in the Soul or Universe.

In common practice, passive affection is linked to an arousal theory of expression according to which the artist gets "pumped up" in order to perform, or in order to write or to paint expressively *versus* routinely. Again, too much "thinking" is considered an interference, likely to "jam" the subliminal machinery. As a voice teacher of mine used to advise, "Put your heart as well as your head into it, Vernon."

Good advice, so far as it goes. But what is the "it" into which the heart is supposed to go? It is not enough simply to say, "the work" (as end product). Quite clearly, a good deal of technical proficiency, a sense of direction, of particular ends-in-view, estimates of appropriate or inappropriate emphasis are also required. As well, one is required to possess a fair degree of competency (in the sense of thoughtful use) of the symbolic medium through which one seeks expression. These are the means of expression. Otherwise, a shout is as good as a song, a blot on paper as good as a *bon mot*.

All that, I should maintain, is implicit in my teacher's advice to put heart *as well as* head into the effort to sing expressively. She was *not* suggesting that I put all thought aside but rather that I attend more *via* my own feelings to the feelings expressed by the work being rehearsed. So al-

ready we have a qualification on the original dichotomy of Mind and Muse in the way that skills and expression combine in actual practice.

But who is in the lead, Mind or Muse? The question is misleading in still clinging to the dichotomy. In practice (good) writers, performers, sculptors, and the like, seldom wait passively for inspiration to strike, but go in pursuit of it by prodding, practicing, and producing something "out there"—a result, however tentative. I am reminded of a parallel in writing instruction according to which "we do not so much send our thoughts in pursuit of words as use words to pursue our thoughts" (Howard & Barton, 1986, p. 24). In effect, *finding* expression or inspiration, on whatever meaning, is more the reward for an effort made than the gift of a secret puppeteer working behind the scenes; that is, artists—productive ones anyway—more often deliberately seek expression by any symbolic means whatever than wait for it, Godot-like, to happen to them and only then to clamp their feelings into symbolic form.

Now if finding expression is more a matter of working than of waiting, more a matter of results achieved than of mysterious origins, what distinguishes those moments of felt fluency and expressiveness from jerky routine and stoppages? In a word, obstacles; usually quite public (if not obvious to anyone) obstacles in the work at hand (cf. Howard, 1982, pp. 32-35). By obstacles in the work at hand I refer to problems of execution, as in singing or acting, as well as to problems of construction, as in putting together the elements of a plot line or combining color and plane in a painting. Too often we attribute blocks to a wrong state of mind, perhaps involving "trying too hard." That may happen, of course; but the attribution to one's state of mind is often hasty. Just as often something more straightforward is responsible: an obstacle in the work itself. Such obstacles are open to public scrutiny by teachers and critics (including self-critics), thereby opening opportunities for evaluation and revision. Making such changes is very much a hands-on affair, as likely to be Mind over Muse as the reverse, and recognizable more in the expressiveness (or lack of it) in the work one does than in the quantity of emotion felt, whatever its origins.

Expression as Hands Aflutter

The second and third corollaries of hands-off expression can be characterized together as "hands aflutter." As described at the outset, that is the view that expression is entirely subjective, emotional, as well as passive in its genesis and essentially incogitant, having little to do with understanding. In *trying* to express something, or the self, through a work of art, the artist is more the medium than the manipulator of expression; more the sensitive collector of expressive "vibrations" than the deliberate controller

of expressive effects. Again, the not so thinly veiled suggestion is that too much "trying," too much "thinking" are bad habits in art.

This is a good spot to underscore the fact that, contrary to popular opinion, expression is not always of emotion; that pictures, for example, can express sounds and physical motions as well as emotions, that music can express colors and spaces as well as feelings (Goodman, 1972, pp. 85-95; Howard, 1971, p. 274). It is easy to imagine a silent, highly agitated work of dance expressing properties of sound or of physical inertia. Furthermore, as Goodman notes, "A painter or composer does not have to have the emotions he expresses in his work" (Goodman, 1972, p. 47). Neither, of course, need the dancers in the aforementioned silent, quick-moving work prep themselves by shouting while standing stock still. Getting "in the mood" to paint, to compose, or to perform is not necessarily getting into the *same* emotional state as gets expressed in the work; still less so if the expression is of something other than emotion.

Yet the idea persists that getting in the mood is entirely emotional and subjective, however we get there, notwithstanding failure of the simplistic notion of the artist-as-emotional-sluice. No doubt, "warming up" is a vital part of preparation sometimes, a flexing of technical skills such as running scales, stretching, or making corrections in the previous evening's manuscript. Clearly more deliberate and cognitive than merely standing aside hands aflutter, such preparations nevertheless do aim at putting oneself in a state of "receptivity"; receptivity now not only to emotions (if we must allow for nonemotional expression), but also to the metaphoric *feel* of sounds, spaces, colors, or whatever one is trying to express. But then, it will be argued, after working ourselves up "technically," we can let go of routine control in order to let the powers of expression take over.

I concede that flat calm is hardly the best mood in which to walk on stage and that emotions have many roles to play in "getting set." For instance, is this something you want to do? Feel confident to do? Are you overanxious? Still, the idea of letting go at the top, as it were, misleads in suggesting that judgment applies only to *where* to deploy routine skills but drops out when expressive spontaneity takes over. Elsewhere I have argued at length that critical judgment (control) is crucial not only to the acquisition and deployment of technical facilities in art, but also at the highest levels of artistry, be it in performance or the creation of new works (Howard, 1982, pp. 181-185).

Even—perhaps especially—when technical facilities are safely tucked away in physical or mental memory, judgment and choice come to the fore in the form of decisions of taste and of style. As I recently wrote on this point, "Looking at the matter this way helps to explain, for instance, the seemingly paradoxical remarks of so distinguished a singer as Alfredo Krause commenting on what it takes to sing expressively. 'Art, for me,' he

said during a recent entre act interview, 'is science. You cannot improvise art. It's not subjective. In art, emotion is intelligence. Emotion has to be controlled by your brain' (Krause, 1985). Krause's remarks make eminent sense in a world where thought and feeling, imagination and judgement, expression and control are frequently united" (Howard, 1987; cf. also Scheffler, 1986). They conflict head-on, however, with the view of expression in performance or elsewhere in artistic activity as passive arousal unfiltered by effort and understanding.

While it is crucial to be poised, focused, receptive, or otherwise "in the mood" to produce an expressive effect in art, such receptivity is a deliberate funneling of feeling in planned ways and directions. One is reminded of Kathleen Ferrier's dramatic last recording with Bruno Walter of Mahler's *Das Lied von der Erde* on the very afternoon she received the diagnosis of her fatal illness. Instead of sitting down and weeping into her hands, she wept into—one might better say through—Mahler's songs. In effect, she *made* something artistic out of her feelings very much in a "hands-on" manner.

Expression as Hands in the Air

If expression is construed as more a happening than a making, then it is bound to come as a complete surprise, something of a "hands-in-the-air" discovery after the fact. One weaves away like Odysseus' Penelope, and lo, an effect is born as much to one's own surprise as to anyone else's. "If artists only find out what their emotions are in the course of finding out how to express them, they cannot begin the work of expression by deciding what emotion to express." So said Collingwood in the *Principles of Art* (1939, p. 117), the most sustained effort in print to avoid a "fabrication" theory of art. The trouble with this view of "expression we know not what nor whence nor whither" is that it robs the artist of all control by foresight (not to be confounded with foreknowledge or prediction) (cf. Howard, 1982, pp. 117-120).

No doubt artists do sometimes clarify or discover their emotions in the act of expressing them; that is not at issue. What I question (aside from the already noted restriction of expression to emotion) is the stronger claim that artists discover their emotions—or anything else expressible—*only* James-Lang style by actually expressing them. For one thing, it seems perfectly comprehensible that one can know in advance *what* one wants to express, if only vaguely, without being able to do so or do so effectively; but let us go to cases to see exactly what gets discovered in the attempt.

The case I have in mind concerns a master class in singing given by Mme. Birget Nilsson at the Manhatten School of Music (*The New Yorker*, December 1984; reprinted by permission).

At the first class . . . a handsome, lanky young man named Ned Barth . . . performed a difficult Bellini aria in a rich but not entirely settled baritone while Mme. Nilsson, a few paces downstage, watched him intently. "You should feel as if you were smelling a flower," she advised. Holding an imaginary bloom to her nose, she mimed delirium, raising her lip and flaring her nostrils. "All the notes up front here," she urged, cupping her hand in front of her nose and brow. "Then they get the shine. Nobody pays for the notes that are going back in our neck. They might sound good to us, but not to the public."

Mr. Barth was invited back to the final class. He sang *"Per me giunto,"* from Verdi's *Don Carlos.* Mme. Nilsson soon had Mr. Barth concentrating on the aria's final phrase, *"morrà per te,"* which contains all the passion of a man telling his best friend that he's about to die for him. "I don't think I would dare to put so much strength on *'morrà,'"* Mme. Nilsson warned. "Start soft. When you think the note is in place, *then* you can open up."

Mr. Barth tried it. On the *"morrà,"* his voice wobbled and cracked. He stopped, frowning.

"I knew that was coming," Mme. Nilsson said, laughing. "There was too much tension here"—in the larynx. "Try it again, softer. Maybe we are lucky, maybe not."

The accompanist gave Mr. Barth his note, he took a breath, and what came out this time was almost a new voice—open, firm, and brilliant. As he brought forth a crescendo on the final E-flat, Mme. Nilsson strode toward him with open arms, and she grabbed his shoulders at precisely the moment of his cutoff. They beamed at each other through the waves of applause. "Wonderful!" she said. "You understand so much of this! Just avoid the tension."

Now what did Mr. Barth discover? One might just say, "How much he could do"—a hands-on statement if ever there was one; but let's look closer at the situation. Up to the point of his breakthrough he was unable properly to express the emotional force of the phrase *"morrà per te."* Did he know what that expressive import was? One can only assume yes, if he studied the text; and there is virtually no chance he'd be allowed on stage with Mme. Nilsson if he hadn't. So again, what did he discover?

Clearly, Mr. Barth had a good idea of what he was aiming for expressively; was technically well prepared to achieve his aim; but failed because of an obstacle. What he discovered—more likely, rediscovered, for a man of his level of competency—was the *means* of expression: a technical maneuver that enabled him to get the best out of himself. More than that, he discovered not only a *way* but how *well* he could express the phrase in question; which is to include, among other things, his own personal coloration of the phrase. He made it his own, so to speak. That is indeed a gratifying discovery, but it hardly amounts to a game of artistic blind man's bluff with himself. Less driven by an inspiration than an aspiration, Mr. Barth might well have said to himself, "My word, look what I can do

if I only *concentrate*."

The point is balance: if finding the right expression is sometimes accidental, discovery of the sort described above is a product of strenuous effort, not of passive receptivity or accident. However "pumped up" Mr. Barth might have been (and we can safely assume, under the circumstances, that he was), he would never have discovered his expressive potential for that single phrase out of *Don Carlos* had he set aside his critical judgment and foresight, not to mention hindsight of his failure.

The moral of this story is that discoveries of expressive potential, as of much else in life, are seldom mere "happenings"—accidents—even if some are, but rather the results of directed, disciplined effort. We try, we fail, we try again, and sometimes we succeed. Even more painful, thoughtful, exhilarating odysseys of expressive discovery than Mr. Barth's are commonplace among artists. It is a distortion of the tough work they do to reduce it all to the level of "surprise, surprise!"

Expression as Hands On

I began by speaking of expression as sometimes passive, sometimes subjective, sometimes uncontrolled, sometimes surprising, and ended with a story of personal discovery in a public forum. My negative aim was to head off those who would substitute the word 'always' for the word 'sometimes' in the preceding sentence. My positive aim was to sketch a portrait of the quest for expression showing it to be as discerning as it is feeling—a matter of making and, therefore, for the most part a "hands-on" constructive affair. To quote Goodman, "Emotion in aesthetic experience is a means of discerning what properties a work of art has and expresses" (Goodman, 1972, p. 248). And that applies as much to what we try to do as to what we finally achieve or appreciate in the work of others.

REFERENCES

Collingwood, R. G. (1938; 1967). *The principles of art*. New York: Oxford University Press.
Dewey, J. (1934; 1980). *Art as experience*. New York: Putnam.
Goodman, N. (1972). *Languages of art: An approach to a theory of symbols*. Indianapolis: Hackett.
Howard, V. A. (1971). On musical expression. *British Journal of Aesthetics, 11*.
Howard, V. A. (1978). Music and constant comment. *Erkenntnis, 12*, 73-82.
Howard, V. A. (1982). *Artistry, the work of artists*. Indianapolis: Hackett.
Howard, V. A., & Barton, J. H. (1986). *Thinking on paper*. New York: William Morrow.
Howard, V. A. (in press). Music as educating imagination. In V. A. Howard (Ed.). *Varieties of thinking: Essays from Harvard's Philosophy of Education Research Center*. London: Routledge & Kegan Paul.

Krause, Alfredo (29 June 1985). Remarks made on CBC Radio, on *Romeo and Juliet*, Dallas Opera Company.

Scheffler, I. (1986). In praise of the cognitive emotions. In *Inquiries: Philosophical studies of language, science, and learning*. Indianapolis: Hackett.

Artistic Learning: What and Where Is It?

DENNIE WOLF

Fig. 1. An early portrait by Sonya.

Fig. 2. A later portrait by Sonya.

A young printmaker, Sonya, cut these two prints twelve months apart. In many ways, the prints are twins—both are portraits; each has an active, even a bristling surface, both have an almost narrative flavor that jumps out of the intensity of the facial expressions. At the same time, there are differences: the scale of Sonya's work has changed dramatically; her original, almost monologuic way of cutting the first block has given way to

a style where one rhythm of strokes comments on others; the smaller, earlier face presents an even, almost flat surface, where the later head is a stark play of light and dark.

But much about these prints is invisible. No amount of thoughtful looking tells how Sonya alternated between the roles of "the imaginer and the producer" and "the critic of inexorable standards" (Shahn, 1964). There is little in the final lines that hints at the kinds of conversations, collaborations, or borrowings that inform the two portraits. Nothing shows how often, and with what emerging sense of purpose, the print-maker drew heads from life, experimented with different approaches to cutting the faces into the linoleum, or played with inking the blocks in varying ways. No matter how vivid the comparison, the finished prints can only document the path of Sonya's hand, not the contents or the course of her thinking. But Sonya's hold on artistic thinking—how she formulates ideas, carries them through from image to print, what she knows about reflection and revision—is what guides and informs her work. The question is, How can the "insides" of artistic learning be made visible?

Arts Propel: What and Where Is Artistic Learning?

The prints and the questions they raise come from an intensive study of artistic thinking known as Arts Propel. Propel is a collaboration between researchers from Educational Testing Service and Harvard Project Zero and teachers in Pittsburgh and Boston –all of whom are asking how to assess artistic development in a diverse group of students—from those who have had little training to those who, like Sonya, have had the chance to work long and hard in a studio. The project involves studies of individual and classroom work in visual arts, music, and imaginative writing. At the heart of this project are these issues: What evidence is there that the arts entail rigorous thinking? What methods will best document changes in the process of artistic thinking? If powerful methods could be found, what might we learn about the dimensions that characterize the development of artistic thinking? And, finally, if qualitative assessment is demonstrably powerful in the arts, what implications would that have for evaluating learning in domains like the humanities or even the sciences?

Awe vs. Inquiry: Studying Artistic Learning

There is a long tradition of portraying artistry as frenzy, dream, or, as Wordsworth would have it, "the spontaneous overflow of strong feeling." In this light, Freud wrote, "Every child at play behaves like the creative

writer, in that he creates a world of his own, or rather, rearranges the things of his world in a way that pleases him" (Freud, 1958). The suggestion is that artistic work is free-ranging, unfettered by notions of what is customary, full of intuitions, impressions, and fantasy. In a parallel vein, since the seventeenth century our views of artistry have stressed individual style, innovation, and surprise. Given the dual emphases on dream and innovation, it is often argued that artistic thought is too mercurial to be accessible to examination, never mind analysis. Awe is the right response, not inquiry.

But this attitude may be more myth than necessity. A number of artists have told quite a different story: for example, Picasso (Glimcher & Glimcher, 1986), Kahlo (Herrera, 1984), and Shahn (1964) have all broken down the mystery surrounding artistry by offering detailed accounts that stress the *work* of art: the way in which they gathered ideas, harbored images, and refined works. Building on these personal records, critics, historians, and psychologists have more than once been able to piece together "biographies" of works from letters, notebooks, and sketches (Arnheim, 1962; Glimcher & Glimcher, 1986). Besides the works of major artists, developmental studies of children's drawings hint that if we have a rich and detailed enough record of an individual's artwork, we can begin to infer shifts and reconfigurations in the underlying thought processes (Gardner, 1980; Gardner & Wolf, 1979). Moreover, by asking people to "think aloud" as they solve problems in domains as diverse as chess playing, circuit diagnosis, and writing, cognitive scientists have developed ways of exposing the complicated thought processes unique to various activities (Flower & Hayes, 1981, 1984; Simon, 1969). Allied work in the arts suggests that the moment-to-moment inventive and reflective processes of poets and painters can be traced—perhaps even be made susceptible to analysis (Perkins, 1981).

Building on these approaches and a long-established portfolio tradition in the visual arts, students participating in Propel create a diverse and detailed account of their own artistic development. In addition to final works, they save doodles, sketches, drafts, and revisions to yield the "biographies" of individual pieces. Using methods common in developmental research, they arrange these in sequence rather than by medium or problem, creating a record of their longer-term development. Using the models of working artists, some students keep journals in which they record experiences, note works they have enjoyed, or react to their own or someone else's work (Brown, 1987). Others have taped interviews in which they reflect on their processes and achievements while they page through their collected works. Building from problem-solving and process-tracing studies, some students have recorded their thoughts in running, on-line commen-

taries while working (Propel, 1986). Much like Sonya's printmaking, the research at Propel is work in progress. However, by looking closely at her prints and her comments on her work, one is able to get an initial sense for the kinds of thinking processes that become visible when students keep portfolios.

Sonya participates in one portion of the Propel project: a long-term study of a small group of students who, during their high school years, have come to see themselves as artists. During her sophomore year she signed up for a print-making class. After one monoprint and one etching, she became deeply involved in cutting a series of linoleum blocks. Over the past two years she has spent up to six hours a week working on a series of linoleum-block portraits. She is blessed with an energetic professional printmaker for a teacher—a man who insists that classes be small, who takes students to museums, who, even as he wipes plates clean, talks to his students as colleagues. Her school is a place where students of all abilities are encouraged to sustain an interest in the arts.

Some Invisible Dimensions of Artistic Learning

Usually, when we define artistic learning, we look for shifts in the way a student controls line, shape, and color; the novelty of imagery; or the technical understanding of the medium. However, the works in Sonya's portfolio suggest that such definitions of "what develops" are much too narrow. Her sketches, trial prints, notes, and interviews suggest that in addition to the visible changes in her technique and imagery, three less visible but no less significant changes occur in the way Sonya engages in artistic thinking. These are: her growing capacity to "walk around a work," examining and enjoying it from the multiple viewpoints of a maker, an observer, and a reflective inquirer; her growing alertness to the many resources she can draw on as an artist; and, finally, her increasing ability to sustain a long arc of work.

Walking around a Work: Multiple Stances

In "full-bodied" encounters with works of art, we respond in multiple ways. We draw on all we understand about production—what we know about handling paint or ink, striving after an image, or achieving a particular quality. At the same time, we perceive in the very broadest sense, not just using our ability to recognize what is in front of our very eyes, but recalling other images, provoking memories. Our reflective capacities—what we know about making choices, editing, judging—are also sparked. When "hooked" by a painting, a piece of music, a play, or a poem, we make use of all these capacities simultaneously, and probably repeatedly,

in order to grasp what it is that holds us so. Our pleasure and understanding come from *combining* or *moving among* those stances (Greene, 1986; Wolf, 1986).

During her first months, Sonya was chiefly a print *maker;* the work of drawing, cutting, and printing consumed her. When she remembered the genesis of an early monoprint, she focused centrally, and exclusively, on the making of the image:

> I always thought I couldn't draw—especially faces—the nose was always the worst part. . . . One day [my print teacher] took out this huge sheet of paper and drew a giant nose. He built it up out of all these little lines and planes . . . he just kept building out into the face . . . for the first time I realized that you don't draw a face by making an oval and filling it with the perfect eyes and lips. It's built up out of planes and lines. . . . the other thing I saw was that if you were willing to play with shapes and textures, you could create effects. Pretty soon after that I did a monoprint where I just used different inks on the plate to suggest the parts of the face.

During this time, her teacher drew her into stepping back and reflecting about her own work. Also, while she was absorbed almost wholly in the making of images, he insisted that she back away and spend time browsing in art history books and catalogues, so that her own stock of visual imagery might be broadened:

> He also got me to look at other block prints and linoleum prints and wood cuts. The printmaking studio has a lot of books. I looked at them to get ideas about the ways you can use linoleum—not just as something you can carve away to leave lines—but as something you carve to leave expressions inside the borders.

However, in the spring of her first year of printmaking, Sonya began to move between and to combine these stances of her own accord. She began to spend time looking at prints in order to understand how the process of cutting the block might actually enhance and support the image. But, interestingly, in order to appreciate what she saw, she had to draw on what she already knew about the work of producing an image on a block:

> When I look at the print [Munch's *The Kiss*] I notice right away how unevenly the figures divide the space. In my mind I imagine how different, how still it would have been if he had placed the figures dead center. The figures have an extraordinary simplicity. Their features aren't defined. So in a way, more than the figures you absorb the softness and roundness of the shapes. That's what says, "This is a kiss." When I look at the one shape for two people, I think about the way he cut the block, getting those long lines that aren't, but are, the real shapes, hard as that is in wood. But I know that if I imagine the figures with elbows and lips, the power drains out.

At the same time that Sonya continued to work on her prints, she developed a critical and a reflective stance:

> All the time you are watching over your own shoulder. You are always asking about your work, "Is this good or bad?" in order to make it better. Doing that so many times sets up a series of reactions in you that go off everytime you see something. You can't learn to look at your own work without learning something about why you like or dislike other work that you see. Now I can appreciate a good etching even though I don't like the picky, scratchy quality of a lot of etchings. Because I've tried my hand, I can see when someone isn't fighting against the thin line or trying to force those tiny tracks of ink into doing what wood or linoleum does. You can tell when you are looking at something where those thin lines speak—even if the surface gives you goosebumps and the image leaves you cold.

In this way, Sonya's prints and interviews pick out one often invisible or unmeasured aspect of artistic learning: the ability to integrate several complementary stances toward the experience of art. During her second year, when she took on a new challenge, she alternately considered it from the perspectives of an artist, a perceiver, and a reflective inquirer. What she developed was the ability to "walk around" a work, drawing from those varied stances the kinds of insights that yield either deeply informed making or what Ansel Adams referred to as "a response on the level of art itself."

Becoming Alert: Mentors and Models

We tend to think of most forms of serious cognitive work as a matter of individual achievement. In the arts, there certainly are persistent myths of the isolated artist and the novelty of individual imagination—both of which lead to a view of artistic creation and artistic learning as intensely private and individual. However, looked at carefully, the arts are profoundly social. No artist could survive without borrowing techniques and images that come either from the public domain or from other artists. Teaching, imitation, and influence are common rather than rare: think of what Hans Hofmann taught a generation of abstract expressionists, the effects of Gauguin on Van Gogh, or the way artists of the Dada, Blaue Reiter, or Bauhaus schools built on one another's work. Further, as much as we talk about individual talent, the art world is a profoundly human construction; what counts as gift, innovation, or cliche is, after all, socially defined (Czikszentmihalyi & Robinson, 1986).

Sonya's work suggests that being able to borrow, imitate, or share may be an achievement—not a failure. Through the two years Sonya engaged with printmaking, what was originally an intense dialogue with her own work opened to admit a widening circle of participants and sources. In the

early months, she enters into an intense dialogue with her teacher:

> We have to work in different media . . . and I was interested in ex-
> perimenting with linoleum as a medium to work on this idea of
> building up forms out of textures. So in talking to Russ about it, he
> thought it was a good idea. His advice when you are first trying to
> work with an idea is [to] take a big piece of paper and make small
> frames and inside those frames you draw just thumbnail sketches.
> He says the point is to get down how you are thinking . . . the ideas,
> not the picture.

It is also through her teacher that she comes to understand that she
has both a heritage and a set of colleagues in the other artists who have
worked before her. Russ encourages her to look at other portraits, espe-
cially directing her to highly stylized early Renaissance and Expressionist
works, both of which share a certain spirit with what is possible in a block
print. He also introduces her to books full of woodcuts—everything from
Hokusai to Munch.

However, throughout this first year, her interviews carried no mention
of any other studio colleague than her teacher. It was not until her second
year that she began to mention how other students' work entered her field
of vision and began to take effect. Even at the close of her second year,
her interview was full of specific illustrations of how social her studio ex-
perience became. In some instances, she mentioned particular peers: "I
was in the studio one day when someone else was working on a plate
where there was a woman turning into a tree. I loved the idea of that trans-
formation, the merger between human and vegetable forms. I wanted to
start my own version of it right there and then." In other cases what she
conveys is a sense for how she came to use, and possibly even depend
upon, the group setting of the studio: "When Russ [her teacher] goes
around the studio, I listen to what he has to say to the other people who
are working there and then look at my print to see whether I would have
given the same critique of my own work." In the spring of her second
year, these interactions moved outside the bounds of her classroom. She
attended a regional printmaking show with another student who is a
photographer:

> We had something in common, both of us working all the time in
> black and white. There were lots of colored prints there that other
> people liked—the biggest crowds were in front of them, ohhhing and
> ahhhing. They seemed too garish to us. We went off by ourselves to
> look at just the black and whites. We talked a lot about how you can
> get a feel for the color of things or how cold or warm things are just
> working with black and white.

It is not only outright social interactions around image making that

changed for Sonya. Sonya's internal interactions with other workers and works also shifted. Nowhere is this clearer than in her growing sense of the many different sources her work can draw on. As mentioned earlier, in her first semester, her teacher encouraged her to look at the works of other block printers—notably the German Expressionists and Munch—to give her "colleagues" in her effort to cut the block expressively rather than sheerly mechanically. But as she continued to work, Sonya absorbed the responsibility for finding these sources and began to reach out, not just to the visual world, but to what she finds in literature:

> I was reading a Greek play where the heroine, Deianira, becomes caught up in one tragedy after another—she gives her husband a shirt to insure his love, but it burns him so that he throws himself onto a funeral pyre. She hangs herself from horror and grief. There's this idea of evil under everything. I got this idea of tangliness out of it. . . . When evil touches one part, it's everywhere. From that I began working on an image of a mythological creature with her hair tangled in the sun.

This opening up and diversifying in Sonya's thinking points to the social embeddedness of artistic learning (John-Steiner, 1985; Wilson, 1977). Sonya happens to turn both to a wider range of cultural resources and to a broader range of social interactions. Other students might widen their sense of resources without ever tying their inquiry to sociability or vice versa. The point is not that development lies necessarily in the direction of more talk or more diverse use of what a culture has to offer. Rather, the suggestion is that one previously unseen dimension of artistic learning *may* be an increased alertness to the works and minds of others—whether that lies in drawing on the storehouse of myths and images or in discussing the discipline of black-and-white media with a peer. It brings to mind Georges Braque's account of the place of friendship and collaboration in the lives of early Cubist painters: "The things that Picasso and I said to one another during those years will never be said again, and even if they were, no one would understand them any more. It was like being roped together on a mountain" (John-Steiner, 1985).

Sustaining an Arc of Work: Prints, Series, and an Oeuvre

Possibly the most dramatic changes in Sonya's portfolio point to her growing ability to sustain a long arc of work that exceeds the span of individual prints. This arc of work refers less to the sheer length of time that a student is involved with a particular work or the sum of works than to what might be called the scope of work an individual is willing to take on. Scope can be thought of in at least two ways. First, there is the question of the different phases or types of work in which an individual can invest. Although it can happen that a very fine work is put down "all in a flash," more often large and serious work endures or goes through several stages

or episodes of development, including simmering, conception, early sketches, execution, revisions, polishing, and editing (Arnheim, 1962). Second, drawing on case studies of artists as well as scientists, we know that skilled or creative individuals often pursue the "same" problem across a series of works or experiments. In this way, they learn to approach an issue or idea from many points of view (Gruber, 1974). Sonya's portfolio provides some initial examples of the ways in which shifts in both aspects of scope can be seen in a student's work.

Sonya's first work was a monoprint portrait drawn directly in the ink and printed. Conception and execution were virtually synonymous, and there was little evidence of an other phase of work. While some of the brevity of her involvement with this work certainly came from the technique, she did not attempt further works which might be seen as experiments building on what happens in the original print. However, beginning with her second print, a triptych of three faces, Sonya engaged deeply enough with her print that she became involved in many different types of work.

Here Sonya talks about her struggles to cut the second woman's portrait to complement the first:

> This time I was technically much better, so that I was able to make lines very clear and precise—which wasn't what I was looking for. In the first one there was a rough-hewn-ness to her which is part of what makes her primitive and strong as a drawing. But when it got all perfect, it was much less interesting to look at. . . . [When I printed it] it was ugly and distracting. . . . So I traced the image all over again on another plate, and carved that out, trying to keep the elements of the first woman.

When she cut the central face, it was to be a man's to contrast with two framing female portraits.

> I needed him to be squarer and to have a different quality. . . . I carved and carved and carved, without any thought to the texture. It was very spare. There was texture but it really wasn't defining any shape. The lines, especially around the eyes were cut very thin. And so there wasn't the same sense of strength to his face. He was just sort of empty-looking and broad. [She explains more about abandoning this first version.] Part of the way to remedy that was not to carve out the hair, but to leave in a lot more actual plate . . . to try and define with white, not black. . . . He had to be even more primitive and strong. [He was] the middle for a reason.

Throughout her later work on the triptych, Sonya was aware of fine-tuning, or polishing, her work. She paused over the effects of inking the block in different ways:

> Here are two prints from the first panel. There's nothing changed in the print but they are very different. In this one the contours have

been over-inked so they bleed and they make the face too complex. I liked the texture . . . but it's not clean enough. In this other one the plate wasn't inked enough. It looks sparse and you lose the contouring and the textures. It looks blank.

Finally, Sonya also exhibited moments of "thinking about her artistic thinking"—moments in which an awareness of herself as an artist took shape. By the end of her first year, she was able to muse about the changes in her own printmaking: "As I was going along I was getting technically better at carving and better at conceiving what I wanted I liked what I saw in the first print of the woman—it was harsh and strong—and that was what I had to work hard not to lose when I got more skill." At the close of her second year, that awareness was quite extensive:

> There are different kinds of success [in my prints]. There is closed, controlled kind of success, like I got in the illustration of the boy and the goose. Then there are prints that are powerful, even if they're not well articulated. . . . Then there are the prints that are successful in terms of teaching you a lesson. . . . And then there's success in terms of the image, the kind that makes you want to go back and work with it again and again, until you get it.

The way Sonya conducted her work over time showed a second change in scope. As she continued to print, she came to think, not just of the particular work at hand, but of a set of larger ideas and projects that span individual prints. For instance, following her first triptych, she attempted a second one, challenging herself to make the three-part structure more adventurous, with each panel being different, yet with an effort for an overall composition. In her second year, she began to think in what she explicitly calls "series." She recognized that a number of prints can figure as moments or steps in the exploration of an evolving visual idea. In order to pursue a fascination with merging shapes, she first made a mythological print of a woman whose hair entangles the sun. In her next print of a forest, two figures merge and then blend into the surrounding tangle of vegetation. In a third block, she cut a profile portrait where a scarf balloons up into the landscape, echoing and melding with the pattern of tree branches: "The idea was that the same action of the wind would move through both of them." In her final interview, in which she looked at this series, she never spoke for long about individual images. Instead, her comments zigzagged between prints, constantly drawing out affinities. What Sonya's long arc of work may yield is depth of work— that is, the ability to stay on task long enough to find out where problems lie and to invent ways of pursuing them (Getzels & Csikszentmihalyi, 1976).

The Arts as Knowledge

Sonya is an unusual case study. She is intensely involved in her printmak-

ing. She is willing to talk about her work and is articulate when she does so. She attends a school that encourages the arts. Her teacher is skilled and thoughtful. But even if she and her circumstances weren't unusual, Sonya is only one individual. The particular dimensions, the directions of change, and the distance covered by Sonya can only be illustrations rather than universals. Nevertheless, her portfolio outlines some answers to the questions posed at the outset of the paper.

First, the term "artwork" is no mistake—Sonya shows us that even during high school, the production of a work involves not just interest, intuition, or gift, but a range of rigorous thinking processes. These include problem finding, pursuit, choice, and reflection. Second, there do seem to be qualitative methods that hold considerable promise for making the processes of artistic thinking visible. Sonya's portfolio is the result of bringing together of at least three such methods: (1) recording the "biography" of a work from initial sketch to finished piece; (2) making a developmental sequence based on several such biographies; (3) asking the student to reflect on the course of her work. Third, this portfolio process, in the expanded and developmental form used by Sonya, indexes not just the progression in finished pieces, but suggests several previously invisible dimensions to artistic learning. In Sonya's case three dimensions stand out: the ability to make use of a variety of stances or perspectives, the widening use of both cultural and social resources, and the increasing capacity to pursue an artistic idea over time.

Finally, Sonya's portfolio may suggest something about assessment even outside the arts. Sonya is working as an artist; her use of stances, her search for sources, and her efforts at editing and polishing go toward the making of visually compelling images. But there is no reason why the notion of portfolios, native as it is to the studio, couldn't have much wider application. Thinkers and students in the humanities, the natural and social sciences can—and often do—generate sketches, drafts, and revisions. Moreover, applied in other fields, the portfolio process might allow us to see processes that are just as critical, but just as invisible, when we look at finished essays or experiments. Writers and scientists, just like artists, alternate between stances. They, too, produce, look at the work of others, play the critic and the philosopher as a way of rounding out their understanding of problems and methods. In both the humanities and the sciences colleaguery and collaboration are vital. Some of the most productive science of the twentieth century emerged when scientists exchanged ideas: Heisenberg and his colleagues debated the flaws of then current paradigms; Albert Einstein and the mathematician Marcel Grossman worked together on gravitational theory (John-Şteiner, 1985). Understanding the long arc of work is essential to unearthing and piecing together the evidence on everyday life of colonial women or a series of experiments.

Here, then, is a turnabout. Often the arts are seen as marginal in educa-

tion. To survive, arts teachers have often had to mimic or borrow from the structures of other disciplines. But what this portfolio research suggests is that the arts carry profound messages for other fields. Across the curriculum, we ought to be studying complex, long-term learning, rather than students' acquisition of particulate facts in isolation. We ought to make use of the naturally occurring developmental materials students generate—rather than separate tests. In making those assessments, we must hunt down not merely the immediately visible, but also invisible, processual dimensions of learning.

REFERENCES

Arnheim, R. (1962). *The genesis of a painting: Picasso's Guernica*. Berkeley: University of California Press.

Brown, N. (1987). Learning from student journals in the visual arts. A presentation at the annual meeting of the National Art Education Association, Boston.

Csikszentmihalyi, M., & Robinson, R. (1986). Culture, times, and the development of talent. In R. J. Sternberg and J. E. Davidson (Eds.), *Conceptions of giftedness* (pp. 264-284). Cambridge: Cambridge University Press.

Flower, L., & Hayes, J. R. (1981). A cognitive process theory of writing. *College Composition and Communication, 32*, 365-387.

Flower, L., & Hayes, J. R. (1984). Images, plans, and prose: The representation of meaning in writing. *Written Communication, 1*, 120-160.

Freud, S. (1958). The relation of the poet to day-dreaming. In *On creativity and the unconscious*. New York: Harper and Row.

Gardner, H. (1980). *Artful scribbles*. New York: Basic Books.

Gardner, H., & Wolf, D. (1979). First drawings: Notes on the relation between perception and production in the visual arts. In D. Fisher and C. Nodine (Eds.), *What is a picture?* New York: Praeger Press.

Getzels, J. W., & Csikszentmihalyi, M. (1976). *The creative vision*. New York: Wiley.

Glimcher, A., & Glimcher, M. (1986). *Je suis le cahier: The notebooks of Picasso*. New York: Atlantic Monthly Press.

Greene, M. (1986). Possible sources for aesthetic content in the classroom. In A. Hurwitz (Ed.), *Aesthetics: The missing dimension* (pp. 53-74). Baltimore: Maryland Institute College of Art.

Gruber, H. (1974). *Darwin on man: A psychological study of scientific creativity*. New York: Dutton.

Herrera, H. (1984). *Frida: The biography of Frida Kahlo*. New York: Harper & Row.

John-Steiner, V. (1985). *Notebooks of the mind: Explorations in thinking*. Albuquerque: University of New Mexico Press.

Perkins, D. (1981). *The mind's best work*. Cambridge: Harvard University Press.

Propel (1986). Towards a portfolio process: A project description. Cambridge: Harvard Project Zero (available from Harvard Project Zero).

Shahn, B. (1964). The biography of a painting. In V. Tomas (Ed.), *Creativity in the arts*. Englewood Cliffs, New Jersey: Prentice-Hall.

Simon, H. (1969). *Sciences of the artificial*. Cambridge: MIT Press.

Wilson, M. (1977). Passage-through-communitas: An interpretative analysis of enculturation in art education. Ph.D. dissertation, Pennsylvania State University.

Wolf, D. (1986). All the pieces that go into it: The many stances of aesthetic understanding. In A. Hurwitz (Ed.), *Aesthetics: The missing dimension* (pp. 75-99). Baltimore: Maryland Institute College of Art.

This research was funded by the Rockefeller Foundation. It was also made possible through the collaboration of a number of teachers and students working in studios and classrooms in Boston and Pittsburgh.

Toward More Effective Arts Education

HOWARD GARDNER

Introducing the Four Elements

The major players on the arts education scene can be likened to the members of a newly formed string quartet. No matter how skilled each of the players may be individually, successful performance as an ensemble remains a formidable challenge. While realizing their individual parts properly, the players must learn to listen to one another, to pick up subtle cues of timing, attack, phrasing, etc., to arrive at the same—or at least concordant—interpretations of a piece and to blend these in a performance which makes sense not only to the players themselves, but also to their wider audience. When—for whatever reason—the players have hit upon the appropriate playing stances, the resulting sounds can be magnificent, but only careful working together over many years can ensure performances of a predictably high quality.

In incipient efforts to improve arts education, I've come to anticipate four separate players, or elements, on the scene. They may announce themselves overtly, or they may lurk in the background; but ultimately they must all be taken into account and synthesized if the effort is to succeed. To begin with, there are the *philosophical* notions of arts education: What is the purpose of teaching the arts, how are the arts construed, how do they relate to the rest of the curriculum and to the rest of society? Next, there are *psychological* accounts of learning in the arts: What is the student like, how can teachers work effectively, what are the effects of particular media of instruction, how does one evaluate success or failure? A third component entails the *artistic practices* of the past: What sorts of things have been done (for whatever reason); which kinds of settings have been favored; who are the masters, the students, the expected audience? And the final component—particularly complex in any industrialized society—is the *ecology of the educational system*: the assigned curricula, the school administration, processes of certification and licensure, the decision-making processes. Certainly, these four elements interact with and

sometimes blend into one another; and a given component might be assigned under one interpretation to one element (say, philosophy) or to another (say, psychology). But in one way or another, concordantly or discordantly, these four voices will be heard.

As related elsewhere in these pages, Project Zero was conceived—and in fact named—over twenty years ago in an attempt to understand, and ultimately to improve the quality of, arts education in our society. To say that at least some of us were naive about the complexity of the arts education scene is neither to criticize nor to compliment us—but that naivete has long since vanished! Many different histories of our Project can be written, reflecting the perspectives of the various participants and of the two major working groups. As it happens, a history which stresses our respective relationships to each of the four elements of arts education proves particularly relevant to my present theme: efforts to improve education in the arts.

The Elements at Project Zero: The View from the Development Group

Building on the work of earlier philosophers, and particularly of founder Nelson Goodman, much of the work at Project Zero during the early years was concerned with discovering a viable *philosophical basis* and working out some of its implications for psychological and educational purposes (Gardner, Howard, Perkins, 1974; Goodman, Perkins, & Gardner, 1972). It has proved epistemologically cogent and empirically suggestive to view trafficking in the arts as the handling of various symbol systems, such as language, picturing, gesturing, or music. Indeed one might think of the arts as involving the use of certain sets of symbols in certain ways—for example, attending to fine details in a symbolic pattern or apprehending the expressive potential of a particular symbolic configuration. On this view, an individual who would participate actively in the artistic process must learn to "read" and "write" in these different symbolic systems. And so arts education can be usefully viewed as the imparting of literacy skills in the area of artistic symbolization.

This apparently simple formulation turns out to be surprisingly productive. On the one hand, it supplies a clear direction—if not a metric—for effective arts education. To the extent that an individual becomes literate with a given symbol system in the arts, to the extent that he or she can productively perceive, create, or reflect within that system, one may assume that arts education has achieved some success. The Goodman formulation also avoids certain problems which have plagued conceptions and programs of arts education. While none would deny the import of issues of artistic value and merit, these prickly issues can be bypassed for many educational purposes. One need not make a decision about the overall merit of a work

in order to understand its import, impact, or mode of functioning. By the same token, a focus on artistic symbolization makes it possible to demystify artistic processes. Whatever the role of inspiration, mystery, or emotional catharsis in the arts, these are much less readily dealt with in education than the regular and systematic (if somewhat less provocative) processes of symbolic cognition.

In our own work in the "Development Group" at Project Zero, we elected early on to examine the development in normal (and later, in gifted) children of various symbol-using capacities in art (Gardner, 1982). In what might be termed the *psychological* phase of Project Zero, we examined the steps through which children pass as they master various components of different artistic symbol systems: how they learn to appreciate style in different art forms; how they come to apprehend metaphor and other forms of figurative language; how they incorporate into their own fledgling works those expressive components which confer power and significance upon artistic symbolization. To be formulaic about it, we sought to cross the Goodman taxonomy of different symbolic systems and processes with the developmental approaches fashioned by Jean Piaget (1970) and other cognitive-developmental psychologists. The story of our principal research approaches and topics has been related in many places, including some of the other essays in this collection, and so it need not be rehearsed in any detail here.

Still, even as we have confessed our naivete above, it is worth spending a moment to consider the various ways in which our view of artistic development has been altered over two decades and as a consequence of several dozen studies of children engaged in artistic activities. At first, like any fledgling research team, we had hoped to document a simple linear story of artistic development, one which would obtain across all art forms and all normal children, one which could take its place along the seemingly straightforward saga of moral development or the development of logical thinking. It was not to be so. (Nor, instructively, did it prove to be so in these other areas of development). One can summarize our various realizations in the following succinct statements:

1. Development of skills in one artistic symbol system, say music, occurs in a systematic way, but the facts of such development cannot simply be applied to other artistic systems. In fact, each artistic area exhibits its own characteristic developmental paths (Gardner, 1983a).

2. Rather than thinking of cognition as developing "of a piece," it is more accurate to view the intellect as having a number of separable components. We speak of the development of several distinctive "intelligences," each with its own peculiar trajectory. Whether an intelligence—like linguistic or bodily—is put to an artistic use turns out to be a personal or cultural decision, not an absolute imperative (Gardner, 1983b).

3. Even as these intelligences develop in distinctive ways, they also have specific representations in the human nervous system. The various human symbolic competences can be mapped, at least roughly, onto different brain regions, across the two cerebral hemispheres, and within these cortical regions as well. Project Zero has pioneered in the study of cortical representation of different artistic symbolic skills (Gardner & Winner, 1981).

4. In some areas of development, children may simply get better with age, but this simple formula proves inadequate, and to some extent erroneous, in the arts. Indeed, in a number of ways, children before the age of seven display behaviors and proclivities which are closer to those of practicing artists than do youngsters who are in middle childhood (Gardner & Winner, 1982).

5. It is possible to put forth a sketch of prototypical artistic development in particular art forms, but there will be significant individual differences even among normal children. Thus, in the course of acquiring drawing skills, some children will focus on contours or patterns of specific objects, while others will rely on preestablished schemas or conventions (Shotwell, Wolf, & Gardner, 1979). Children with unusual talent or pathologies may follow still other courses. And the course of development may once again differ in cultures which are remote from one another.

6. Even as there are different courses of development in the productive sphere, there are separate developmental sagas which govern skills of perception, reflection, and critical judgment. Oftentimes, as in other developmental domains, perceptual capacities are more sophisticated than productive skills, but there are also some instances where production can be precocious (Winner et al., 1983). The orchestration of perceptual, productive, and critical skills turns out to be a complex undertaking.

While it could be readily extended, this list of findings should give a feeling for the kinds of concerns which the development group has pursued and the kinds of conclusions to which we currently subscribe. Our area of study is still in its infancy, but it would not be inappropriate to claim that we have put forth an initial developmental psychology of the arts, one which can now be pitted against competing formulations.

But a developmental psychology is not a pedagogy of the arts. It soon became apparent to us—and our critics were quick to remind us—that what happens "naturally" in the course of development is in no way equivalent to what *can* happen, given a particular educational regimen or in light of the messages embedded in a given cultural setting. Developmental factors may set a kind of upper bound on what can be mastered at any particular time, but certainly the crucial factor in artistic achievement is the quality of education. If we were to move from philosophy and psychology to education proper, it was necessary for us to consider the relationship between developmental and educational factors—between development and learning.

Initial Forays into Education

It would be a gross caricature of Project Zero's history to contend that our philosophical and psychological studies were ever all-consuming. Indeed, from its earliest days Project Zero has been involved in a variety of ways in educational concerns. Under founding director Nelson Goodman, a memorable series of lecture-performances was staged for the Boston community in the late 1960s. At the same time, members of the staff undertook a rather detailed survey of ongoing effective arts-educational programs. This study not only familiarized us with the facts—and the conditions—of American arts education; it also gave us a preliminary feeling for the kinds of approaches which are usually successful and for those which are not. Thus, for example, we observed that the stated goal of a program was an unreliable guide to its overall quality or even to what was actually done from one day to the next: philosophical statements sometimes loom in splendid isolation from day-to-day practice. On the other hand, a tremendous amount of educationally effective insight might be conveyed "on the scene," in a manner akin to coaching, even by individuals who were notably inarticulate about what they were doing or why they were doing it.

Over the years there have been many other involvements, indeed forays far too numerous to mention, ranging from participation in the planning of radio and television programs in arts education to studies of effective museum education to the staging of pilot programs of artistic training in local public schools. To my own mind a particularly memorable experience was the assembling outside of Boston of some thirty arts teachers from all over the nation who had been singled out for the excellence of the arts programs in their local schools. Once again, these teachers differed enormously from one another on almost every dimension, and certainly in terms of their articulateness. But what joined them was incredible dedication to their task; a studied indifference to "negative signs" from uncaring colleagues or administrators; the capacity to integrate personally significant messages and themes into their pedagogy and their work; and a desire to provide means of expression and communication, as well as clear-cut skills, to all students, and perhaps especially to those who do not stand out in the traditional academic subjects.

But informative and even bracing as such forays may be, they cannot substitute for a more intensive and longer-term involvement in the arena of education. Project Zero might have elected to remain primarily an "ivory tower" undertaking, tolerating occasional flirtations with practice. In recent years, however, we have felt an ever-stronger urge to collaborate with practitioners in arts education and to become involved in projects located in the schools. We hope that, as a consequence of two decades of research, we have something to contribute; and we are quite certain that we have much to learn about the two elements of arts education which

until now have not constituted a primary focus of our inquiry: effective artistic practices and the ecology of the educational system.

Project Spectrum and Arts Propel: Two New Initiatives in the School

In our observations of American schooling we have been struck by the relative neglect of artistic intelligences and artistic education. The "proto-type" in most educational environments remains the identification, culti-vation, and rewarding of two forms of intelligence—linguistic and logical-mathematical talent. Those blessed with that combination of intelligence are virtually guaranteed a positive experience in the schools, while those exhibiting poor performances in these two intellectual areas are destined to have a frustrating school career and, in too many cases, a flawed con-ception of self.

Two collaborative initiatives that we have recently undertaken have grown out of our work in the theory of multiple intelligences and our dedication to the improvement of education in the arts. One, Project Spec-trum, undertaken in conjunction with David Feldman of the Eliot-Pearson Children's School at Tufts University, is concerned particularly with pre-school education. It has as a principal goal the devising of new means for assessing the intellectual proclivities of young children, and especially those proclivities which lie outside of standard academic areas. Increas-ingly, Spectrum has also emerged as a model of curriculum in the preschool area (see Malkus, Feldman, & Gardner, 1988).

The second effort, Arts Propel, a coventure with the Educational Test-ing Service and the Pittsburgh Public Schools, is an attempt to develop reliable means of assessing artistic potential and achievement in junior and senior high school children. We hope that these new means of assessment will be useful both to school teachers and to college admissions officers as a means of broadening their conceptions of student achievement.

Project Spectrum is built on two assumptions. First, that as young as the age of three or four, children differ from one another in systematic ways in the kinds of intellectual proclivities they exhibit. Second, the optimal way in which to assess—and to cultivate—these proclivities is to provide ample opportunities for youngsters to explore materials which engage their intellectual strengths.

Accordingly, working with teachers in a classroom at the Eliot-Pearson Children's School, we have created a rich environment consisting of puz-zles, games, expressive media, instruments, activities, "nooks," and other paraphernalia which should engage various intelligences and combinations of intelligences. A large proportion of these materials is drawn from the arts—an appropriate tack at any age, but particularly so during the early childhood years. By watching the children as they interact with these

materials during "free play" and by monitoring their behaviors as well under more controlled conditions, we secure information on the intellectual propensities of these children. We also are assessing their working styles.

At the conclusion of the year, we summarize our findings in Spectrum Reports, brief essays which seek to portray the landscape of the child's mind. Coupled with this description are suggestions of the kinds of activities which might engage the child further—at home, in school, and in the wider community.

Conceived of initially as a means of assessment, Spectrum has increasingly become an approach to curriculum. We feel that, at this early point in development, the provision of rich opportunities for exploration, invention, and transformation constitutes the optimal educational approach. When children hesitate to become involved with our materials, we provide special scaffolding; and when children are precocious, we propose more systematic training. But by and large, our developmental findings suggest that this is a time for self-initiated discovery and mastery.

A few years later, the time has come for more active intervention in the child's learning. We believe, nonetheless, that much in the ambience of the Spectrum classroom atmosphere ought to be preserved. Perhaps there can be a kind of "trickle-up" process, whereby aspects of Spectrum can also permeate the elementary grades. Indeed, a "Key" elementary school, based in part on Spectrum and multiple-intelligence concepts, is currently in operation in Indianapolis. Not surprisingly, its architects are arts teachers; and, without question, such a school is hospitable to the arts.

But schools and school systems which welcome the arts are a rare commodity on the contemporary American scene. The original purpose of our second initiative in the schools—Arts Propel—was to assess artistic potential, much in the way that IQ or SAT instruments are *designed* to assess scholastic potential. But we soon discovered that it was virtually impossible to assess artistic potential: most American children and adolescents have so little artistic training that one has to start from scratch. Thus, once again, what began as an assessment endeavor has come to resemble a curricular undertaking.

Based on our own studies of practicing artists, of effective arts education, and of children developing in the arts, we have arrived at a particular perspective on arts education. Arts Propel is an acronym which seeks to capture the principal components of an arts education: production, perception, and reflection. In our view, which contrasts in certain respects with that of the Getty Trust, production must remain central in arts education and particularly so among precollegiate students. The heart of any arts-educational process must be the capacity to handle, to use, to transform different artistic symbol systems—to *think with and in* the materials

of an artistic medium. Such processes can occur only if artistic creation remains the cornerstone of all pedagogical efforts.

Yet production alone is not enough, at least not enough in the current cultural ambience. Nor does it suffice—as it once did—for a teacher simply to be a good practitioner of an art form. No, on our formulation the ability to effect discriminations, to perceive artistically distinctive features, is a necessary partner in artistic competence. So, too, is the capacity to reflect upon the arts, upon one's own goals and methods in artistic production, and upon the means and aims of other artistic practitioners. And so, in our Arts Propel conception, there is a constant dialectic among production, perception, and reflection, with each step informing and enriching the others.

How does Arts Propel work? There are two important and related components. On the one hand, we have devised richly textured tasks in several art forms—music, imaginative writing, and drawing—which call upon the skills of production, reflection, and perception. In one task in the visual arts, for example, students begin with the perceptual task of discriminating an original of the *Mona Lisa* from fakes of various degrees of persuasiveness; this perceptual task leads to a set of reflective exercises and also to productive experiments in handwriting and calligraphy. To take another example, this time from music, students begin by rehearsing a piece of music, but use this activity as a springboard for effecting various kinds of aesthetic discriminations and for reflecting upon what makes for a stunning or a lackluster performance.

Clearly, it should be possible—though it may not be easy—to arrive at means of assessing success at these various projects. Indeed, we can to some extent adapt the scoring systems developed in earlier empirical work at Harvard Project Zero. The greater challenge will be the development of assessment techniques for the second prong of Arts Propel—the collection of student portfolios.

Portfolios are familiar to observers of art education, because most professional schools require aspiring students to present a collection of their best work. We have greatly expanded the notion of the student portfolio. In our version, we are interested not primarily in the final or the best works, but rather in the processes and the components of the student's growth over significant periods of time. Thus the portfolios for which we are calling consist of notes on the gestation of a work; successive drafts, models, and reformulations; journal entries about one's learning, including reflections on exercises and projects; fine-grained tracings of the steps in a single work as well as broader surveys of the development of a theme over the course of a semester or a year.

Collecting these portfolios should be a relatively straightforward undertaking; but arriving at a reliable and effective means of evaluating the port-

folio will be a formidable challenge. How, after all, does one reduce dozens or even hundreds of pages to a manageable but still representative sample and a succinct score or description? We are currently exploring a number of approaches which include self-descriptions and evaluations; scoring the number of different attacks which a student makes on a problem; the variety of ways in which a theme is revisited; the extent of interplay among productive, perceptual, and reflective components; the evolution of ideas over a significant period of time; the ability to introduce personal elements in an effective manner, and the like. Some of these approaches can be quantitative, but many will need to rely on subjective impressions, interjudge reliability, or "holistic" scoring methods.

Even if our attempts to boil down a portfolio to a precise cipher or predicate are not wholly successful, the effort will not necessarily be unworthwhile. In our own view, the very practice of assembling a portfolio, in which the development of one's own artistic thinking can be captured, may constitute an extremely important and valuable educational exercise. (Indeed, it has been a mainstay of one of the most successful of contemporary alternative schools—the Prospect School in North Bennington, Vermont.) Portfolio-centered education may provide a counterexample to the amassing of rote knowledge which many mistake to be the purpose of secondary education; it may bring students into closer contact with their own feelings and goals; it may provide a unique experience of exploring a theme or issue in great depth, an experience which is close to vanishing in the fast-paced America of today. Not least, from our own parochial perspective, it can provide a model of how productive, perceptual, and reflective elements—which certainly mesh in the mature artist—can come together in the artistic learner as well.

Conclusion: The Enduring Rehearsal

Until now, hugging our scholarly heritage, we have described our ideas with relatively little attention to the facts of implementation. Even as we have moved from the experimental laboratory to the Spectrum or Propel classroom, we have written as if there were no autonomous culture with which to deal—no school environment which could serve as a hospitable host, or as a skeptical spectator, or a formidable foe.

But of course, this rhetorical ploy embodies a fiction. Schools and school systems are among the most enduring of American institutions and, as nearly every student of the American educational system has pointed out, they are conservative institutions, slow to change, virtually impervious to radical alteration. Nor is this steadfastness a dysfunctional feature: few institutions can cope with radical change, and, given the superficiality of

most educational fads, a healthy skepticism is probably a desirable trait.

There is no royal road to success in affecting American education, but many roadmarks to ensured failure. In Project Spectrum and in Arts Propel we seek to avoid these pitfalls. While we do not hesitate to put forth and defend our own ideas, we have sought to understand the issues and concerns of teachers and administrators, to listen to their own ideas, to engage in a dialectic of give-and-take where we are learning as well as sharing our own insights. If we are fortunate, what will eventually emerge is a revised notion of each project. This reconceptualization should reflect the legitimate interests and concerns of all the participants and therefore stand a greater possibility of achieving some success—and of being on the mark!

Speaking after the Battle of Britain, Winston Churchill cautioned his fellow citizens, "We are not at the end." Then he proceeded to add, "We are not even at the beginning of the end. But we are at the end of the beginning." If the goal of Project Zero is to be realized—if we are to witness and foster the improvement of arts education—we must be prepared for a very long engagement. Certainly it will be less dangerous than war—in fact, it ought at least on occasion to be fun. But it will be a difficult and long-term endeavor. Re-embracing the opening metaphor of a string quartet, I see the collaboration among the elements less as a rehearsal leading to a final performance than as a continuing open rehearsal. As the players get to know one another better, the resulting renditions should prove increasingly effective and enjoyable. We hope that efforts in Spectrum, Arts Propel, the Indianapolis Key school, and other similar ventures will come to exhibit these qualities.

Speaking about his own profession, the great economist John Maynard Keynes once declared, "The ideas of economists and political philosphers, both when they are right and when they are wrong, are more powerful than is commonly understood. Indeed, the world is ruled by little else. Practical men, who believe themselves to be quite exempt from any intellectual influences, are usually the slave of some defunct economist" (quoted in Hession, 1984, p. 286). I would not be so bold as to make analogous assertions about any area of educational thinking, and yet I think that Lord Keynes had a point. The ideas of Project Zero, and of others who have thought about arts education, are potentially important. Having had the luxury of developing these notions over the past two decades, we feel it is now incumbent upon us to try to introduce them to the wider community. Perhaps, as we collaborate with artists, teachers, and students, as we seek to combine psychology and philosophy with educational practice in active school environments, we will produce some works which merit the rapt attention of others.

REFERENCES

Gardner, H. (1982). *Art, mind and brain: A cognitive approach to creativity*. New York: Basic Books.

Gardner, H. (1983a). Artistic intelligence. *Art Education, 36*, 47-49.

Gardner, H. (1983b). *Frames of mind: The theory of multiple intelligences*. New York: Basic Books.

Gardner, H., Howard, V., & Perkins, D. (1974). Symbol systems: A philosophical, psychological, and educational investigation. In D. Olson (Ed.), *Media and symbols: The forms of expression, communication, and education* (pp. 27-56). Chicago: University of Chicago Press.

Gardner, H., & Winner, E. (1981). Artistry and aphasia. In M. T. Sarno (Ed.), *Acquired aphasia*. New York: Academic Press.

Gardner, H., & Winner E. (1982). First intimations of artistry. In S. Strauss (Ed.), *U-shaped behavioral growth*. New York: Academic Press.

Goodman, N. (1976). *Languages of art*. Indianapolis: Hackett.

Goodman, N., Perkins, D., & Gardner, H. (1972). *Summary report*. Harvard Project Zero.

Hession, C. (1984). *John Maynard Keynes*. New York: Macmillan.

Malkus, U., Feldman, D., & Gardner, H. (1988). Dimensions of mind in early childhood. In A. D. Pellegrini (Ed.), *The psychological bases of early childhood*. Chichester, U.K.: John Wiley.

Piaget, J. (1970). Piaget's theory. In P. Mussen (Ed.), *Carmichael's manual of child psychology*, vol. 1. New York: Wiley.

Shotwell, J., Wolf, D., & Gardner, H. (1979). Styles of achievement in early symbolization. In M. Foster & S. Brandes (Eds.), *Symbol as sense: New approaches to the analysis of meaning* (pp. 361-387). New York: Academic Press.

Winner, E., Blank, P., Massey, C., & Gardner, H. (1983). Children's sensitivity to aesthetic properties of line drawings. In D. R. Rogers & J. A. Sloboda (Eds.), *The acquisition of symbolic skills*. London: Plenum Press.

The work described here has been supported by the Ahmanson Foundation, the Rockefeller Brothers Fund, the Rockefeller Foundation, and the Spencer Foundation. I am grateful to these agencies for their generous and flexible support of our work.

CONTRIBUTORS

Laurene Krasny Brown, who was formerly associated with Harvard Project Zero, now works as a consultant to media producers for children. She is the author of *A Manual for Parents and Teachers: Taking Advantage of Media*, a preprimer textbook, and a preprimer story book. She has also written numerous picture books for children.

Lyle Davidson, a composer, is Chairman of the Undergraduate Theory Department at the New England Conservatory of Music, where he teaches solfege and counterpoint. He is a member of the Harvard Project Zero community, with research interests in music and development. Recent papers include "Young Children's Musical Representations: Windows on Music Cognition" and "From Collections to Structure: The Developmental Path of Tonal Thinking."

Howard Gardner was a founding member and is now Co-Director of Harvard Project Zero. He is also a research psychologist at the Boston Veterans Administration Hospital, Professor of Neurology at the Boston University School of Medicine, and Professor of Education in the Harvard Graduate School of Education. His most recent books are *Frames of Mind: The Theory of Multiple Intelligences* and *The Mind's New Science: A History of the Cognitive Revolution*.

Nelson Goodman, the distinguished philosopher, was the founder and first Director of Harvard Project Zero. He is now Professor Emeritus of Philosophy at Harvard University. Among the more recent of his many books and articles are *Ways of Worldmaking* and *Of Mind and Other Matters*.

Matthew Hodges, an advanced doctoral student at Harvard Graduate School of Education, is employed in research and development by Digital Equipment Corporation. He has created an innovative application of video-disk technology called "Navigation."

V. A. Howard is co-founder and, with Israel Scheffler, Co-Director of the Philosophy of Education Research Center in the Harvard Graduate School of Education. He did postdoctoral study on aspects of symbolism and art with Nelson Goodman and for several years was a member of the Project Zero staff. His most recent books are *Artistry: The Work of Artists* and, with J. H. Barton, *Thinking on Paper*.

Joan Kaplan is a research assistant at Harvard Project Zero and the Boston Veterans Administration Medical Center. Her research has focused on the development of nonliteral language capacities in children and the breakdown of narrative comprehension following brain damage. She has co--authored a chapter on artistic deficits due to strokes that will appear in the *Handbook of Neuropsychology*.

Jonathan Levy is Professor of Theatre Arts at the State University of New York at Stony Brook and Visiting Scholar at Harvard University. His plays, for both adults and children, have been performed widely. He recently published *A Theatre of the Imagination and Other Essays on Children and the Theatre* and, with Martha Mahard, a bibliography of early children's plays in English.

Kathryn Lowry is now a graduate student in East Asian Studies at Harvard University and has been a research assistant at Harvard Project Zero, where her research has focused on music and music education in China. Her recent projects have included a book-length manuscript on arts education in China, co-written with Howard Gardner and Constance Wolf, and interviews and field researches on oral and traditional music in China and the United States.

Joan Meyaard holds a master's degree in Theoretical Studies from the New England Conservatory of Music. She is currently a research assistant at Harvard Project Zero, studying children's interactions with computers and the arts. Her previous work concentrated on the development of musical perception and internalized structures for musical representation.

D. N. Perkins is Co-Director of Harvard Project Zero. His current research emphasis on the nature of understanding and the development of critical and creative thinking skills in the context of subject-matter learning is reflected in his *Knowledge as Design*. He is also the author of *The Mind's Best Work*, on the psychology of creative thinking, and, with Raymond Nickerson and Edward Smith, co-author of *The Teaching of Thinking*, a review of efforts to teach thinking skills.

Martha Davis Perry, while at Harvard Project Zero, conducted research on children's early notational development, including map making, music notation, and the use of numerals and diagrams. She is currently a free-lance editor for publications in psychology and medicine.

Elizabeth Rosenblatt is a senior research assistant at Harvard Project Zero. Her work has focused on the development of exceptional abilities in the visual arts, arts education, and the comprehension of figurative language. She recently co-authored a chapter on the visual memory skills of children gifted in art that will appear in *The Neurospychology of Talent*.

Israel Scheffler is Victor S. Thomas Professor of Education and Philosophy at Harvard University and is Co-Director of the Philosophy of Education Research Center in the Harvard Graduate School of Education. His most recent book is *Inquiries: Philosophical Studies of Language, Science, and Learning*.

Larry Scripp, a member of the faculties of the New England Conservatory of Music and the Longy School of Music, is currently a research associate at Harvard Project Zero. He is co-author of "Young Children's Musical Representations: Windows on Music Cognition." As an advanced student at the Harvard Graduate School of Education, he is investigating the relationship of music reading skills to musical development.

Seymour Simmons is an artist and the author of *Drawing: The Creative Process*. He completed his doctoral studies in the philosophy of education at Harvard University in 1987.

Joseph Walters is a research associate at Harvard Project Zero. He investigates how children and adults use notational tools, from pencil and paper to computers, to solve different kinds of problems in music and the visual arts.

Patricia Welsh teaches solfege at the Longy School of Music and the preparatory division of the New England Conservatory of Music. She is completing a master's degree in Voice at the New England Conservatory and is co-author of "From Collections to Structure: The Developmental Path of Tonal Thinking."

Ellen Winner is Associate Professor of Psychology at Boston College and a research associate at Harvard Project Zero. In 1982 she published *Invented Worlds: The Psychology of the Arts*. Her book on figurative language development, *The Point of Words: Children's Understanding of Metaphor and Irony*, has just appeared with Harvard University Press.

Constance Wolf is now a graduate student at the California Arts Institute and has been a research assistant at Harvard Project Zero. Her work has focused on arts education in China, with an emphasis on the visual arts. With Howard Gardner and Kathryn Lowry, she is preparing a book-length manuscript titled *Arts Education in China: A Cross-Cultural Perspective*.

Dennie Wolf is a research associate at the Harvard Graduate School of Education and works at Project Zero. Her research concentrates on early symbolic development, particularly in the areas of drawing and language. She is the author of numerous research articles and several books, the latter including *The Arts Go to School, Academic Preparation in the Arts*, and *Early Symbolization*.

INDEX

Aesthetic:
—effects: mood, 121, 122, 123; motion (and stillness), 121, 122, 123; personality, 121, 122; surprise, 121, 122, 123
—properties: of lines, 7; of drawings, 10
—quality: age-related decline in, 5, 6
—sensitivity: age-related decline in, 9; in gifted children, 13

Artistic:
—development: in pre- and post-conventional years, 5; in conventional years, 5, 6; function of film imagery in, 40; role of family in, 91; individual differences in, 160; relationship between learning and, 160
—learning: defining, 146, 153; visible dimensions of, 146, 153; invisible dimensions of, 146-152, 153, 154; multiple stances in, 146-148
—symbolization, 158-159
—thinking: methods for making visible, 153

Arts education: as component of educational process, 1; shortcomings of ordinary, 14; components of, 157; philosophical notions of, 157, 158; artistic practices in, 157, 161; environments for, 162
—in U.S. and China: definition of, 91; means, 91; endstates, 91, 92; career paths, 91, 92, 96; role of family in, 91, 93; training methods, 91, 93-95; goals and values, 91, 96; role of artist, 96; respect for tradition, 97

Arts Propel, 144, 162, 163-164

Boulanger, Nadia, 72
Boundaries: blurring of conventional, 22; content across media, 35
Brain: laterality, 12; regions, 160

Cognitive: content, 46; development, 82, 85
Coherence: standards of, 115; paradox, 115; celebration of paradox, 117; context, 120, 129; superficial, 123; new, 126; mentioned, 119, 122, 124
Color: as mechanism, 122; relations, 123
Competency: as thoughtful use of medium, 135
Completions: age-related decline in aesthetic quality of, 6-11
Composition: definition of, 7; at preconventional and conventional stages, 8; use of computers in, 108, 109
Compositional: ability, 77; development, 79, 81; process, 82, 83, 87
Computer: in arts education, 99-110; generated visual images, 102-103, 106
Conception, musical: conflict with perception, 70; ways to resolve, 71
Conceptual: knowledge, 67-70, 72; advance, 126
Content: effect of change in media on, 37; remembered film, 40
Context: art historical, 120-121; coherence in, 129
Contour, 65, 68
Creation of art: role of emotion in, 127; effects of misunderstanding on, 128

Detail: in different genres, 25-26
Detection: of non-literal intent, 54, 55, 56, 58, 60; of relation between what is said and what is meant, 54, 55, 56, 59, 60; of unstated meaning, 54, 55, 57, 59, 60, 61
Developmental paths: in artistic areas, 159-160
Discourse: about art, 129
Dissonance: control of, 79, 81